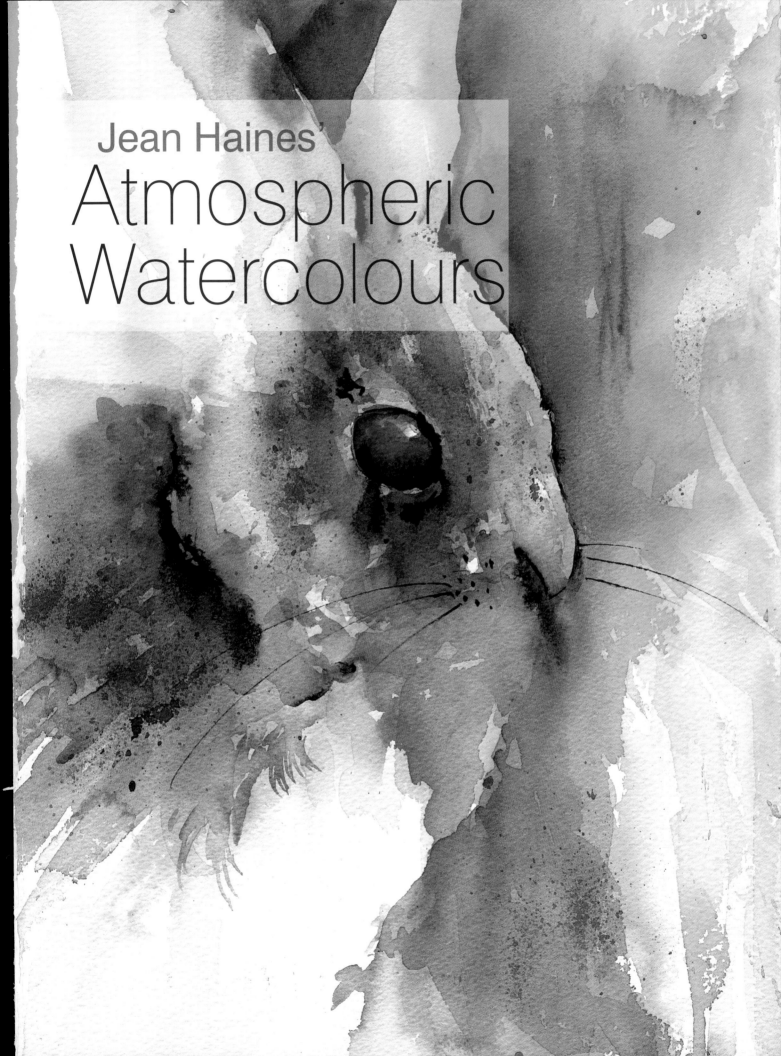

Jean Haines'
Atmospheric
Watercolours

Dedication

To my hero, who makes me believe
all things are possible, John.

Jean Haines'
Atmospheric Watercolours

Painting with expression, freedom and style

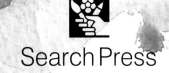

Search Press

First published in Great Britain 2012

Search Press Limited
Wellwood, North Farm Road,
Tunbridge Wells, Kent TN2 3DR

Reprinted 2012, 2013 (twice),
2014 (twice), 2015, 2016 (twice),
2017, 2018

Text copyright © Jean Haines 2012

Photographs by Roddy Paine
Photographic Studio
Photographs and design copyright
© Search Press Ltd 2012

ISBN: 978-1-84448-674-8

The Publishers and author can accept
no responsibility for any consequences
arising from the information, advice or
instructions given in this publication.

Suppliers
For details of suppliers, please visit
the Search Press website:
www.searchpress.com.

Printed in Malaysia by Times Offset (M) Sdn. Bhd.

Acknowledgments

There are so many wonderful people who have contributed to this publication. My dream has always been to write a book on watercolour that is full of inspiration and to share my passion for working in watercolour.

No author can exist without a publisher, and I have the best. Search Press, my amazing publishers, and their incredible team made my dream come true. I owe a huge thank you to Roz Dace for seeing my vision and Katie Sparkes for enabling it to come to print. Juan Hayward, the designer, is incredible for taking the impossible as a suggestion and making it happen.

Roddy Paine and Gavin Sawyer – thank you for always making the photographic sessions the most memorable of occasions.

Nick Horton, computer specialist, has saved my life on numerous occasions when a studio move has created unforeseen technical hiccups.

I owe a very special mention to Barbara Penketh Simpson who, as President of the Society of Women Artists (SWA), gave me wonderful advice as an artist that I will always be very grateful for. There have been times in my life when my head has not caught up with my art, but I think it is about to now.

My husband deserves the biggest acknowledgement for not only allowing me to follow my dream but also missing me for so much of the time when I chose to work on my book. John, my life has always been incredible because you are in it and I will always owe so much to you. Thank you, with all of my heart.

Winsor & Newton, Daniel Smith and Schmincke deserve a mention because without any of their incredible watercolours this book would not have been possible. I am very much in love with colour and they light up my art life.

I am also going to thank Jean Louis Morelle who, as an artist, opened my eyes to the fact that there is excitement behind holding a brush and seeing results when working in this most magical of mediums.

Most of all, I want to thank you, the reader, for reading my book because without you I could not be an author. May all your own dreams come true.

Jean

Page 1
Spring Bunny

Pages 2–3
Floral Mood

Opposite
Woodland Fantasy

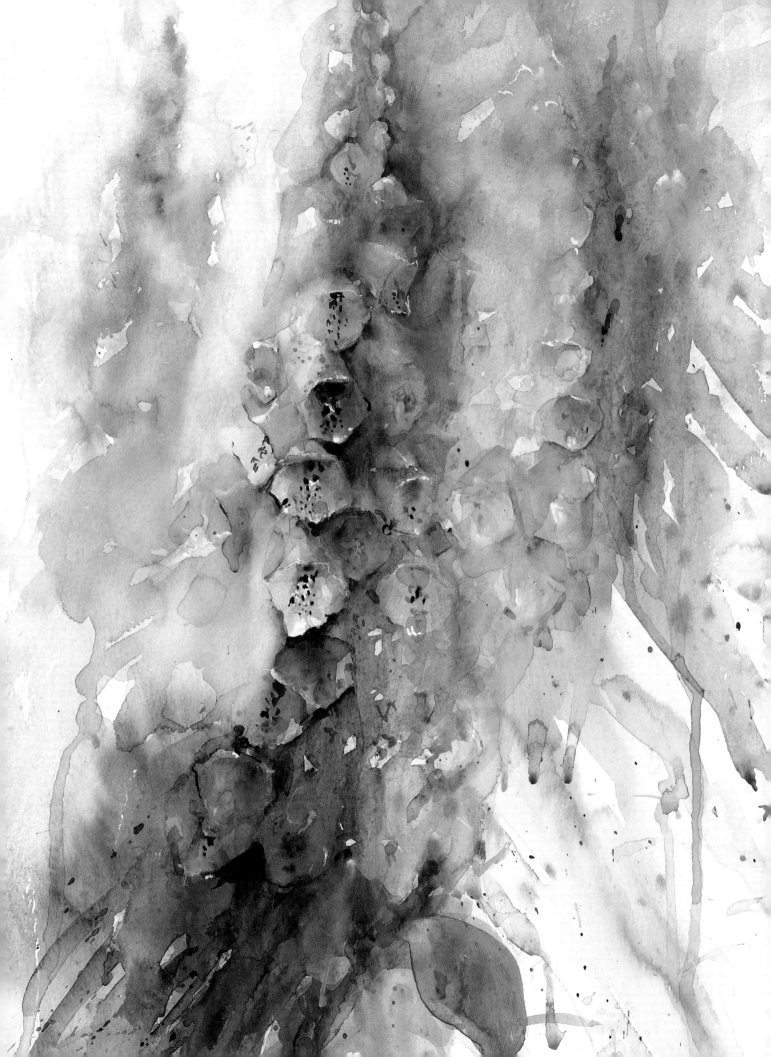

Contents

Preface

"Let your inner artist shine because it is so worth being alive when you do."

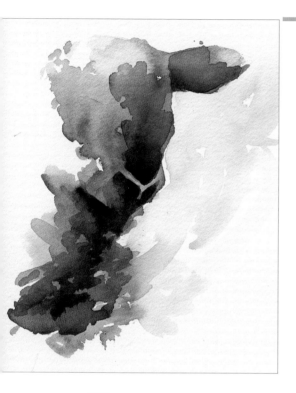

"Don't be a sheep, be unique."

There is no doubt that writing this book has been educational, motivational and inspirational to me as an artist, so I truly hope you will feel the same way once you have had time to absorb the many new techniques and exciting colour combinations found on these pages. I know many artists wish to paint in a loose style, but it is important not to lose sight of the fact that you do need some experience of drawing and sketching to understand how subjects work before you can paint in this way with successful results. Having said that, I do believe that if you have a good eye for colour placement you will obtain stunning paintings that have a sense of freedom far more easily than if you worked from sketching alone.

What you do need is the enthusiasm to try, the urge to keep painting in this style, and the desire to improve. Remember that the only thing getting in the way of you being a brilliant artist is you.

Whatever you love to paint, whether it is animals, flowers, still life or landscapes, this way of working opens many doors to gorgeously unique results. I love the quote 'Don't be a sheep, be unique', which says so much about learning to be a creative artist. You can only learn so much by copying, and by doing so continually you are depriving yourself of the pleasure of knowing you have created a painting that is totally yours.

My book is aimed at bringing the very best out of you. It doesn't take a miracle to achieve a great painting; it takes determination, positive thoughts and a relaxed state of mind. Whatever you choose to paint, do so with freely flowing, beautiful colour, paint regularly and never give up. Remember you can be a great artist if that is what you decide you wish to be. But most of all, never forget that painting can be fun, totally enjoyable and the most magical therapy of all. It can lift your spirits at times when you are low or unhappy and it is the one thing we can do at any age without tiring ourselves out. It is an escape from life when we need it and, via the flick of a brush, we can be anywhere in the world we wish to be. On rainy days we can paint sunshine, on hot ones we can paint cool scenes. Anything and everything is possible.

But for now, enjoy my book, read each chapter, follow it at your leisure and return over and over again to your favourite sections. Feel free and more energised than you have ever felt in your life, and let your inner artist shine. Because it is so worth being alive when you do.

The Folk Singer

Layers of colour, unique brushwork and unusual watermarks lead to a face full of personality and character in the first stages of this portrait in watercolour.

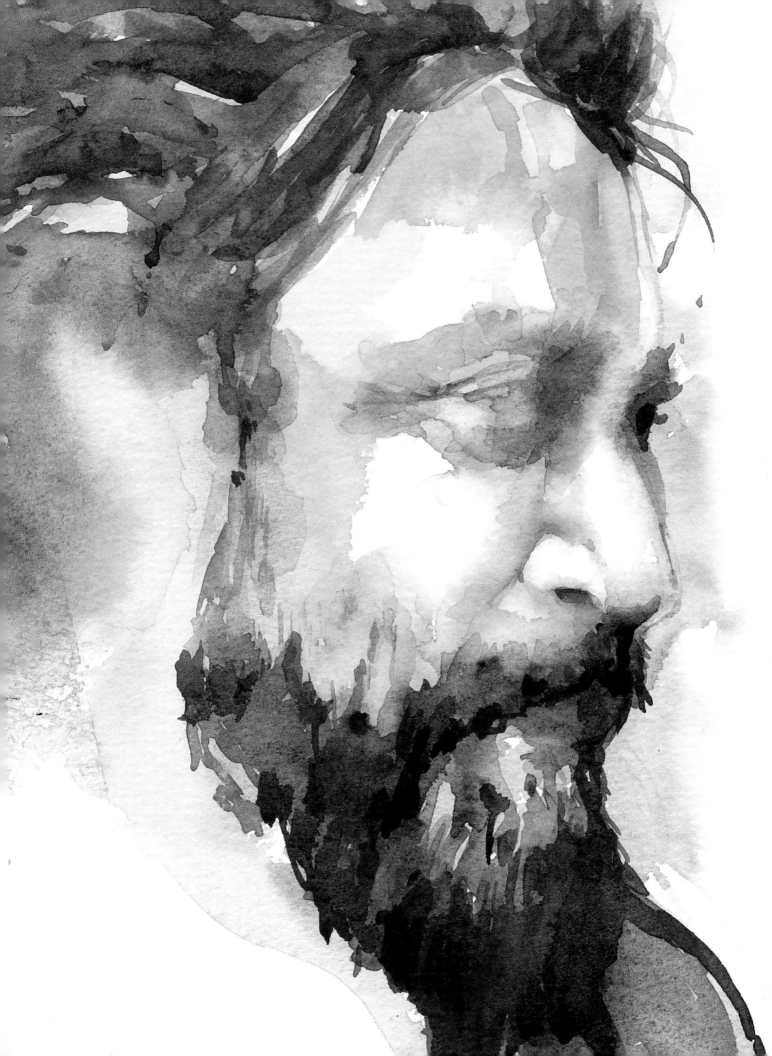

Introduction

"Believing you can paint and having the confidence to try makes all the difference on the journey to becoming a successful artist."

I FIRST BECAME FASCINATED WITH ART AS A CHILD. Like many artists, my early years of drawing were full of innocence and wonder at the pleasure of being able simply to create. It didn't matter what I achieved as long as I was playing with colour and loving every minute of the process of a picture developing. The outcome was totally unimportant. The fun in creating was everything. At every opportunity I would be capturing a favourite subject on paper. But there were many emotional issues that I am only just beginning to understand behind these creations of my past; and many are connected with the techniques I use today.

My parents had separated while I was very young and so I was taken to my grandmother's home to live. Here I was lonely and very lost. It was a time when children should be seen and not heard. In an effort to keep a small child occupied and quiet, my grandmother placed huge, fat, wax crayons in my tiny hand, sat me at a table where my small legs would dangle from the high, wooden chair and gave me paper. I can close my eyes and still imagine the smell of those crayons – you would have to remove the paper gradually from the coloured stick as the wax wore down from use. I lived in a silent world drawing the dogs I was never allowed to own and the flowers I was never allowed to pick from my grandfather's garden. I drew a happier place. I escaped. Without my knowing it at the time, this was the beginning of my career in art and of my painting style.

Thread Bare

An old teddy coming to life through a mixture of colour placement and simple brushstrokes.

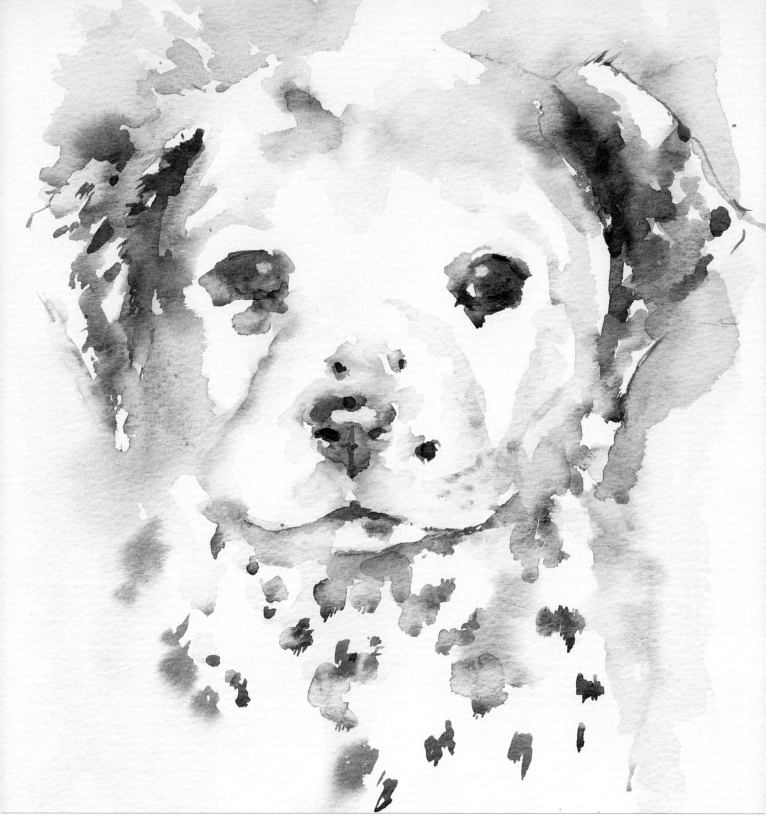

The Biggest Spotty Dog You Ever Did See
(as a puppy)

Only those who grew up with a children's programme called 'The Wooden Tops' will understand the choice of a dalmatian here!

I will readily fall in love with any subject and, like the small child of my past, not once consider I cannot paint it. The idea simply doesn't enter my head. Instead, I relish the thoughts I have of ways in which I *can* paint it. With my technique I can approach every object and paint it from a single starting point or bring it to life from a vibrant colourful wash. Nothing is out of my reach as an artist and everything is within it. Doubt does not enter into it, and the two words 'I can't' do not exist, because I know I can. What is more, I believe that everyone, by following me, can paint if they wish to.

I have met many people attending my workshops over the years who let me know beforehand that they feel they are useless at art and cannot draw. Or they will tell me that they are brilliant at painting flowers, for example, but not other subjects. You will gain a wonderful feeling of freedom knowing that, once you have mastered my technique, nothing is out of your grasp as an artist and nothing is impossible to paint. In fact, the whole creative process turns into an addiction. Eventually, as for a child, new subjects become a delight and fascination rather than a fearful journey into the unknown. It is facing that fear, believing you can paint, and having the confidence to try that really makes all the difference. Set out to enjoy painting rather than committing yourself to painting a masterpiece every time you pick up a brush – that is the key to success.

We all want to paint for a number of reasons. Some dream of becoming a professional artist, while to many painting is a wonderful hobby. Others desperately want to paint anything that is instantly recognisable. Have you ever experienced an over-enthusiastic youngster showing a parent a painting from school and heard the mother say, 'That's a wonderful elephant, darling', only to hear the child's dismissive response, 'It's a dog!'. The child is often completely uninterested in the fact that the parent got it wrong. They know it is a dog and that is all that counts. We should feel the same way about our own paintings when we receive feedback from others as this can have a negative impact on our development, and on the progress we make on our personal art journey. Somehow we have to forget what others see in

"For everyone who wants to enjoy painting, feels a need to escape from their lives from time to time, has had their artist's soul trodden on, or who has painted for years but feels desperate for a breath of fresh air, this book is for you."

our work and enjoy it for the personal bond we create with each brushstroke. Falling in love with creating and not caring what anyone else thinks can be an important factor in building self-confidence. Only then can we be bold enough to explore new techniques, have new adventures with art and grow as an artist.

Over the last twenty years and more I have listened to art critics' comments on art explaining why it is or it isn't good. And I have witnessed incredible artists have their souls crushed by negative comments from peers who couldn't hold a candle to their amazing talent. I have seen adults in their senior years avoid painting because someone in their school when they were a teenager told them they didn't have an artistic bone in their body. But I have also seen happiness cover the same faces when they understand for the first time in their lives that they are not only good but fantastic with watercolour.

For everyone who wants to enjoy painting, feels a need to escape from their lives from time to time, has had their artist's soul trodden on, or who has painted for years but feels desperate for a breath of fresh air, this book is for you. By reading it you are being given permission to feel the innocent joy of a child, as if creating for the very first time. I expect you to feel thrilled at every success no matter how small it is, and over the moon at achieving amazing results that are far better than mine purely from the journey you are about to embark on – taking one page at a time, through exciting colour combinations and brushstrokes. My aim is to leave a sense of excitement in your work and a feeling akin to an adrenaline rush like you have never experienced before, simply by moving a brush and playing with colour.

If you don't wish to be addicted to watercolour as I am, now is the time to escape. Or you can be brave, take the risk and read on. I feel you are with me while you are reading this so I am going to say: go for gold, turn the page over and prepare for the ride of your life in my favourite medium – watercolour!

Elephant Study
Despite what you may think at this stage, a study like this is both simple and easy!

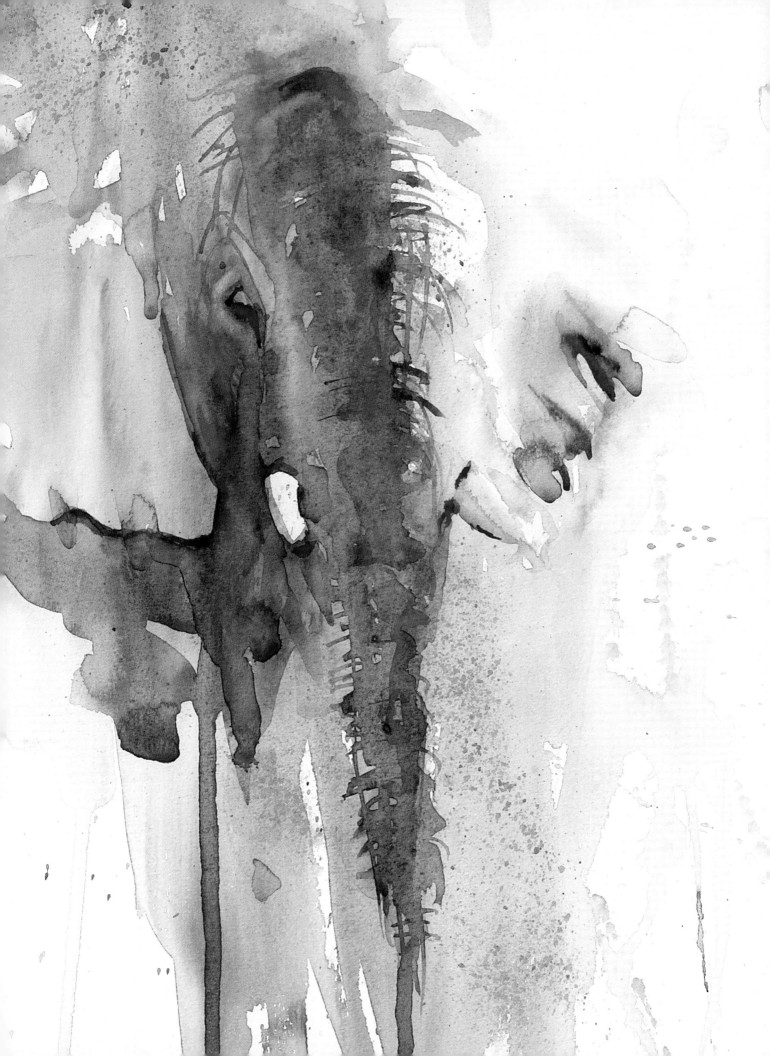

The Creative Journey

East meets West
Influences on technique

"There is great value in understanding good composition, leaving white paper and placement of a subject to create harmony that is pleasing to the eye."

I have been fortunate not only to travel but also to live in many countries. This has enabled me to meet artists from all over the world. Every time I moved I would search for artists whose work I admired and approach them to ask if I could watch them while they painted. When possible, I would attend classes to study the way they worked. In many countries I was approached to teach, and I would happily pass on all that I knew to everyone attending my workshops. It is this passing on of information that keeps the tradition of watercolour alive. Sharing, inspiring and motivating are an essential part of the art world, so to gather knowledge and then give it away is, to me, a natural process. This is why I love being able to write this book and give everything I know to you.

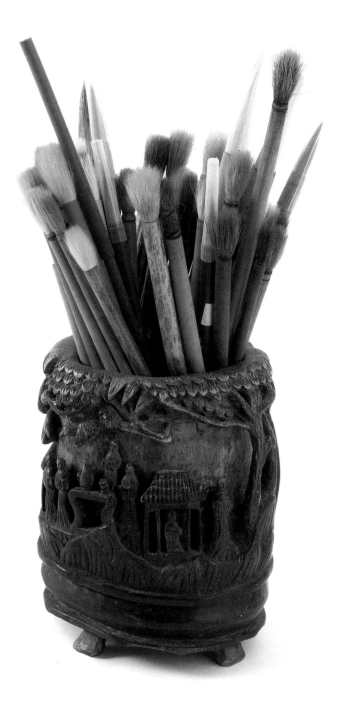

Chinese brushes given to me as gifts while studying watercolour in China.

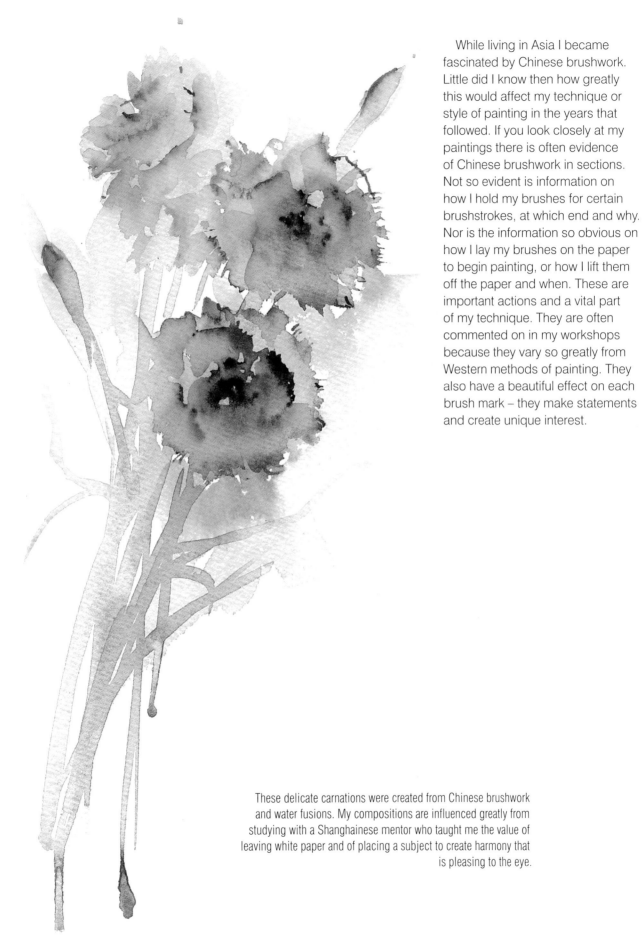

While living in Asia I became fascinated by Chinese brushwork. Little did I know then how greatly this would affect my technique or style of painting in the years that followed. If you look closely at my paintings there is often evidence of Chinese brushwork in sections. Not so evident is information on how I hold my brushes for certain brushstrokes, at which end and why. Nor is the information so obvious on how I lay my brushes on the paper to begin painting, or how I lift them off the paper and when. These are important actions and a vital part of my technique. They are often commented on in my workshops because they vary so greatly from Western methods of painting. They also have a beautiful effect on each brush mark – they make statements and create unique interest.

These delicate carnations were created from Chinese brushwork and water fusions. My compositions are influenced greatly from studying with a Shanghainese mentor who taught me the value of leaving white paper and of placing a subject to create harmony that is pleasing to the eye.

Later I travelled to Dubai and joined an art class there at the original Dubai International Arts Centre. I soon realised, with a sense of embarrassment, that during the sessions the students were continually asking for my help instead of approaching the watercolourist who was teaching them. I left out of respect for the teacher so that they would regain their students' full attention, but the Centre then contacted me at my home and asked me if I would consider teaching. I agreed and started with beginners' classes. This was quickly followed by sessions for intermediates but soon professional artists were coming to me for advice. My workshops were always fully booked and I loved every second of making each one more exciting than the last.

Old Dubai
Less detail in the background section creates an illusion of distance and adds intrigue to the composition.

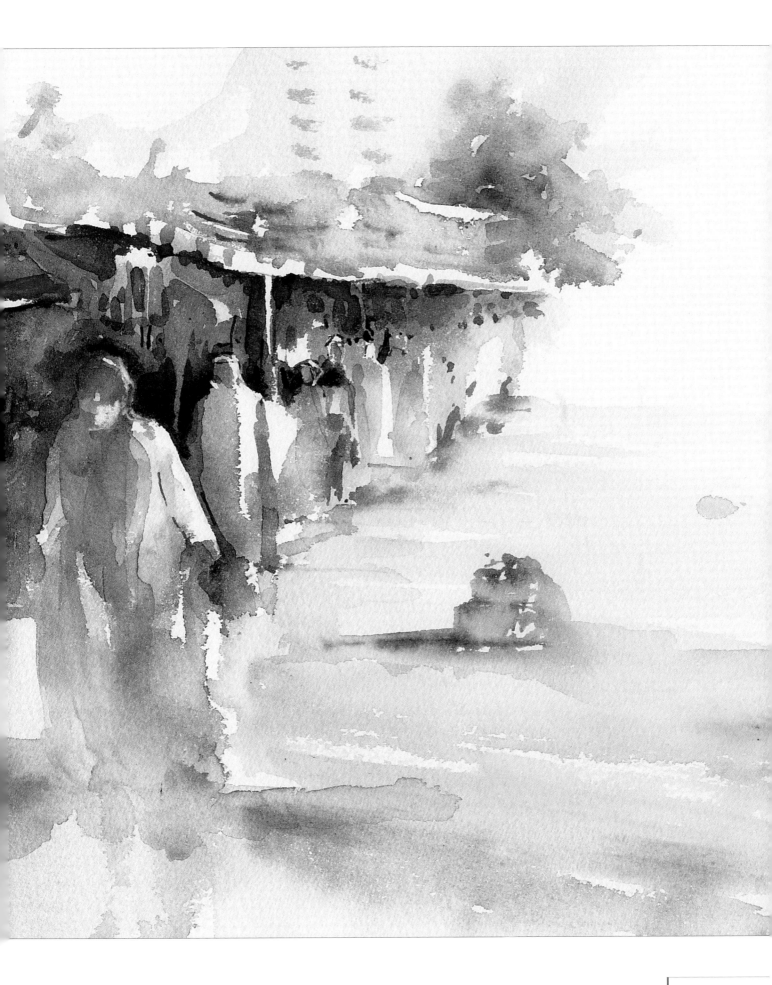

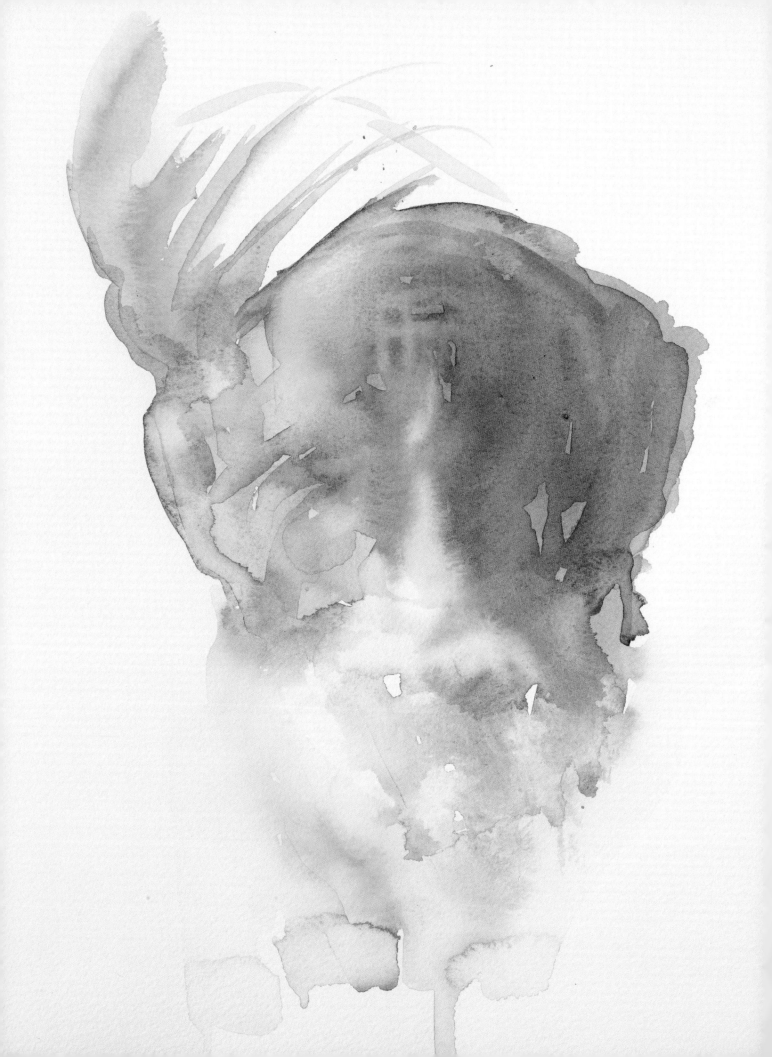

Unknown to me, my students were framing the little homework exercises I was giving to them to take home and copy. A gallery that was framing them then approached me to sell my work. My very first painting of a mosque sold the day I took it in to be framed, and from there I went on to show my work in galleries all over the world. My art career is founded on this special time of my life, when I was giving away all my tips and techniques, and this is still an intrinsic part of what I do today.

Dubai taught me many things. It showed me there does not have to be a blue sky to make a great landscape. My watercolours started to include beautiful red, orange or pink skylines. My selection of colour gradually became even more intense in my desire to capture the subjects, hit by very strong sunlight, that I observed daily. I held my very first solo exhibition at the same time as that of a visiting Western artist who had taught me when I lived in England many years previously. I later learned that those who attended both exhibitions fell in love with the stronger colours I used, whereas it was felt that the paler colours used by the talented English artist were not telling the true story of life in Dubai. From this I learned that it simply isn't enough to have the ability to paint a scene accurately in every detail. An artist has to transport the viewer to the country they are trying to portray, using colours that accurately re-create the atmosphere and mood of the place. Those who have travelled to or lived in the country that the painting represents will readily and instinctively dismiss any shades that are not correct.

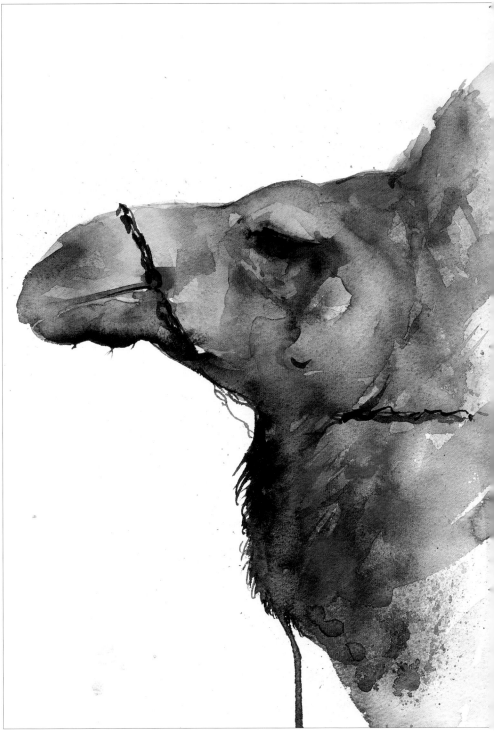

Colourful Character (above)
Living in Dubai meant I saw and painted many camels. They soon became a favourite subject and one I often miss!

Face of Dubai (left)
First signs of a face appearing magically from a first wash of watercolour.

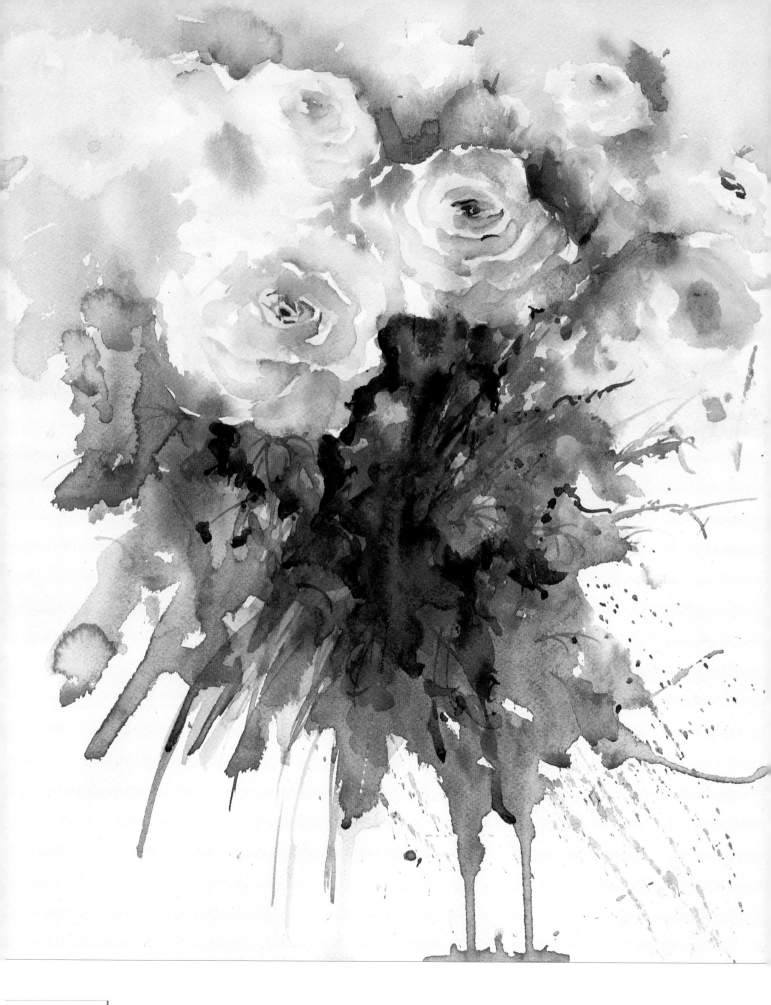

This point became even more significant when I moved to France. Here I was influenced by the incredible watercolours of Madame Blanche Odin. In Bagnères-de-Bigorre, France you can see this amazing woman's work. Her passion for painting roses and other flowers lives in me and I cannot pass a summer without becoming engrossed in capturing these beautiful blooms in watercolour.

My life is rich because of the people I have met, the friends I have made from all over the world and the watercolour tips I have been given by so many incredible and outstanding artists. These tips are held within the pages of this book and I give them to you with my blessing that whatever you create you enjoy. Life as an artist is wonderful and I want to share with you the wonder that is in mine.

"I believe we often take for granted the little – or big – things that affect our reason for painting, and the way in which we paint."

Scents of Summer (left)

Roses inspired by Madame Blanche Odin. We may be very different in terms of technique, but I am strongly influenced by the talent of this lady. She could draw the viewer of her work into feeling as though they could touch the petals or even smell the fragrance of roses in a painting.

Brushstrokes with a difference

"How we hold our brush for each brushstroke helps tell the story in a composition."

It wasn't until I lived in Asia and studied with my Shanghainese mentor that I fully comprehended that how we use our brushes can make both subtle and dramatic differences to our paintings. Where we hold our brushes, the pressure we use, where we place the brush tip on the paper and where we take it off, are important factors. All leawo incredible marks and effects within our compositions.

When I studied Chinese painting I was taught to make each mark repeatedly until I had learnt how to hold, load and move my brush correctly. I have now combined my Eastern teaching with my Western way of working. Artists watching me paint often comment on how gently I move my brushes, so please bear this in mind when you move yours. The most beauty can be gained from watercolours when they are free to flow naturally, so I move my hand as if it has been touched by a soft breeze.

"I move my hand as if it has been touched by a soft breeze, allowing my watercolours freedom to flow and merge naturally."

Exercise: Brush handling

The old canal bridge

Try this simple exercise to learn how to use your brushes in the way that I do. It will help you enormously in the rest of the exercises in this book.

Before you start, test the pressure you use on your paper by placing a dry brush on the back of your hand. If you can feel it you are pushing the brush too hard. You should feel a gentle whisper of a touch. This will allow your watercolours to flow freely and beautifully on the paper.

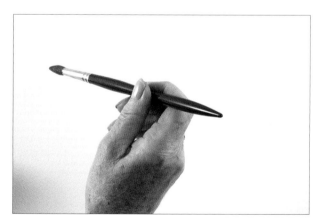

1 How we hold our brush for each brushstroke helps tell the story in a composition. Start by holding your brush in the centre of the handle. Here I am using a no. 10 sable.

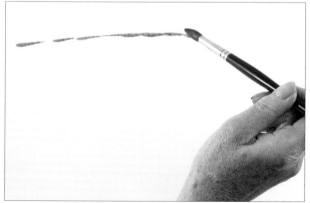

2 Next, gently move your arm sideways, drawing the brush to the right, and leaving a fine line of pigment across the paper. Here, I have used Winsor & Newton Alizarin Crimson and Cadmium Orange mixed together.

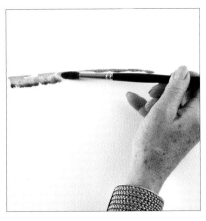
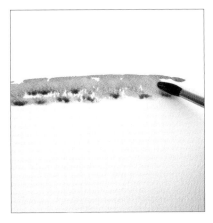
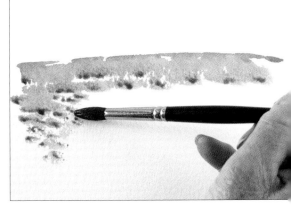

3 Still holding the brush at the centre of the handle, turn your hand so that the sable lies almost flat against the paper. You are going to use the length of the sable to make marks on the paper that represent the bricks in the old bridge. But you are not painting any detail, just pulling the colour downwards from the first brushstroke that formed a line for a starting point.

4 Work a second row of bricks by lifting your brush on and off the paper in a sideways movement as you apply the colour. You can touch the line of existing bricks above the new line to allow colour from the first section to run into the new area. Relax your hand, touch the paper very gently and allow some sections of paper to remain white.

5 Now make marks with your brush to suggest bricks to form the left-hand side of the arch. Your brush should be at a slight angle to the paper now and you should be making marks that show, for each brick, where you put your brush on the paper and where you took it off. These will be more obvious when the pigment is dry.

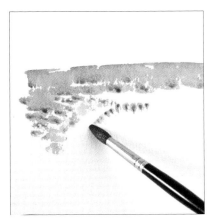
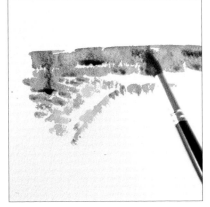
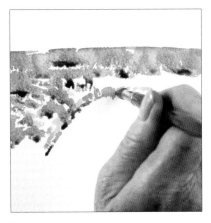

6 Move your hand to the very end of the brush handle for this next curved application of colour, where we are merely hinting at the first signs of the bridge arch. If you are relaxed and holding your brush at the end furthest from the sable, you will gain a more fluid, curved brushstroke. Make small marks to represent where the curve of bricks forms the arch of the bridge.

7 Have fun holding the brush in this way, with your hand right at the far end of the handle. Load your brush with fresh pigment from your palette and drop it into the still-wet sections, allowing this new, stronger application to merge with the existing colour.

8 Move your hand back to the centre of the brush handle for more control as you now make a definite arch under the curved brick section. This will define the edge of the line of bricks here.

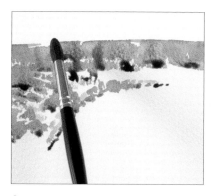

9 Now add another shade. I have used Winsor & Newton French Ultramarine Blue and just dropped it in by gently touching the paper with my loaded brush.

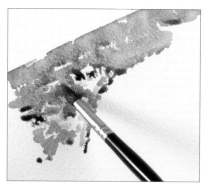

10 Turn your paper at an angle and drop some warm pigment in to give a glow to your bricks. I have used Schmincke Translucent Orange for this stunning touch of warmth here. Once you have dropped the colour in, lift your brush and do not return to the section.

Tips

The way pigments fuse naturally is far more attractive without our help. Do not interfere when colours are merging while they are still wet.

For backgrounds, I often allow branch lines to merge initially in a first wash but strengthen them further in at a later stage (see steps 16–18).

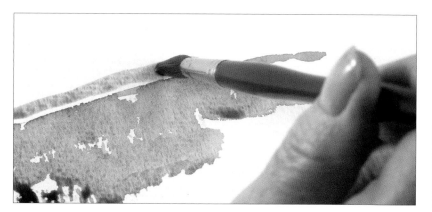

11 Now let's try another straight line with a sideways brushstroke. Load your brush with a colour to represent the sky behind the bridge. I have used a mix of Winsor & Newton French Ultramarine Blue and Alizarin Crimson for a slightly violet sky, which will give a great atmosphere. I avoid plain blue skies as I find them uninteresting! As for the first line of the bridge, at the start of this exercise, move your arm sideways to draw the brush line. Remember to do this with very gentle pressure. My hand at this stage is raised so as not to touch the section that is wet and I have left a fine white line between the bridge and the new skyline, which will prevent the colour of the sky merging with the still-wet section of the bridge. This will also add a dramatic hint of light hitting the top line of the bridge when the painting is dry – a technique I like to call 'trapping the light'.

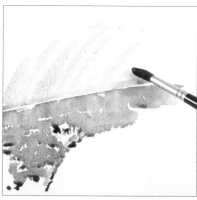

12 Quickly make some diagonal brushstrokes away from the line of sky. Place colour right across the line of sky in beautiful marks that suggest movement. We are not aiming for flat, perfect colour as we want a scene that is full of life and energy. Even though this exercise is about how we use our brushes, we are already starting to think about creating atmosphere and energy in our results. Be emboldened in how you plan your paintings by knowing how to use your brushes well.

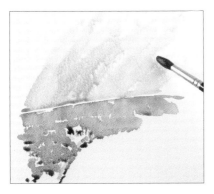 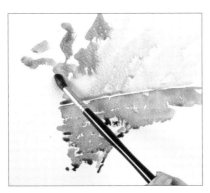 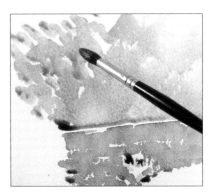

13 Before this line of brush marks is dry, swiftly drop in some glorious blue. I have used Daniel Smith Sleeping Beauty Turquoise Genuine here as it is such a gorgeous colour. You will find my colour selections are very individual, as I want to produce striking and unusual effects. This darker, new application of colour will merge with the existing sky and fade as it dries.

14 At the top left-hand corner of the paper, drop in some autumnal shades towards the edge of the already placed still-wet sky. My sable brush is placed at an angle on the paper here, and I am repeating the shades I used for the bricks in this new section to create harmony in my scene.

15 Lift your brush on and off the paper in a dabbing motion, as with the bricks section, to achieve foliage effects. Quick, sharp movements are best for this effect. Do not overwork, as simple colour application is the best way to achieve natural, fresh results.

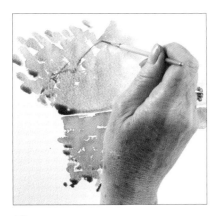 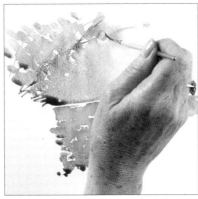 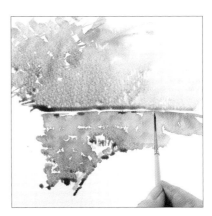

16 Now move to a rigger to make branches and twigs. Using Schmincke Translucent Orange, I have allowed my arm to draw the brush gently across the foliage to make soft lines while the background pigment is still damp. These will merge softly to create branches, as if seen on a hazy day.

17 Add more branches by laying applications of blue for further interest. Use the same blue as that used for the bricks in step 9.

18 Running my rigger above the line at the top of the bridge moves any pigment that may be 'puddling' here. If you have too much of a puddle at the top of the bridge during this stage, simply turn your paper upside down and let the excess water and pigment run smoothly into the sky section.

19 Now start working on the top right-hand corner of your painting. I want contrast here, so I have opted for a foundation of vibrant Daniel Smith Cadmium Yellow Deep Hue. This colour application is added to dry paper.

20 Then, with my brush loaded with water, I moved this colour softly to the new surrounding section I want it to be included in.

21 I have added Daniel Smith Sleeping Beauty Turquoise Genuine while the yellow application is still wet so that a gorgeous green will result from the two interacting pigments.

22 Encourage a flow of blue in a diagonal brushstroke so that it runs towards the bridge, which is the focal point.

23 Wetting the surrounding area and then turning the paper so that the colours all merge beautifully creates soft background atmosphere.

24 Strengthening the original blue diagonal by adding fresh pigment (as we enhanced the bricks earlier) adds drama.

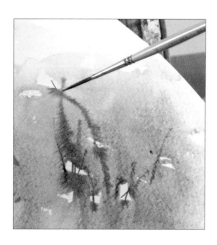

25 Where your brush leaves the paper, there will often be a finer mark than where you first place it on the paper. So hold your rigger at the end of the handle and make your first mark by starting at the opposite end to where you wish to lift your brush from the paper. Here, I am starting at the ends of the branches within the foliage and moving my brush gently towards the sky before lifting it swiftly from the paper. This is another useful brushstroke to practise.

Tips

Drawing subtle brush marks or colour to a focal point is a clever artist's trick. Use it often!

I always add colour where I feel I wish it to be by instinct. This is a technique that comes with practice. If an area is too warm I cool it down with blues and, vice versa, I hot up cool sections by adding warmth.

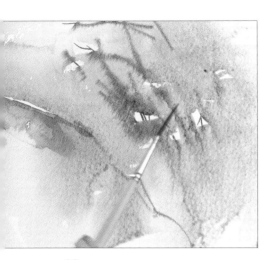

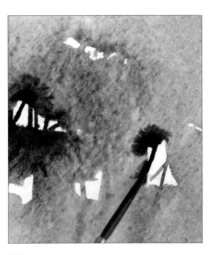

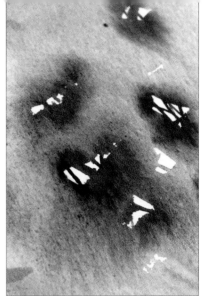

26 Try moving your rigger in curved directions to allow the branches to bow towards the focal point of the arch.

27 I have deliberately left some white spaces in the foliage of the trees. Here, while the pigment is still wet, I can drop stronger pigment in around the white section edges and draw my rigger through them to make hints of branches within this tree section.

28 Gorgeous water flow, vibrant colour, and soft and dark contrast make this a fabulous and interesting section.

Tip

Sometimes I work with the direction of the water-flow marks and at others I make bold contrasts by making the lines move in opposite directions. This is an invaluable tip for the landscape artist!

This is not a finished painting – it is simply an exercise in how to hold your brushes and why this makes a difference. Experimenting with how we touch the paper, how much pressure we use, how we encourage colour to flow and how we place marks on the paper all add up to producing incredible work. This is exactly what I am aiming for in this book – to show you how to create paintings that are full of atmosphere and life and painted by artists who make the most of every single action.

Tip

Try changing the season and paint this scene in summer colours, spring greens or even winter whites.

Philosophy

"We have the power to free our souls, open our creative senses and control how we feel through the positive use of colour and the energising movement of brushstrokes."

It is amazing how colour can affect our lives. As I am writing this chapter, from my window I see grey winter skies and English countryside. Rain is falling heavily and the scene looks quite gloomy. I'm wearing a bright colourful dress with vibrant patterns on it, chosen this morning deliberately to fight the less cheerful elements of the weather outside. I have experienced in the past that colour selection can positively alter mood, so I have chosen my clothes accordingly.

When I first started painting years ago, I was a botanical artist who paid attention to every detail. If I painted a daisy, every single petal would have to be added. With poppies I would add every small hair on the stem and every stamen in the centre of each flower. These paintings were painstakingly created while I studied the form and then chose accurate colours for every section. This attention to detail flowed into my home, and everything was always perfect. I am not saying my home is now untidy but it is certainly far more relaxed!

Peaceful blues flowing gently across paper.

Christmas Roses
Dark blue against white gives an impression of winter months.

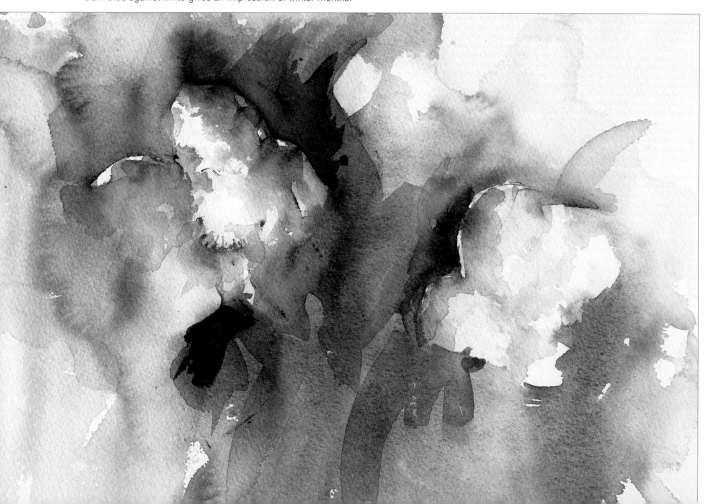

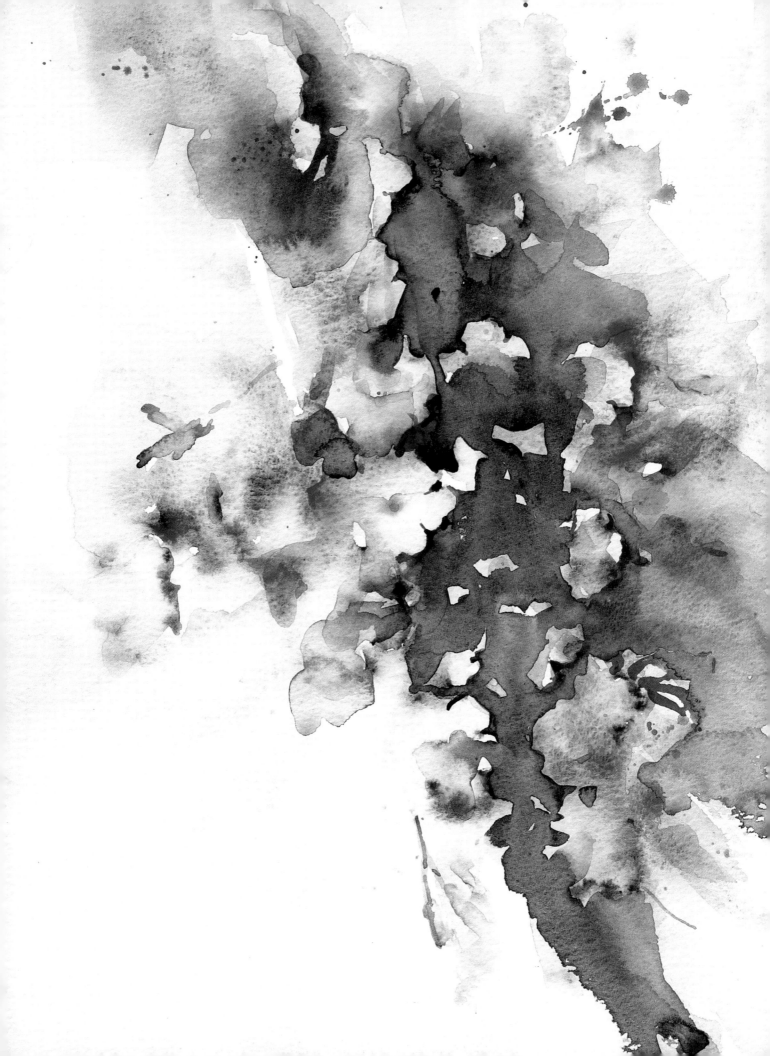

Positive thinking

I now have the ability to focus on what is important. I can prioritise, and this approach to life has flowed into my painting technique. In a new painting I may place my priority on the focal point, with everything else in the composition adding to that area. It is similar to having a lead singer as the main star and an orchestral backing, the two combining magically to create music.

To paint as freely as I do, my mind has to be clear of clutter. I simplify. I see the most beautiful point in a subject and enhance it with the use of exciting colour combinations and directional brushstrokes. I have no room for negative thoughts as I believe these can have a strong influence on our decisions and results when we work. Painting should be an act that gives pleasure to the artist and elicits an emotive response from, or connection with, the viewer of the finished piece.

Life changes

Choosing colour really can be a way to lift our mood, to cheer us when we are down, calm us when we are stressed or add a general sense of wellbeing. Simply by placing pigment on paper we have the ability to make a difference to our day. By wearing red on this cold winter day I have lifted my spirits and taken my mind off the weather. But had I been feeling tired or low, painting in a brilliant red shade could have the same effect. On this note I often suggest not painting in reds just before you go to sleep as it is an energising colour. If you are an insomniac it is incredible what painting in soft violets or blues can do to calm your mind.

Colour is often used as a form of therapy, for example in care homes or centres for the terminally ill where rooms are painted in subtle, carefully chosen shades to bring peace to the patients. Imagine, then, if we took this train of thought one step further and looked not only at the shades we use but also at the style in which we paint. We have the power to free our souls, open our creative senses and control how we feel through the positive use of colour and the energising movement of brushstrokes. If we choose to – and believe we can – we can magically feel more cheerful, relax, smile and let go of all our worries by the touch of a brush.

With my technique, I encourage everyone to be who they want to be; to paint to please themselves in every sense and enjoy each brushstroke and choice of colour. There is no need to feel anxious about what may happen or what the result may be. Throw all your tension out of the window.

Initially, we are going to paint deliberately for the bin and have fun throwing away our first attempts at painting in a loose style. On top of that, we are going to laugh while we do so. This whole process of moving to a loose style with unique results has to be a pleasant journey from the minute we start the exercises and demonstrations. Everyone is able to paint this way, and within every one of us is an artist screaming to get out. Sadly, however, they are often prevented from creating what they are fully capable of.

Daisy Daze

The combinations of sections harmonize beautifully in this colourful, flowing composition. I have used a technique I refer to as the 'seaweed effect' in the top right-hand corner, and the main, central daisy was created by painting the negative spaces around the outer edge of the petals (see page 91).

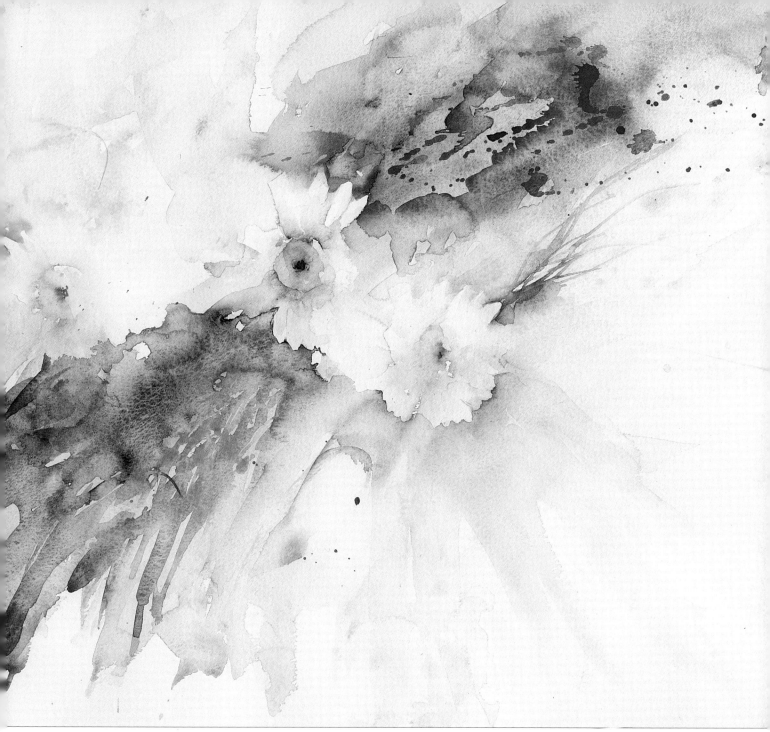

The seaweed effect

This technique, which I have used in the top right-hand corner of 'Daisy Daze', consists of simply laying a pale base colour and then working darker, flowing shapes on top. This unusual way of working connects different sections of a painting and gives a wonderful feeling of freedom.

This close-up of the top right-hand corner of the painting above shows my use of the seaweed effect clearly.

You are the master

Before we move forward, let us look at a word that is often closely linked with the process of working with watercolour. 'Control', or lack of it, is something that can put many artists off working in this medium. I believe it is possible not only to control watercolour but also to work with its many gorgeous facets to our advantage. Rather than seeing it as a challenge, I see it as a fantastic friend that surprises me continually with amazing effects in so many ways.

Exercise: Exploring control

Blue and white

You have control in every single painting you decide to create, so let us see just how you can make watercolour move as you wish it to and do what you want. As always, we start with a white piece of paper and in the centre we are going to keep a circle dry and white.

Tips

'Bleeding colour away' (step 3) is an artist's term for using a wet brush to draw colour from one area to another.

'Soft edges' (step 6) describe sections that are subtle and fade into the surrounding area. 'Hard edges' are sections that are completely defined.

'Invitation' (step 8) is a term I use when I decide to 'invite' colour from one area to the next in a painting. Where my colour flows is always my own choice!

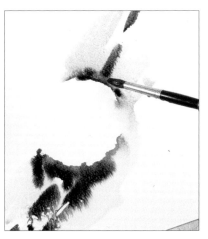

1 Imagine there is a white circle in the centre of your paper and make a line around half of one upper, outer edge of it in blue. I have used Winsor & Newton Indigo for this exercise. Using a clean, damp brush, bleed the colour away from this first circular line towards the outer edges of the paper. Repeat this exercise with a second curved line underneath the dry, white central circle. Quickly bleed this second line of colour away towards the opposite lower corner.

2 Now drop some darker pigment of the same blue you are using into the recently wet and coloured sections around the central dry, white circle.

3 You can bleed the colour away slightly with your brush or alternatively move your paper to allow the colour to run in a certain direction; the angle you hold your paper at will dictate the direction in which the water will carry the pigment.

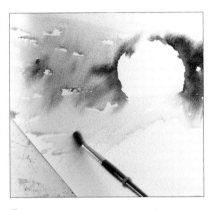

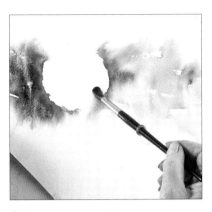

4 At this stage, if you flick a few small drops of water on to your blue sections and, again, tilt your paper slightly, you will create a beautiful water flow as the pigment is moved out of the way by the clean, fresh water application.

5 Stay with water-only application by brush to soften the outer edges of the blue. This will guide colour into a faded section that will connect to the area of white paper without leaving an obvious, defined line of painted and unpainted paper.

6 Begin to soften the gap between the circle halves by placing water here to allow 'whispers' of blue to run gently towards each other. This will give you a soft edge with no definition of the circle when dry.

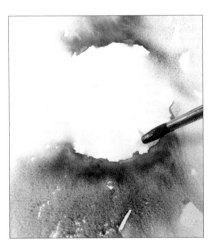

7 Enjoy what is happening in the area where you have added colour. Do not return to these sections with your brush at all. Simply allow colour to fuse naturally with water to create dark and light-blue sections with varying degrees of depth. Notice that the colour is only running to areas of the paper that are wet, where you invite it to go. It will not move to the dry sections of paper unless you move it there with your brush.

8 You can encourage colour from the outer blue edge of the dry circle to flow into the centre by adding clean water inside the inner edge and just lightly touching the outer colour with your brush. This is an 'invitation' for the outer colour to flow into the once-dry section. Leave it to fuse and dry naturally and see what happens.

9 Stop! Do not try to turn this into a painting. This was merely an exercise in how we can control the flow of colour by using brushstrokes, placement of water and pigment, and by holding the paper at an angle.

Losing the cage

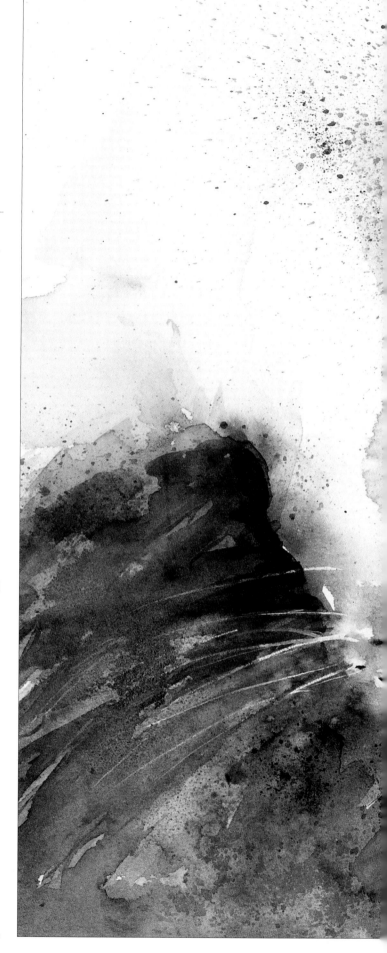

"If you allow yourself to have fun with colour alone you may just find the artist within you that has for years been dying to escape."

Restrictions in art are similar to living within a cage. If bars surrounded us we would feel suffocated, depressed and jaded with no motivation for living. If we are comfortable creating without boundaries or limitations, our imaginations can run free.

To work within set lines can be intimidating in many ways. Imagine you are painting from a pencil sketch. Yes, you may have accurate guidelines to direct your placement of colour but these very pencil marks can also destroy the life in a painting, often leading to results that appear wooden and lifeless. This way of working can also be easily copied.

In order to fly during our own art journey while creating unique results, we need to discard all forms of restriction. We also need to learn to have fun while we explore new possibilities in how to approach or find our own style. We need to find the child within us who simply works with colour minus the fear of failure that an adult may carry. Losing that desperation to always succeed is a very difficult task, but if we manage to overcome this emotion our whole lives can be affected in the process. Joy should be the sensation you feel when you are painting, along with a tingling thrill down your spine when things magically appear and go right. There should be a sense of excitement when you know that you are about to produce something so incredible that your heart will skip a beat.

Freedom is king.

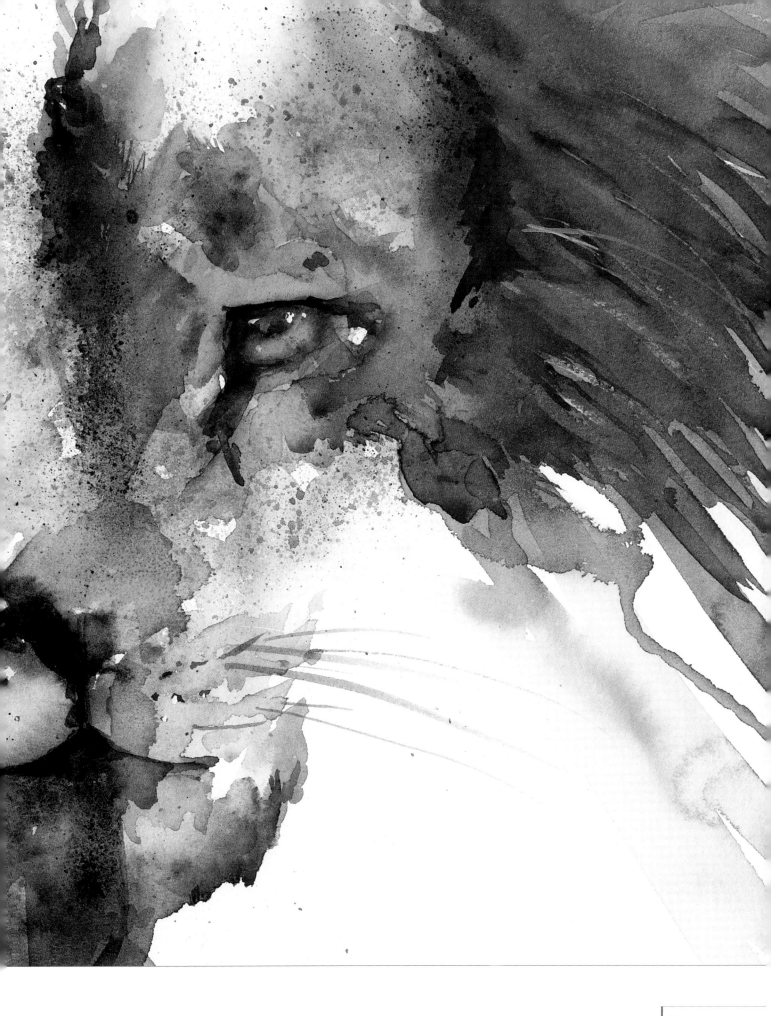

Barriers can also come from within the artist. Lack of confidence or belief in one's ability to paint can be very negative influences. But these 'cages' and restrictions can only prevent us from being brilliant at painting if we allow them to. Being a great artist is often all in the mind. If you tell yourself you cannot paint, you never will. But if you allow yourself to have fun with colour alone you may just find the artist within you that has for years been desperate to escape.

Freedom is such a wonderful word. It means so much to me, as an artist who adores painting minus any form of preliminary sketch or 'bars'! I invite you, through this book, to open the door to the new you. Allow all negative feelings and thoughts on how you work to be left behind as you pass through the door represented by the turn of this page to the next. Smile and imagine you are free from all worries and can achieve anything you wish for. What you imagine will soon be turned into reality.

"Enthusiasm to try something new is all that is needed for this style of painting, and the will to have an adventure each time you pick up a brush."

To fly or not to fly.

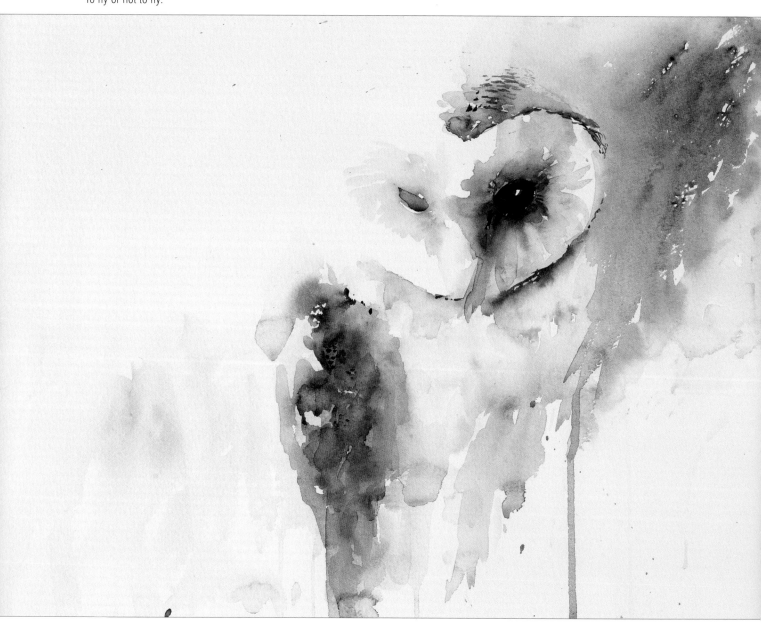

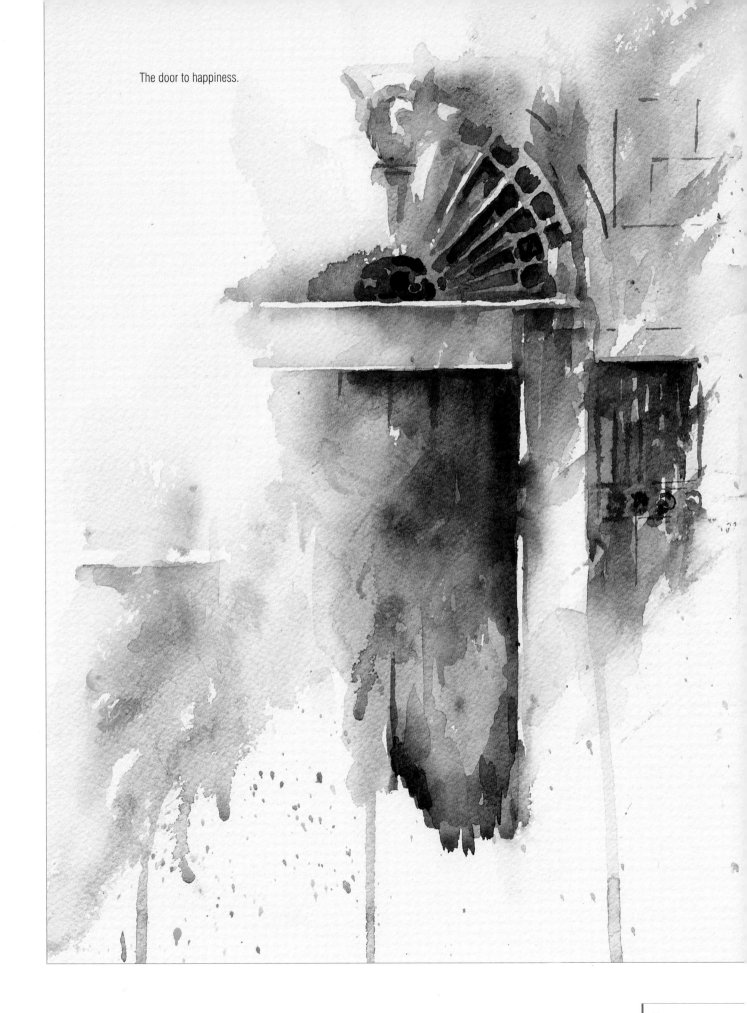

The door to happiness.

Opening doors

"Wrapping, splattering and patternising. Who knew life as an artist could be so much fun?"

Doors are wonderful to paint, and this one, inspired by a trip to Venice, has enchanted me many times in workshops and demonstrations. It is a wonderful subject that allows me to teach many tips and techniques very easily and is a brilliant exercise to follow. On the previous page you can see the same door, but it is very different from the one you will achieve in this exercise, which includes the Venetian technique as a watercolour technique. This is explored in more detail in the 'Bridge of Sighs' exercise on pages 136–146.

'Losing the cage' means freeing yourself of any restrictions imposed by working inside pencil lines. See how you can achieve straight lines where you need them in a loose style and at the same time create a sense of atmosphere. Forget the pencil – you really don't need to sketch this!

Exercise: The Venetian door

There are many useful tips in this exercise that can be used on so many wonderful subjects, so have fun wrapping, splattering and patternising!

First, decide where you wish the top of your door to be on your paper, remembering the architectural arch that will sit at its head.

Tips

The 'wrap technique' is an exciting method I have discovered of pressing plastic wrap (Clingfilm) on to wet paint to create energised areas in the background or foreground, or even for suggesting flower petals (see pages 118–119). Here, I have combined the technique with salt for even more amazing results. It's a Jean Haines special and I call it 'the Venetian technique' (see pages 136–146).

'Patternising' is a term I have invented for creating texture and pattern within a composition using salt.

'Splattering' means exactly that – splattering your picture with paint using a paintbrush to break up areas of solid colour.

1 Place a card with a straight edge where you wish to paint the top of the door. With a suitable mix of colours draw a line along this edge. Carefully lift the card so that you do not disturb the line you have created.

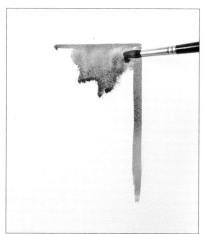

2 Repeat this stage to create a line at the side of the door. Gradually draw colour from both lines downwards to form the wooden door section.

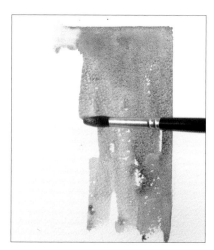

3 I have added some Winsor & Newton Alizarin Crimson and Schmincke Translucent Orange to my initial door wash to bring warmth into my scene. I rarely use just one colour in any one section of my work.

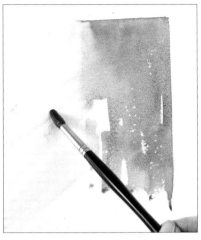

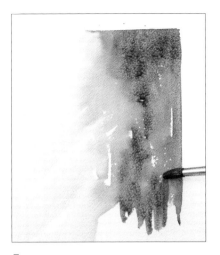

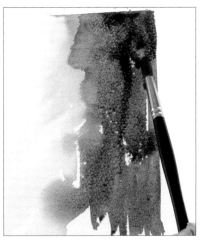

4 Next, with just clean water on your brush, make a sweeping movement to draw the colour from the door into the side section of your painting. This swift movement will create a sense of flow from one section to the next, connecting the different parts of the composition. It is often wonderful to work on as a foundation in later stages of a painting's development.

5 Strengthen the colours. Add bolder versions of the shades you like in the door, which are drying to a quiet whisper of colour. This will enhance the shades you are enjoying already and encourage exciting watermarks to form.

6 I want the top corner of the door to be really dark, as if in shadow, and aged, so here I add Indigo and allow it to merge into the existing colours of the door.

Tip

If you like a section of your work, strengthen the colour there to highlight its beauty.

7 Wetting the section next to the side of the door, I 'invite' colour to flow into the new white area. Use straight brush movements here to contrast with the directional lines on the other side of the door. Together they will form more drama in the finished painting. These simple techniques can make a painting unique.

8 Sprinkle salt evenly on the door while the watercolour pigment is still wet. The 'patternising' that is already happening is absolutely gorgeous, so this section is gradually becoming more fascinating to work on.

9 Take a piece of plastic wrap, such as Clingfilm, and stretch it so that straight lines form. Lay these on to the wet wash with the salt on it. The plastic wrap will trap the granules of salt, adding to the texture when the watercolour is dry. (See pages 136–146 for more on this technique.)

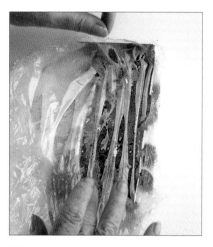

10 Use your fingers to strengthen the pattern and improve the design you can see through the plastic wrap.

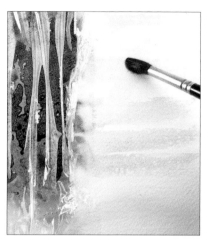

11 Without disturbing the plastic wrap, work the watercolour you have previously invited into the side section of the door, taking it towards the outer edge of your paper.

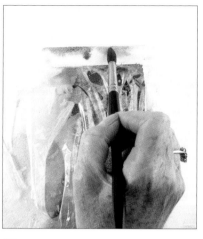

12 Return to using the card to add a new line at the top of the door, forming the base of the arch. Pull the colour from the line downwards towards the door underneath to soften the new straight edge slightly.

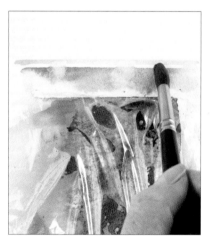

13 Add another line above the previous one, but with a smaller gap than between the first one and the door. Remove the card carefully and now touch this section lightly with your brush to bring the two lines together in a few places.

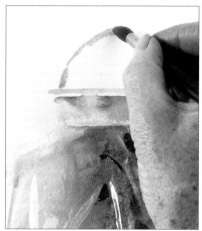

14 It is time to start working on the arch above the door, so make a curved line with blue.

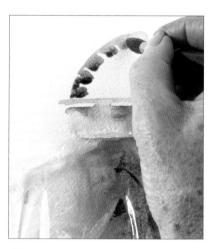

15 Begin to form the stained-glass sections by making marks evenly around the inner edge of the arch.

Tip

My Venetian technique can be used for plants, leaves, buildings, beach scenes, animals, portraits and many more subjects. Use your imagination to see what you can create with it.

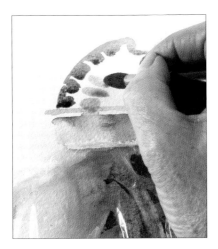

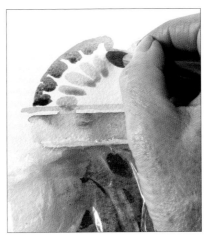

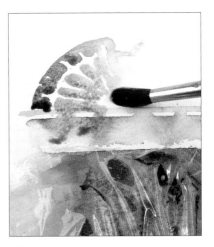

16 You may expect me to use the same blue for the innermost sections of the stained glass but instead I am opting for orange here to hint at warmth inside the building.

17 Use your brush to pick up some wet pigment from the blue sections and drop these into the new orange sections. Allowing them to fuse naturally will create an intriguing harmony in the finished piece.

18 Leave the right-hand side of the arch to the viewer's imagination. Use clean water on your brush to soften the painted edges and then fade them gradually into the white area of the paper.

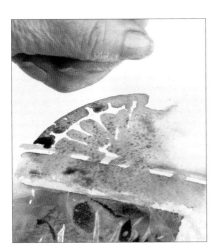

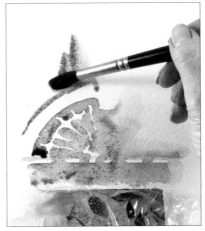

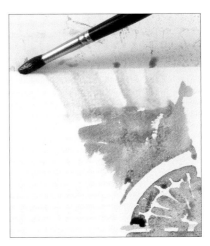

19 Dropping in a small amount of Alizarin Crimson and Schmincke Translucent Orange here will draw a glow into the central area. A little salt is added simply to create a touch of texture.

20 Now it is time to work away from above the arch, so add a second curved line and encourage the colour to bleed away into the space above the door.

21 I am deliberately using cool colour now to detract from the glow of the welcoming old door. Who knows who could have walked through it in days gone by?

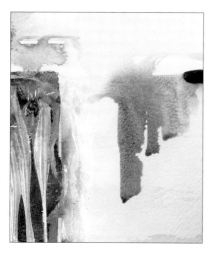

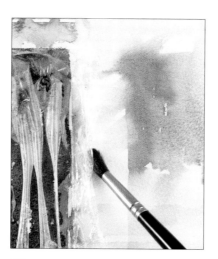

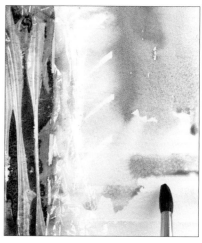

22 Adding just two sides of a square of colour for a hint of the window comes next. Strokes of gorgeous Quinacridone Gold and stunning violet make the window burst into life.

23 Allowing the edges of the window to vary rather than all be perfect will give the illusion of sunlight hitting this section. As with the door, a few directional brushstrokes, just with water, sweeping away from the window at an angle, add a sense of movement to the painting.

24 Next add some bricks, as in the bridge demonstration (see page 27) using the sable no. 10 brush to create interesting shapes.

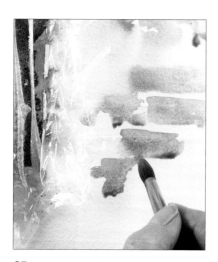

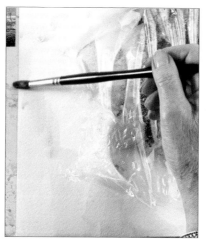

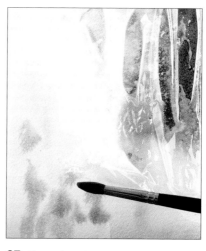

25 Avoiding dull, boring brick colours, I am opting to drop beautiful turquoise pigment and violets into the glorious gold shapes. These colours will merge and form amazing results when dry.

26 This door sits over a canal in Venice, so to the left foreground corner I am adding Cadmium Yellow to brighten up the scene. I am moving my brush upwards to cover this area.

27 Dropping the shades used within the door itself into this new yellow corner will create harmony and connect the door with the foreground.

Tip

It is worth remembering that watercolours always dry paler than when you first apply them.

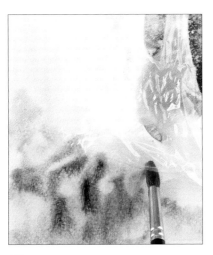

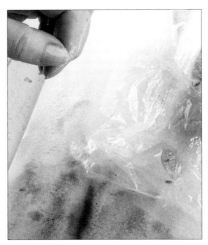

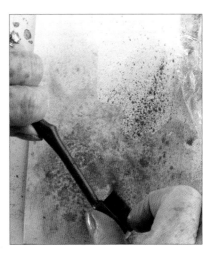

28 Adding Indigo to the yellow will turn this area into a beautiful canal shade of green. Move the colour towards the lower corner of the door.

29 When the colours have merged well, add salt to create interest in this section.

30 This is my favourite part! Splattering colour at an angle with a toothbrush to break up solid colour in any given area. Randomly splattering in various areas also adds a sense of connection throughout the composition.

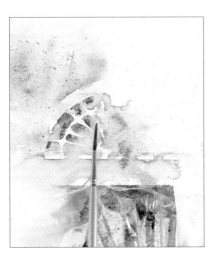

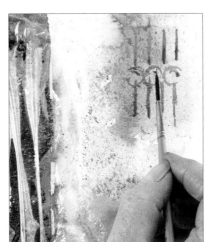

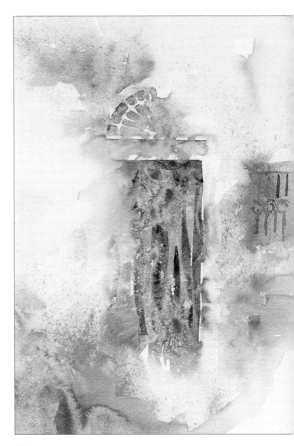

31 As the arch is now dry, you can add a little definition in this area using a rigger, but not too much. Avoid overworking.

32 With your rigger, make lines by moving your arm downwards as you add the detail to finish the window. Making small circles within the wrought-iron rails gives a subtle touch of interest.

33 When the painting is dry, remove the plastic wrap and the salt and your painting is complete.

Tip

After a working session, always try to leave a painting that is going well on your easel. When you return to it, the feeling of success will carry you into an even better day's painting!

Taking the First Steps

Materials

"There is no denying that every product we use does make a difference and that there are times when we can be economical and others when we simply can't."

Every time I start to write about which materials I use, I find my list has changed. There was a time when I used only three favourite brushes and made every single shade by mixing the same three primary colours. The quality of the paper I use has also changed as my art has improved and my career as an artist has evolved.

Do enjoy looking for new ways to add life to your work, especially if you have been painting with exactly the same shades for years. Have a 'product holiday' and try something new! Wake up to what is out there and have fun with it. Never be boring or stuck in a rut for long periods of time. Think of colour: find energy by painting with exciting new reds, calm down by working with sensational blues, enrich your life with warm, glowing, golden shades. Above all, be vibrant, alive and unique in your colour choices.

Using cheaper products while we practise is wise to an extent, but sadly by doing so our results are less fabulous than they would be if we were using first-rate materials. Many artists, over the years, have told me they were amazed at how much better their paintings became by moving to better paper or professional artists' quality watercolours. There is no denying that everything we use does make a difference and that there are times when we can be economical and others when we simply can't. Let's start with brushes.

Sable watercolour brushes

There is no alternative to holding a pure sable brush in your hand and feeling it glide smoothly over paper. Investing in these wonderful brushes from a good manufacturer will be a real asset. Cheaper brushes do not load well with water and have a habit of losing hairs. You need to be able to encourage pigment to flow wherever you wish it to go – cheap brushes will simply hinder this creative process. I cannot recommend highly enough buying the very best brushes you can afford.

Learning how to hold every brush to gain a variety of brushstrokes from each is a valuable way of understanding how to get the most from your equipment. My Chinese mentor could gain many effects, from the finest of lines to the thickest of brushstrokes, simply by altering the way she handled a large brush. Practice really does make perfect!

Three brushes are highly recommended: the smallest of riggers for fine lines, as in the snowdrop stem on the facing page, a no. 10 round sable for medium brushwork and a large brush for covering vast sections of paper in colourful washes. And look after them! Never allow your brushes to stand in water pots as this definitely shortens their life span!

Good-quality sable brushes are a wise investment for artists of all abilities.

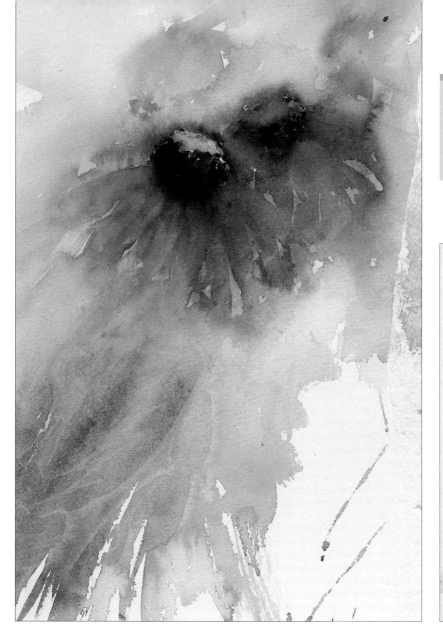

Hazy Days of Summer

This painting of flowers was created using a no. 10 round sable. By painting with the brush on its side I created impressions of petals. With one sweeping action I covered a block section with colour in the foreground corner and background. By raising the brush so that only the tip touched the paper I created petal-tip illusions.

Snowdrop

The fine stem was painted using a very fine rigger.

Paper

Knowing how to use your gorgeous brushes is not going to be very helpful unless you have terrific paper to work on, and I use the very best. I use a heavy-weight paper, but this is expensive for the non-professional artist or beginner. If you are new to working in watercolour you would be better off practising the exercises on cheaper varieties of paper. Even so, have a few pieces of fabulous paper as well to see what you could achieve with it, because the difference you can experience will definitely encourage you to be a better artist.

The beautifully rough surface of Arches paper is wonderful to work on when texture is required.

Why use a heavy-weight paper?

Thin or poor-quality paper can buckle as it dries, leaving you with an uneven surface that is impossible to frame. Imagine painting for hours and creating the most wonderful of compositions only to have to throw it in the bin later. We can change this scenario to one in which we have spent hours creating a disaster that has to be discarded, using paper that cost a fortune. These two examples show that we really do have to look at what we use and when we should use it.

To beginners and amateur artists I would suggest having economical paper to hand for trying out different brushstrokes and colour combinations. When you gain confidence and your paintings are becoming more successful, start using paper of a much better quality. I adore Saunders and Arches 640gsm (300lb) rough paper, though for practice I also use Bockingford 300gsm (140lb) extra rough because it is of a quality suitable for working a large number of paintings and learning from them.

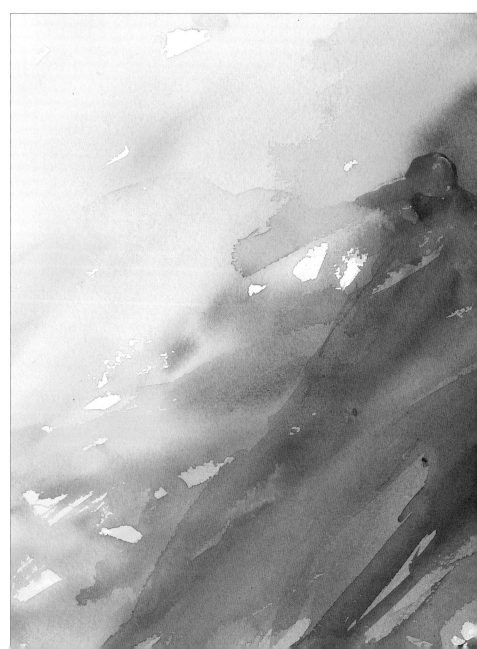

Above: simple colour exercise on Bockingford 425gsm (200lb) rough paper. The paper has not been stretched beforehand and was not taped to a board while I was working on this colour experiment. The result was a completely flat surface when the paper was dry.

Paper surfaces

The majority of my work is carried out on extra-rough watercolour paper because I love how pigment sits in the pockets on the surface, creating textural effects and giving my results added interest. For painting animals with fur, buildings and action scenes, rough paper is invaluable as it helps aid texture and colour effects, especially with pigment that naturally granulates such as French Ultramarine Blue. However, when painting silken poppy petals or the smooth skin of a child in a portrait, I want my colours to flow over the paper to give a fantastic glow without the interruption of pigment granules breaking the surface.

We are all different, so choosing what is right for you is very important. Many manufacturers have sample packs of a variety of papers and these are well worth investing in. The most important point is to enjoy painting. If you are using inferior paper, this will affect your results, so always aim to buy the best you can afford when you are trying for a more 'serious' piece of art, and don't forget you can paint on both sides! I never throw a single scrap of paper away because even my fun experiments can somehow be transformed into a lovely painting. It is all in the imagination and what you see in the colours that are already there.

Tip

Because I use good-quality, heavy-weight paper, I do not have to stretch my paper or tape it to a board before working. Lightweight paper should really be stretched.

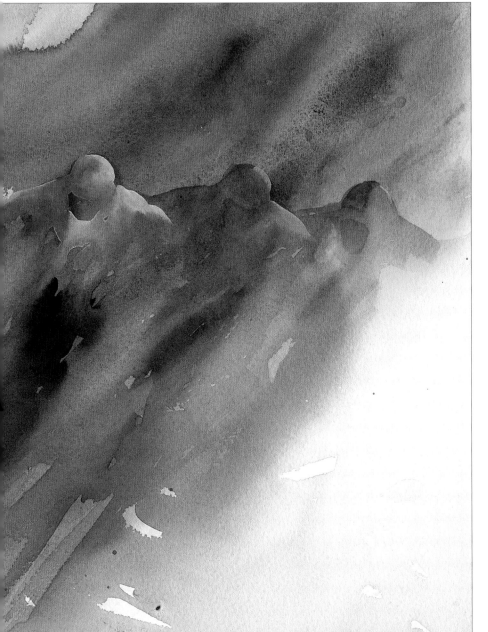

Out of the Blue

Colour in an action scene flows easily over the surface of Arches 640gsm (300lb) rough paper. I could add water from my brush directly to force the colours to move in a diagonal direction and still have completely flat paper when it was dry, without taping my paper or stretching it first.

Palette

There are many palettes available and I have seen artists arrive at my workshops with everything from large, white plates (which are brilliant for working with large amounts of colour) to ice-cube containers to hold their pigment and shade selections.

I use a very big, radial palette and squeeze large amounts of my favourite colours into each section. If the colours on your palette look inviting to use you will love the creative process even more! The sections of my palette are large enough to hold a whole tube of product so that I don't have to interrupt my painting sessions by continually refilling them. I mix my colours on paper, and use my palette's large, central well merely as a place to see the dilution of each colour I am using clearly.

You can use anything at all to hold your colours but find a palette that suits your method of working, and don't forget that white gives you the best idea of what your colour is going to look like on white paper.

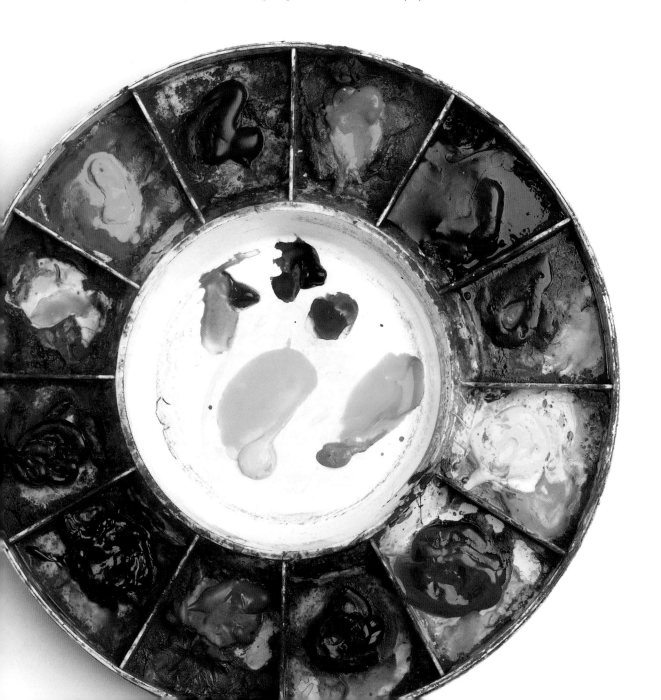

Watercolour

Tubes or pans?

I love colour and lots of it, so I find watercolour products in pans far too restricting. I want to work freely with lots of juicy blobs of colour in my palette. Every single colour selection is a personal choice that will bring your work to life, so this is a very important part of the painting process.

There was a time when I used only one manufacturer's products. I loved them so much and knew them so well that in every workshop I held I used the same shades. I know many artists who are exactly the same, but times have changed and the market is growing in the ever-evolving art world. With so much to choose from, why restrict yourself? You could be missing out on some fabulous colours, so be daring and try something new as often as possible. Don't get stuck in a rut!

I experiment a lot. Due to the internet and travelling, I have contact with artists from all over the world. I have listened to different artists' opinions on their favourite shades and now use a much bigger variety of colours. This has resulted in making me even more excited about working in watercolour – something I never thought possible.

At an art fair I came across a colour I would now be lost without – if you haven't tried Schmincke Translucent Orange you are really missing out on something very wonderful! When diluted, it is really transparent, glowingly vibrant and works well with many other shades as a contrast.

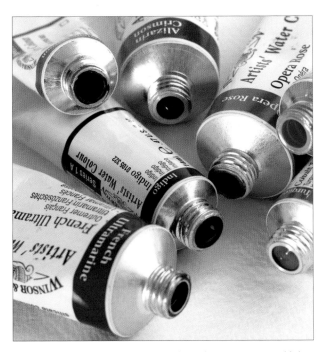

I have used Winsor & Newton watercolours for many years and it is impossible for me not to mention them in this book. Their artists' watercolour range includes a broad spectrum of reliable colours suitable for professional artists as well as those new to painting.

I have fallen in love with Daniel Smith watercolours. They have the most incredible range of shades with beautiful names. Here are some of my favourites – Cadmium Yellow Deep Hue, Natural Sleeping Beauty Turquoise Genuine, Amethyst Genuine and Mummy Bauxite. You can even buy 'Dot Try-It' colour charts without buying the whole range so you will know what your favourite shades are before you purchase them.

Other useful things

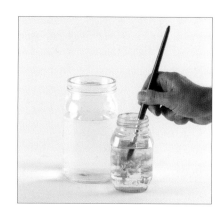

Water containers

We all need water containers. I use two clear-plastic containers that are light to carry, disposable and easy to replace. I prefer very large containers because I use a lot of water. I ensure I change my water regularly to keep my pigment application fresh and clean. One container holds the dirty water from rinsing my brushes, and the other holds clean water for when I pick up new shades. It's that simple.

Easels

I have two easels: a table-top easel and an upright, studio easel. This latter easel I have at a height that I can either stand in front of to work or sit at to add detail. My easels are placed at an angle to encourage colour flow across the paper. I don't hover over my easel, continually looking closely at my work. I prefer to stand at a slight distance so that I can see the 'bigger picture' evolving rather than focus on small sections of a painting. If you work on one area of a painting for too long you can overwork it. Take breaks while you are working and leave half-finished pieces for a while, preferably overnight, so that you can look at them with fresh eyes the next day.

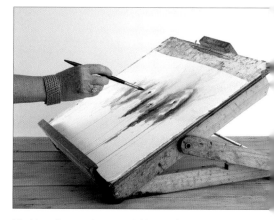

Working at an angle on my table easel.

Accessories

I use salt and plastic wrap, such as Clingfilm, to create textural effects. These are really the only extras I use. I do not enjoy using masking fluid as I find it far too restricting, preferring instead to work with colour and brushstrokes alone.

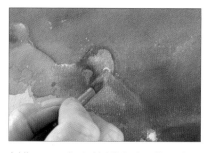

Adding gouache to highlight the effect of sunlight playing on the jockey's cap. The finished painting is shown on page 158.

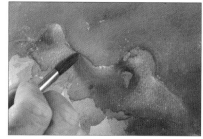

Taking the line of white lightly across one shoulder and connecting to the jockey behind.

When dry, the layer of white is transparent if enough water is added to dilute the gouache on application.

Gouache

If I lose my whites I will add a tiny touch of gouache. Gouache is more opaque than watercolour.

Subjects

I do need subjects to work from and I always find inspiration from going out in all weathers for long walks. I will always find 'treasure' to carry home and paint, such as small leaves, berries or twigs. I also have resource photographs from all over the world and I can work from these when I need to.

I always recommend painting from your own photographs and not from those you find online. Bear in mind that any images that can be accessed by thousands of other artists will not lead to you creating work that is your own. The photographer captured the original composition and is therefore the original artist. Be unique from the word go and create from your own images and imagination. Your results will be a part of you, and you are capable of being a far better artist than you realise!

"Working from life is always more appealing to me and often gives me far better results."

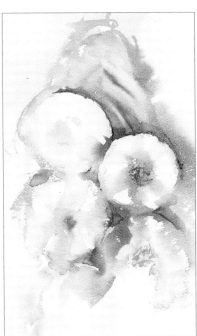

Keeping vampires at bay!

"Being boring is NOT an option."

Getting excited about colour

"Every single decision we make in every painting has to add beauty, not take away from it."

Before we even begin to think about painting we need to fall in love with our subjects and be mesmerised by the colour choices that could bring them to life in watercolour. It is the 'buzz' of getting turned on and excited by colour that leads us into beautiful work that is incredible. Our choice of colour can be affected by our personal preferences. Many artists will adore working with brilliantly vibrant shades while others prefer using softer, muted tones. I often prefer a mixture of both as I find the combination can add magic and impact to my finished results. But as my mood changes, so will my decisions about which pigments to work with.

Looking at colour throughout the seasons can really help artists to open their eyes to stunning new colour combinations. We can easily learn from nature, starting with spring and observing the change from dull, drab winter greys to lighter and more alive, fresh shades. Imagine soft, pale primroses peeping out of woodland banks as sunlight shines on them. The light playing tricks, creating illusions of which shapes you can and which you cannot see, leads us into creating stunning watercolours. To capture that feeling of life and freshness we need to work with very clean pigment.

Painting from life opens the eyes to a gorgeous clarity of shade selection. When we paint from photographs we are inclined to notice the negative darks. It is a frequent mistake of any artist who works from resource images alone to add far too heavy pigment or use the addition of black or brown shades to strengthen tonal values. This often detracts from a subject rather than making the focal point more interesting. We do need dark against light tones for contrast but they can be beautiful variations of dark blue or violet rather than depressing, dull shades. Every single decision we make in every painting has to add beauty, not take away from it.

Tip

Try to paint from life as much as possible to open your eyes to really seeing colour.

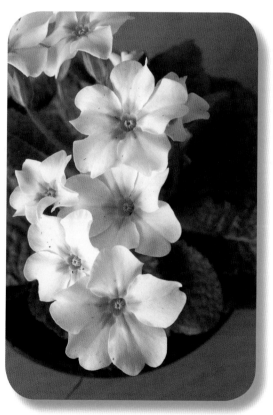

In this photograph of spring primroses, notice the darks and imagine how you could paint these sections to add excitement to the composition.

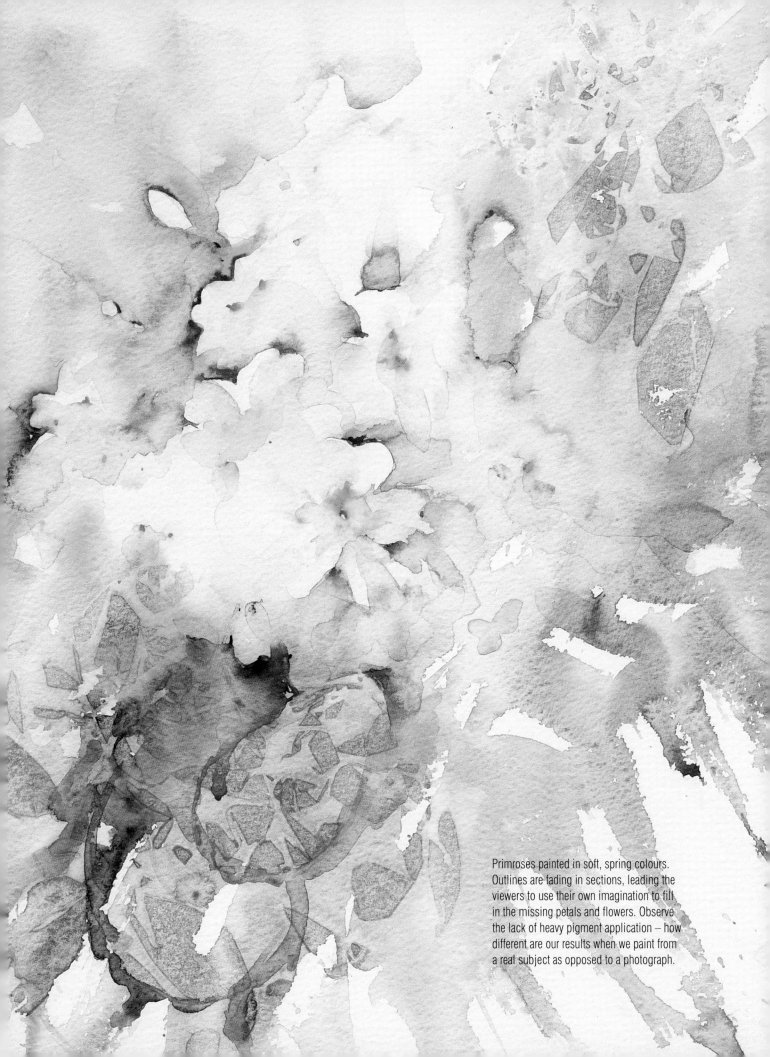

Primroses painted in soft, spring colours. Outlines are fading in sections, leading the viewers to use their own imagination to fill in the missing petals and flowers. Observe the lack of heavy pigment application — how different are our results when we paint from a real subject as opposed to a photograph.

If we look at the black-and-white version of the primrose photograph (opposite), we can see clearly how the darker background in places makes the lighter areas sing. Choosing the right colour can lead to the difference between a painting that is alive and one that appears flat. Dull paintings can seem disinteresting, which is what we are trying to avoid. We are looking at how to bring a sense of movement and excitement into our work, no matter what the subject is that we are painting.

The contrast between autumn russets and golds and spring yellows and greens is a wonderful way of comparing what works and what doesn't in order to set a mood. For an autumnal feeling, we can rely on reds, oranges and violets to harmonise and create excitement. I never use brown or black shades as I believe they destroy what we are desperately working so hard to achieve, which is a painting that carries a feeling of light and energy. So to keep colours alive we first need to observe them in natural light and in reality.

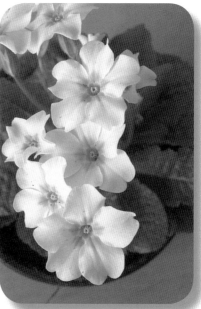

Black-and-white version of the primrose photograph on the previous page.

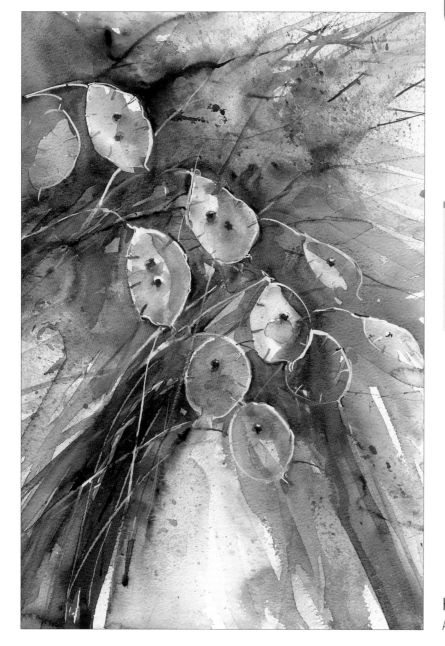

Tip

Never use brown or black shades in your paintings as these can kill light and life in your results, as well as detract from your focal point or subject.

Honesty

Autumn seed heads in reds and golds.

Exercise: Playing with colour

In this exercise you will make four different colour selections, one for each season. For example, you might start with vibrant yellows for spring or bright orange shades for autumn and then decide what colours say winter or summer to you. Start by closing your eyes and thinking of the season, then enjoy playing with the colours you see in your imagination. Choose the closest ones to these from your palette and use them to paint half of a subject of your choice. Alternatively, simply cover a piece of paper with your chosen colours for each season – a warm-up exercise to get you in the mood for painting something a little more serious.

 If you play with colour swatches like this on a regular basis, without the pressure of having to produce a masterpiece, you will discover many colour combinations and watercolour effects that will work really well in your compositions. You will learn about pigment, improve your knowledge of how to handle the medium, and above all have fun. You may also end up with exciting paintings on your hands without even trying!

Tip

When you are experimenting with your seasonal colour selections, the subjects you choose to paint don't have to be related to the seasons they represent.

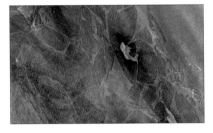

Winter

Simple blues and violets on a scrap of paper with texture effects created by placing plastic wrap (Clingfilm) on the colour when the paper was still damp. This form of experimentation is a great way to work, and leads to more abstract compositions.

Spring

Warm yellow mixed with an addition of blue gives a feeling of warmth, sunshine and freshness. This experiment could later be turned into a painting of daffodils.

Summer

Red flowing across a horizontal line was later turned into poppies – a reminder of hot summer days.

Autumn

Shades of gold, orange and purple were gradually added to form hints of an autumnal hedgerow. The colour choice of imagined autumnal shades inspired me to bring this subject to life in an exciting first wash. Once berries are added in detail, this simple experiment could turn into an exciting painting!

Choosing a subject

"It is important to keep your enthusiasm and motivation for picking up a brush very high."

Knowing what to paint should be an easy task as the subjects we choose are a clue to our inner passions – things that turn us on or excite us and that we feel a strong connection or bond with. Artists who adore animals, for example, may find they are drawn to painting them, while those who love gardening or nature may find flowers and landscapes more appealing. But this isn't always the case. I often find in my workshops that the last thing an architect wants to paint is buildings.

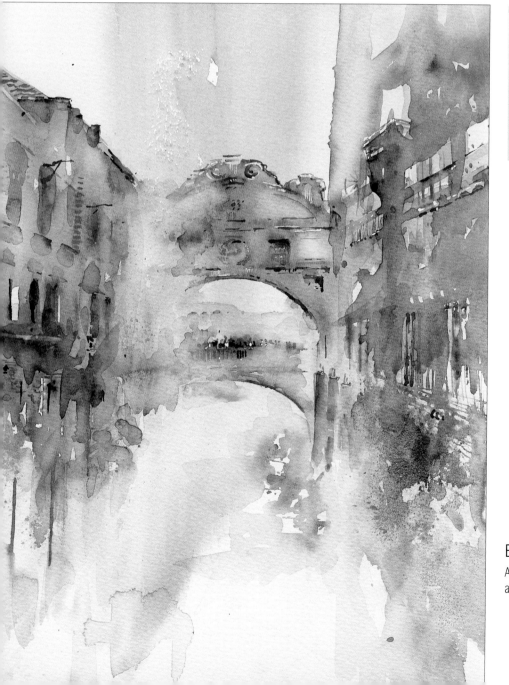

Bridge of Sighs, Venice
Architecture may not always appeal to architects as an obvious subject!

Tip

Always look for new subjects wherever you happen to be each day. Build up a collection of resource photographs of your own to fall back on at times when you feel uncertain about what to paint.

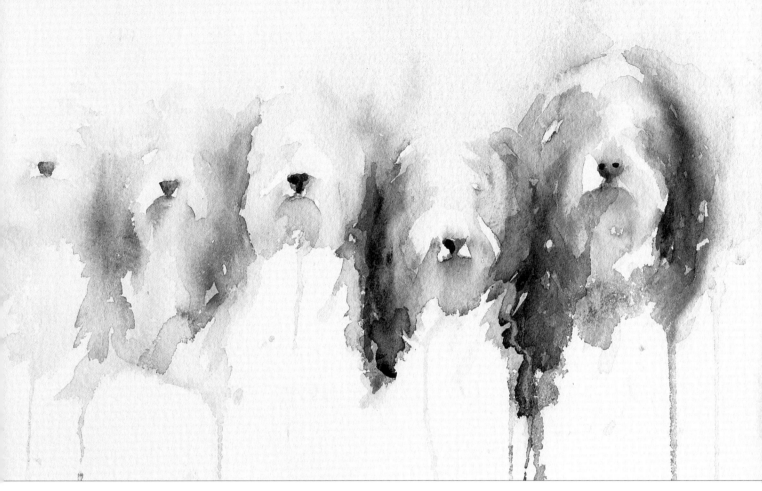

Bearded Collies
A work in progress and a favourite subject of mine!

I have also come across artists who paint at their best when given subjects they don't normally select. Their thought processes are switched on because they are working on something completely new; their brain has to think harder when seeing and painting something unfamiliar than it does when working with something that is familiar. So if, for example, you are always painting dogs, every now and then break free and paint something else. This is like taking a holiday and waking up to new ideas.

It is important to keep our enthusiasm and motivation for picking up a brush very high. So how do we keep our inner artist's soul alive and eager to paint? First, always aim to paint something that you really love and feel a connection with. If you want to paint something at an emotional level from the outset, you will stand a far better chance of doing so successfully.

Artists who paint commissions often feel under pressure to meet a deadline. Even more worryingly they often dread picking up their brushes. The results can show clearly in the finished work; it is easy to tell which paintings are simply churned out for the sake of it rather than created for the pleasure of painting. I believe it is possible to walk around an exhibition and know if the artist behind each painting actually enjoyed working on the piece. Enjoying every brushstroke is so important.

Painting a favourite flower in a favourite colour!

So what are your favourite subjects? What do you enjoy most in life? What are your hobbies? What are your favourite foods? Everything and anything can be a wonderful subject to paint and we are going to look at many different ways of doing so. We don't always have to paint what we see as we see it. Taking an ordinary subject and making it a little more unusual, as in 'Watching Ewe', can be a fascinating process for both you as the artist and the viewer of your finished piece.

Exercise: Observation

I challenge you to find something that isn't worth painting! Because, if you think about it, everything is a terrific challenge and, with just a small stretch of the imagination, a possible composition.

1 Start each day by enjoying what you see. It could be simple rays of light on a white subject, reflections in water, formations in stones and bricks, shadows on the ground, or patterns in bark.

2 Use your imagination and observe how all the things in your life are possible paintings, from the minute you make that first cup of tea or coffee in the morning to the second you lay your head on your pillow to sleep at night.

Watching Ewe

An ordinary subject created to become extraordinary by unique colour and technique selection.

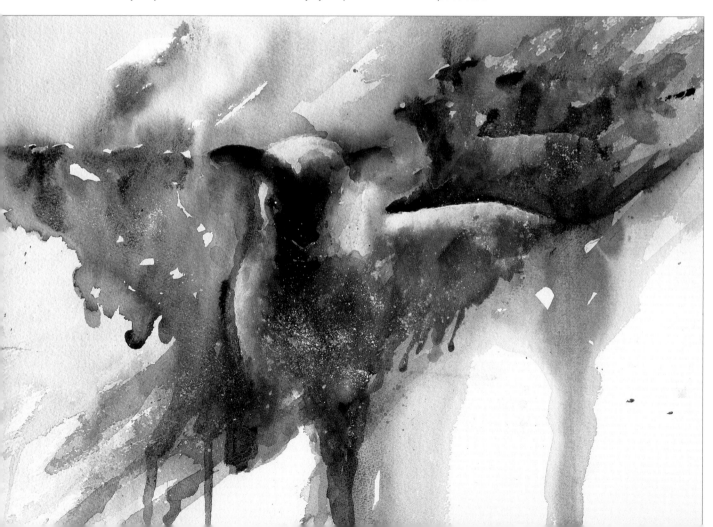

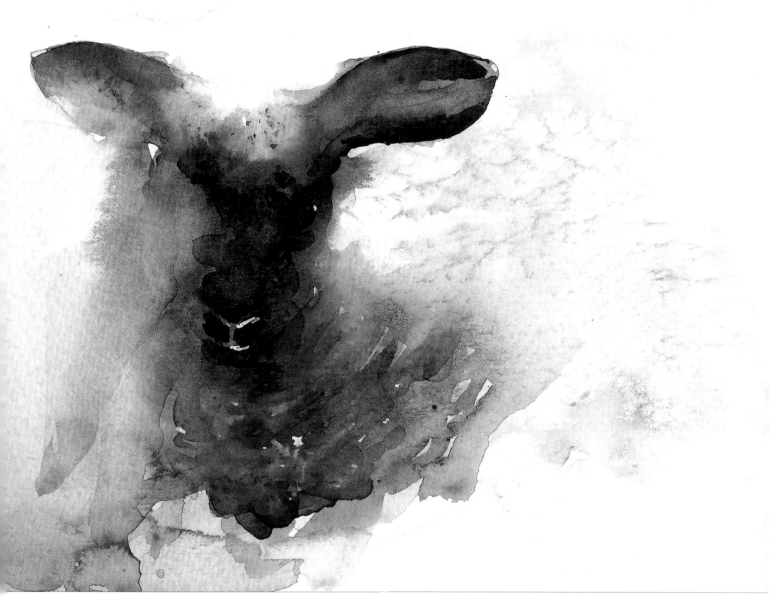

Just Ewe

A fun study of a sheep using vibrant, colourful effects.

If you follow this advice you may come up with something that up until now has not been a popular subject choice. I am imagining a row of teaspoons with varying shadows. How would I paint silver? One train of thought will lead to another and you may have a brilliant idea that no one else has yet thought about – our goal is to be unique.

Use your imagination and try painting subjects you don't particularly like. Stretch yourself as an artist and always be on the lookout for something new. In time you will grow, like me, to love painting absolutely everything and, as an artist, that is a fantastic way to be.

Getting started

"It is amazing that in just a few seconds we can learn so much purely from experimenting with colour and painting simple subjects."

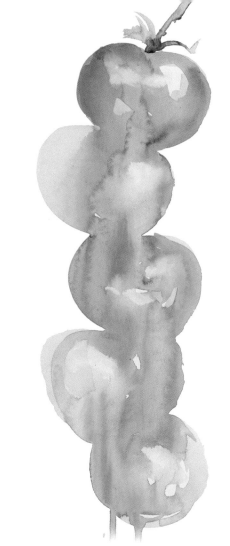

Sometimes you might resist picking up a paintbrush. This might be because you feel that what you are about to paint is too difficult. Many artists have a hidden fear of disaster, so for these initial exercises let's simply paint 'for the bin'. We will aim to make everything we do very easy so that we have a base from which to grow, working loosely and aiming to work up to slightly more complicated compositions. For now, this is to be a simple process of playing with colour; having fun minus any pressure to succeed.

Choosing colour the easy way

Let's start by looking at subjects and colour. Anything at all will do for these practice exercises, so grab anything that's to hand and place tubes of colour next to what you have chosen to see which ones work and which ones don't. I want to work with the three primary colours first, which are red, yellow and blue.

Exercise: Red

For my red subject I have taken tomatoes, placed them on white paper and then selected a few tubes of red colour to lie against them. I can see easily that Cadmium Red is a much better choice, and even Gold Ochre works for the orange. So before I have even picked up a brush I am confident of what colours to use to capture a true likeness.

If I play with the idea of painting tomatoes just for fun, I don't have to paint just one or two. I don't have to paint the tomatoes just how I see them either. I can use my imagination and create something totally unique instead. I have had fun here painting a tower of tomatoes, adding interest by allowing colours to flow into each other.

If you look at my fun tower of tomatoes it really does become quite fascinating and not just a simple exercise. Notice that I have left white paper for the highlights and added a few green lines at the top for the greenery of the fruits. Only one tomato has a complete outer edge; all the others are softer with missing sections, which creates a wonderful study of interesting shapes built up of colour and trapped light.

Laying tubes of colour next to your subject is an economical way of making colour selection. It is also a great time saver as there is no need to keep trying out colours to find the right one.

Exercise: Yellow and blue

There was a time when I only worked with the three primary colours. When mixed, they gave me a fantastic range of shades. Now I am more experimental but still prefer the natural mixes that form on my paper rather than colours created in the palette.

Learning how pigments interact and fuse is fun. It is also wonderfully rewarding in that it leads us into new and exciting possibilities for colour selection in all sorts of subjects. Exploring fantastically unusual colour combinations is an endless journey, but an extremely valuable one. For the artist who wants to be unique, it is time well spent.

Now try this simple exercise. Work with your paper angled, so that the paint tends to flow from the top to the bottom. Choose just one tube of yellow and one of blue and place a generous blob of each colour in the mixing well of your palette.

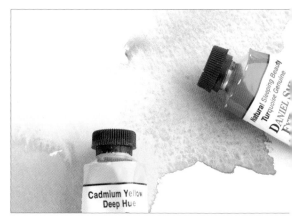

Daniel Smith Cadmium Yellow Deep Hue and Natural Sleeping Beauty Turquoise Genuine. When these colours merge naturally on paper the most glorious of greens appears in the fusion area. 'Fusion area' is the term I use for where pigments interact on paper. If they are left undisturbed while the fusion takes place the most beautiful effects can occur.

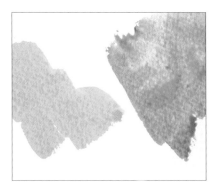

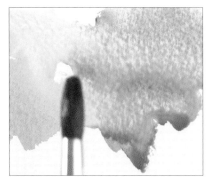

1 Place a small amount of yellow on a piece of scrap paper. Next to the yellow, add an application of the blue pigment.

2 Gently touch the gap in between the two colours with a damp brush, then take your brush away, leaving the two colours to flow into each other and 'fuse'. Learning not to touch this section while it is fusing will help you gain an understanding of how pigments work naturally in more complex compositions.

3 As your paper is at an angle, the paint will 'puddle' at the base of the colour area, but notice that it stays put. It does not run on to the dry area of paper so we are in complete control.

Tips

Take time to play with colour selection before you even pick up a brush. Look for new paint colours to use such as the Gold Ochre in the previous exercise, which wasn't my first colour choice.

Bear in mind that not all pigments are happy to interact freely. Opaque pigments like to boss other pigments around, so will push the quiet-natured Alizarin Crimson, for example, out of the way. Heavier application of colour will result in less flow; add a lot of water and you will speed up the flow.

Learning about pigments

Learning how much paint to place on the paper, how much it will fade when dry and how vibrant certain pigments are, requires some fascinating experiments with watercolour that will lead to amazing discoveries about this fantastic medium. Take time each day to experiment and always be on the look out for new shades to try.

Save every scrap of paper you can, and every day play with colour. Match colour in tubes to subjects, as in the tomato exercise on page 66, or simply place shades side by side on paper and watch them fuse together. Watercolour has many amazing facets, and only through regular practice will they be revealed to you. You will learn that some pigments are happy to be moved by water, others can be gently lifted to create patterns within a wash, and some work well with salt or plastic wrap (Clingfilm) to create texture. To miss out on becoming the best artist you can be purely because you have dismissed the value of learning about the medium you are working in would be a wasted opportunity. Being an artist means far more than simply placing colour on paper and hoping for the best. It is about finding out as much as you can about the pigments you use to compose gorgeous paintings. So go for gold and don't leave a single colour combination out!

The colour exercise on the facing page is easy to achieve in just a few minutes. Combined with the previous exercises in this chapter, you will be amazed at how much you have now learned about working with watercolour and painting simple subjects:

- When possible, always select colour by placing tubes next to your subject before you start painting.

- Select shades that match your subject and then choose an alternative contrast to go alongside them in your painting to make an attractive colour combination.

- Don't always paint the subject exactly as you see it. Try using your imagination to achieve a more unique result.

- Always aim for a variety of edges around your subject. Soft, less defined edges provide a fabulous contrast to hard, more detailed edges. This can create far more interest in your painting.

- Allow pigments to merge on the paper rather than in the palette for wonderful new colour effects and combinations.

- Leave a few watermarks for fun and to gain unusual results.

- Take your time and enjoy each brushstroke or colour placement. Learn as you work about how colours merge and how paint actually dries, observing as much as you can while you are painting.

These tips will help you on your journey to becoming a far better artist!

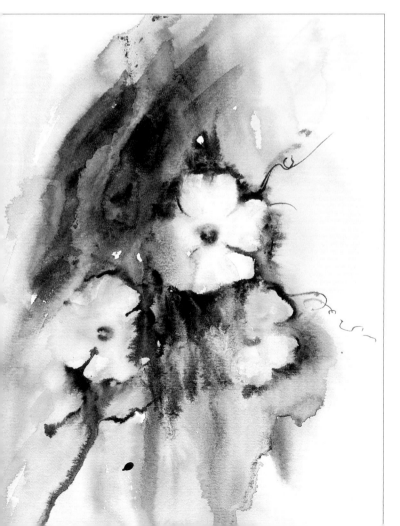

Floral Fantasy

Simple white flowers come to life in a beautiful wash of blue and yellow, where pigment has been encouraged to create gorgeous effects purely by allowing water to flow through the application of colour in the first wash.

Exercise: Colour

Painting lemons

1 Make your first mark on paper with your chosen yellow.

2 Add an outer line of blue to fuse with the yellow.

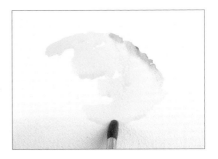

3 Soften the lower outer edge of the lemon.

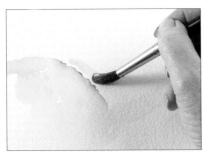

4 Add a second lemon behind the first, trapping a line of light in between the two.

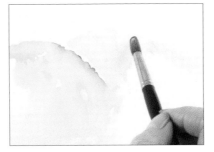

5 Bleed the colour away from the line of the second lemon.

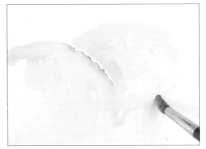

6 Build the shape of the second lemon lightly.

7 Drop some more blue against the line at the base of the second lemon and allow the colour here to fuse naturally.

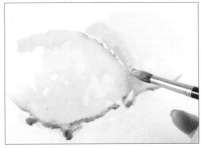

8 Extend the blue to form a shadow along the base of the first lemon.

9 Soften the lower edge to hint at light hitting the subject here.

10 You could gently lift an area of light with a brushstroke of water in a circular movement. Now stop before you add far too much detail. Don't paint all the edges of the lemons and just enjoy what colour does best!

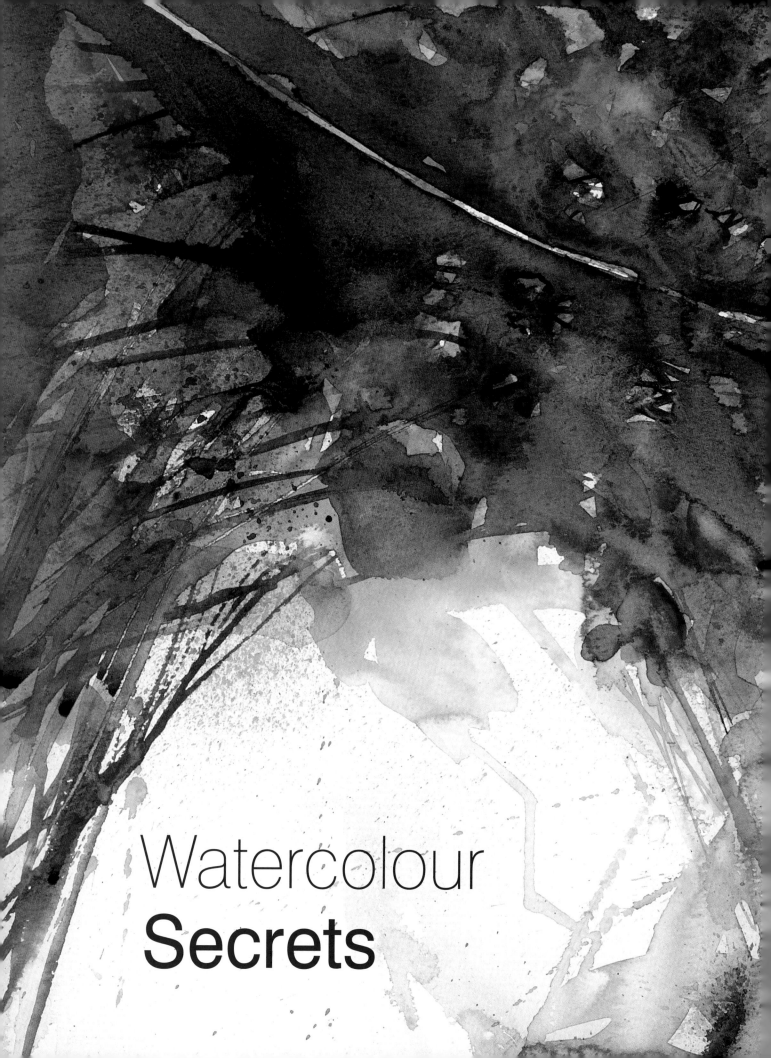

Watercolour
Secrets

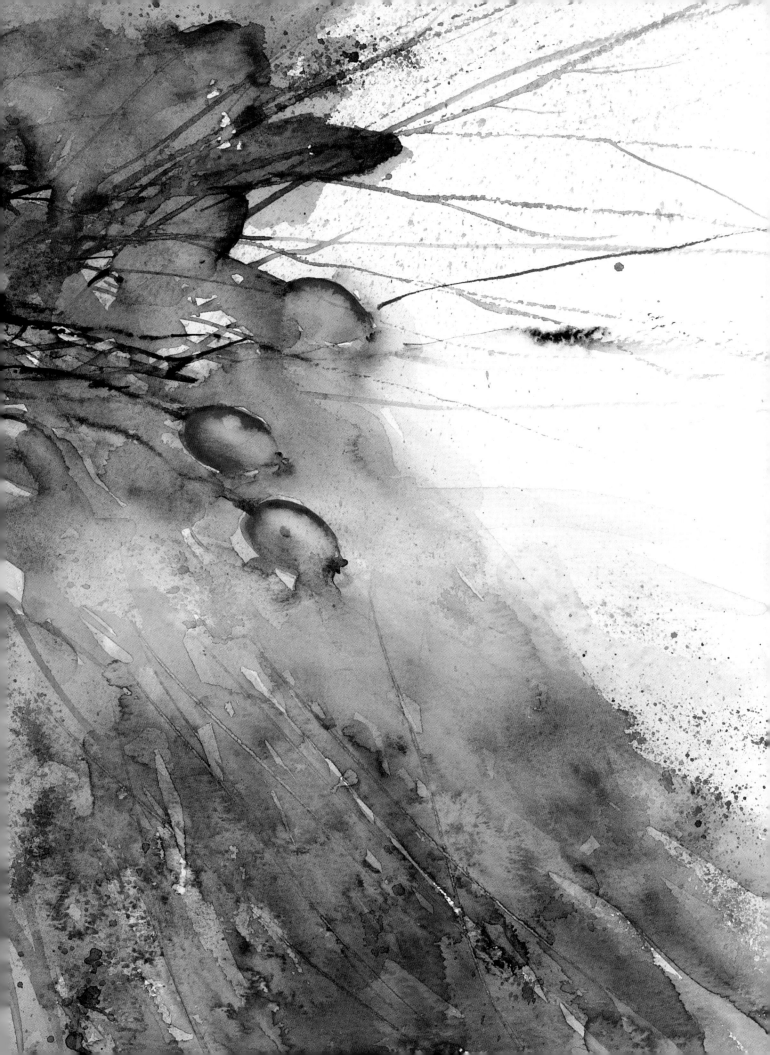

Introduction

"You will only find excitement in your work when you believe in yourself as an artist and find your own personal style."

Throughout this section of my book I am aiming to inspire you with fresh ideas on technique and share with you how I work. When we have a treasure chest full of techniques, only then can we create magical paintings that sing with life, movement and excitement. By discovering new ways to work we open our artistic souls and ignite the passion that may have been lying dormant for so long.

I am constantly experimenting and discovering amazing ways to work in watercolour. This is my life and I love it because every single day there is a new discovery. These personal tips and the thrill I feel when I paint I wish to give to you, to enjoy.

When I first picked up my brushes and was taught how to work in my favourite medium by traditional artists, I soon found I became bored with what was expected of me. I painted beautiful, smooth, classical skies. I painted landscape after landscape that looked exactly the same as everyone else's landscapes. My still-life work was so still it was utterly lifeless. In my classes I witnessed painting after painting leaving the room looking almost identical in both composition and colour selection. My paintings then were classed as beautiful and yet they felt flat and wooden to me.

I eagerly explored other workshops, searching for something new and exciting. I looked for a master who could make me feel alive when I painted. Travelling all over the world helped me meet so many wonderful mentors and many gave me the same advice: 'you will only find excitement in your work when you find your own style'. These words are so true. When we copy to learn we grow as artists, and this is a vital part of our journey. But when we get to a stage where we can truly paint for ourselves without anyone else's influence, then art takes on a whole new meaning. But you need to believe you are capable of being an artist first; and also have faith that your own way of working is just as good as those of the most successful artists in the world. For many, this isn't always easy. I intend to encourage you to be yourself and find your own style in the next few pages. Take every watercolour secret I give you, give it a twist and make it unique in your own special way. You can do it – I did, so you can too!

Let's get started in building up a terrific treasure chest of techniques to fall back on for every single subject that you see.

All That Jazz
Musician developing in watercolour during a first wash.

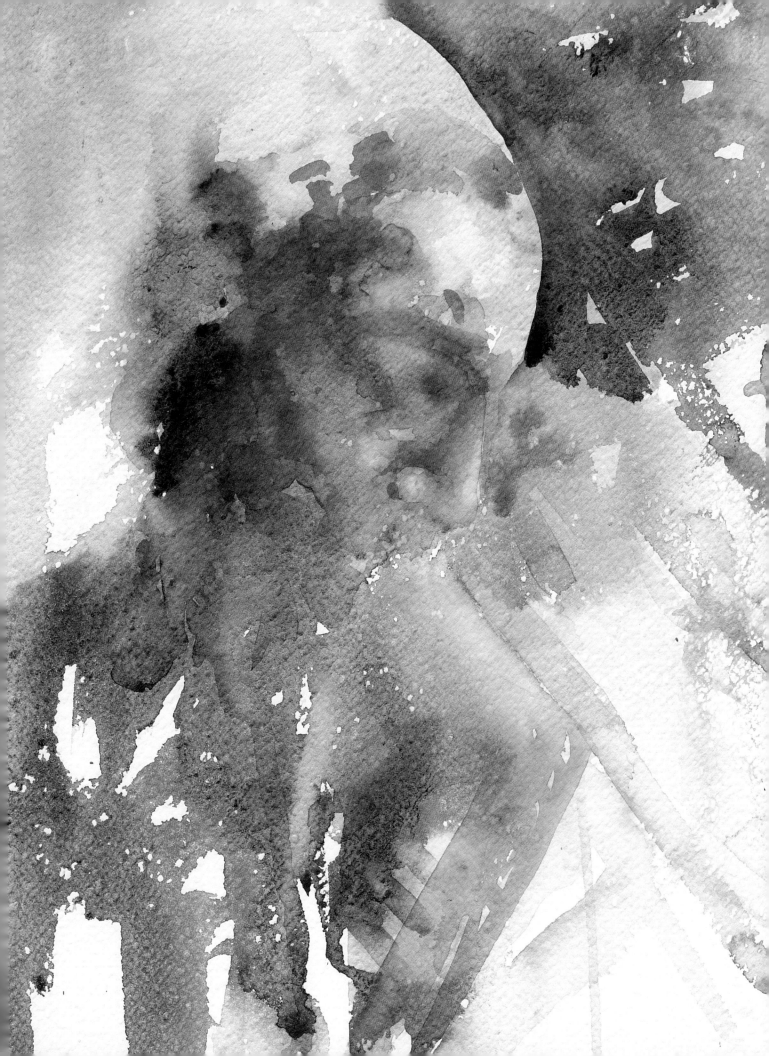

Glorious washes

"If we are aiming to be original artists, how we use colour has to be original and unique also."

I often begin a painting with an exciting wash to capture the mood and essence of my subjects. By placing colour all over my paper first, I alleviate the problem of how to paint a background later on as it is already there!

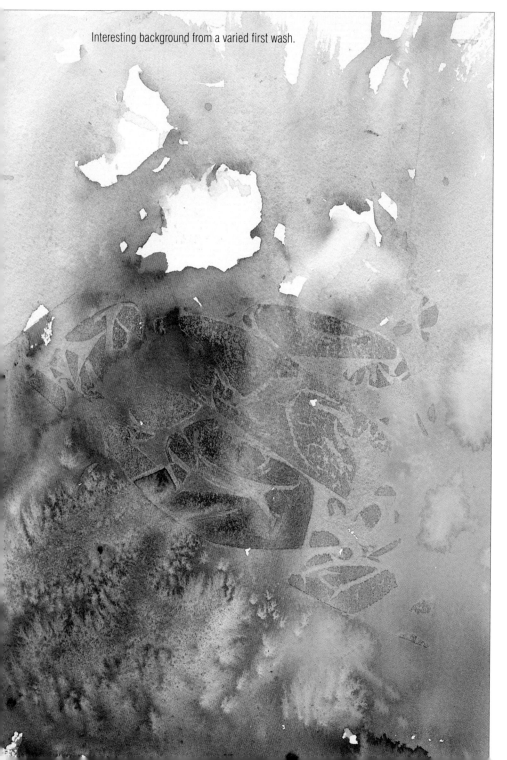

Interesting background from a varied first wash.

What is a 'wash'? A wash is a widely used term for colour placement over paper. It can be one colour or many shades merging beautifully, covering the whole or just selected sections of the paper. Washes can be used as backgrounds on fresh paper or applied as transparent layers on top of existing colour to increase depth. A one-colour wash of blue, for example, could be a flat sky in the background of a landscape. Large or small, washes can make or break a painting and every artist needs to know how to paint them well.

For me, a wash is an opportunity to add excitement to a painting. There are times when a simple, quiet application of colour can bring a touch of subtle beauty to a composition. Washes with texture effects and directional brushstrokes can add a feeling of movement and life to a painting. As we are aiming to be original artists, our watercolour washes have to be original and unique also.

Let's try an experimental wash just for fun.

Tip

Do not interfere with pigments while they are interacting on the paper. Leave them to dry on their own for the most beautiful of effects.

Exercise: Getting started with exciting washes

The aim of this exercise is simply to cover a piece of paper with colour following some tips and ideas on how to do so. The idea is not to achieve a finished painting, but instead to learn how to create colour effects by moving the brush, using water and placing pigment.

1 Starting at the upper corner of your dry paper, add a colour of your choice. I am working with diluted Cadmium Yellow to create a feeling of sunshine. Moving your brush, encourage this colour to flow into the central section of the paper. Add fresh colour as you move, connecting to the original starting point.

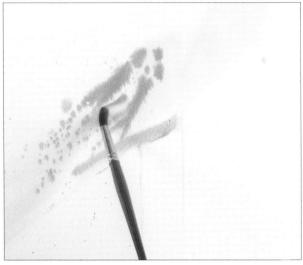

2 With a light touch of the brush, drop in a second colour while the initial pigment on the paper is still wet. I have used Cadmium Orange as I have decided to create a warm, glowing wash. Do not touch the second colour once it has been added! Allow it to fuse and merge with the first pigment and leave this area alone for now.

3 Turn the paper and work the colour away from the centre to an outer edge section by constantly adding water and pigment as needed. Lay a line of clean water at an angle alongside the previously placed pigment and allow the colour to flow into the new wet section. Keep adding water alongside each previous placement to allow colour to flow away from its original starting point. As the colour moves into each new application of water it will naturally dilute and so lighten when dry. This is called a 'natural fade' in colour graduation from dark to light.

4 Turn the paper completely upside down and flick droplets of water on to the still-wet paper. These will create intriguing patterns and add an interesting sense of texture. When this wash is dry, observe which colour and water application methods gave you the most magical of results.

5 Add some drama by wetting one corner of the paper and flicking some contrasting colour into this new working section. I have used Cadmium Violet and Cobalt Turquoise. Using a cool colour to contrast against a larger section of a warm shade creates interest and impact. Be dramatic in your paint selection and placement.

6 Add some strong, warm colour to the same lower corner. This affects the balance of colour and creates a fascinating result. Throw a little Opera Rose diagonally across the lower left-hand corner of the painting. Now there is a fabulous mixture of soft shades that you can see working away from a gentle, warm, central area. This wash flows on the paper to beautiful, glowing, rich, deeper colour at the paper edges. But this wash still looks flat, so let's add some texture.

Tips

Do not underestimate how simple drops of water can break up an otherwise boring area of colour.

Watercolour will always appear lighter when dry, so remember this when loading your brush with pigment.

You may wish to stop now if you already have a great result, or you may wish to continue. Do start a new painting if you have a fabulous looking wash at this stage.

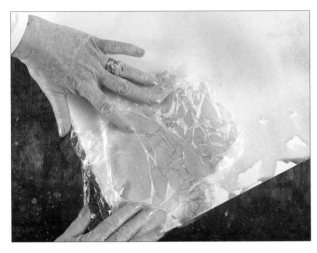

7 While the warm corner is still wet, lay some crinkled plastic wrap (Clingfilm) over this section. Push the plastic wrap together to form small patterns on the pigment and leave it in place until the paper is totally dry (see the wrap technique, page 112).

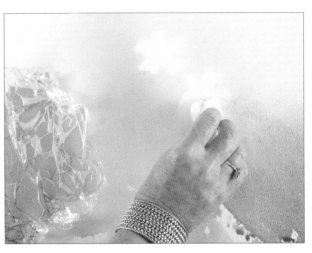

8 Try making shapes by lifting colour. With a clean tissue, I have created petal shapes on the damp centre section of the paper. Touch the paper very gently and only once to get a clean, fresh result.

9 Now you have a base consisting of a first wash that can be left to dry and worked on further. The result will be a beautiful painting that is unique, interesting and full of gorgeous, colourful fusions, with patterns giving marvellous effects.

Tip

Move quickly when creating washes to avoid hard lines that are difficult to work on in future stages.

Practise painting washes for a variety of subjects, seasons and moods. For one session, try working in cool colours only; for another, work solely in golds. Try imagining what colours you would use for a spring flower painting and start with yellows and cool soft greens, then lift out your flower shapes and leave to dry.

Whether you are painting a cityscape or a still life, this technique provides a fabulous foundation for your painting. Deciding which colours you need in order to set the mood and atmosphere before you move into the detail is very exciting. In later sections, we will look at ways we can develop this technique and use it as a foundation for a wide variety of subjects (see overleaf and page 104).

Making washes work

Applying colour to a white sheet of paper can be a glorious feeling. Simply watching the pigment flow and interact with other shades is the most magical feeling of all when working in watercolour. Far too often the initial stages of any painting are raced rather than enjoyed.

For me, picking up a brush and capturing the mood of any given subject is often the initial stage in the creative process. I will look at my chosen subject and select shades that I feel might bring it to life in a composition. I will then use this selection of colour and lay it in a first wash, allowing it to dry so that I can pick out my subject at the next stage. For example, when thinking of a display of tulips in my garden I would cover my paper initially with the colours I can see in the flowers. In this case, pink (Alizarin Crimson), yellow (Cadmium Yellow) and French Ultramarine Blue to add depth at the base of the foliage.

Exercise: Making washes work

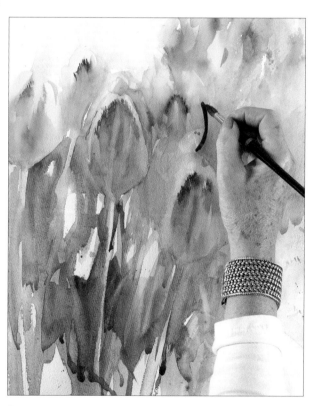

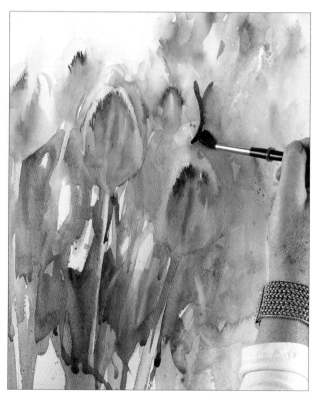

1 Look for an area in the first wash to introduce another tulip, then add an outline for the edge of the next flower using Alizarin Crimson.

2 When you are sure this is where you want the flower to be, strengthen the colour of the outline.

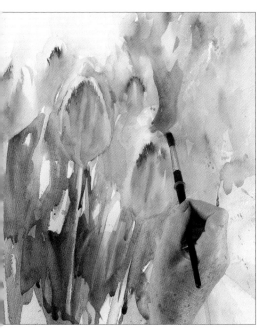

3 Work downwards to connect with the next flower that is already taking shape in the composition.

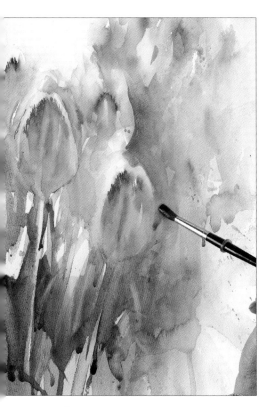

4 Leaving a block of colour on one side of the painting will draw interest to the section with more detail and definite shapes in it.

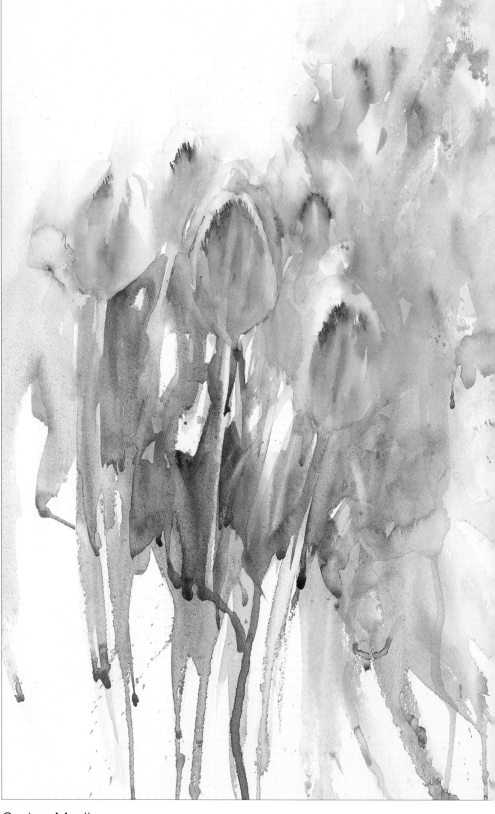

Spring Medley

A wash of pink, yellow and blue was applied over the whole paper and then an outline for each tulip was worked on top to bring each flower to life. Sections were worked in a negative way (see page 91) to introduce stems for each flower.

Magical water flow

"We often believe that all techniques in watercolour have already been discovered. By practising regularly you may find something new that has never been shared before. Dare to be unique."

I have been looking forward to writing this section. As far as I know I have yet to come across another artist who uses this technique, which has evolved from my demonstrations over the years.

When I stand in front of a room full of eager artists I often find it easier to work at an angle on an easel so that everyone in the room can see clearly. However, working like this means water will naturally flow to the foot of the paper, carrying pigment with it. This often leaves wonderful sections, created by the water runs, that are paler, with outer colour edges fusing with the existing shades.

Morning Light

Cockerel in an exciting first wash with water and colour flow adding life and the impression of light in sections. This is a time to stop and enjoy what you have created. By looking at this stage for a few days you will gain a sense of what the painting needs next.

At first, I considered working more quickly to avoid these water runs, but then I started to become excited as I realised how they could be used to make my paintings come to life. I experimented with them and discovered that they add a brilliant sense of atmosphere to a painting in a way that, for me, no other technique had before. I have even been advised to keep this 'secret' to myself, but what is the joy of an experience if you cannot share it with others?

Look at the first wash of a cockerel on the previous page. Isn't it thrilling? From this starting point I have a base for a unique piece that is full of light. I began painting this subject from a starting point at the head, gradually working away from this area and introducing the body and tail. As the water and colour have been applied I have allowed water runs to occur and be a part of my painting.

Having found that I can use my water flow technique to add light and life to a subject, I went on to experiment further by moving the paper when working to encourage a directional flow. My new technique then became even more exciting as I was thrilled to discover a beautiful feeling of harmony created by the water runs pulling all the subjects and colours together. Look at the daffodil wash below. There is a wonderful water flow running through the whole painting, and it really does give an amazing effect of movement and life.

Tip

Never race to complete a painting. Always enjoy every stage of the creative process and learn from each experience. Had I raced to finish every painting when demonstrating I would never have discovered this technique!

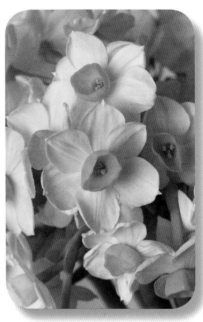

The most beautiful outcome of discovering this new technique is that now I can look at any number of subjects and instantly see how I can use it. Look at the simple group of daffodils shown above. They could all be painted individually, but how much more exciting they would be if Cadmium Yellow and Cadmium Orange were first applied as a wash and water allowed to run through it? Then the subjects could simply be picked out of or found within the wash.

Whispers of Spring

Daffodils in a first wash flowing together in harmony, united by a thrilling water flow. This effect is created simply by allowing clean water to flow through previously placed pigment on the paper.

Breaking pigment

If you allow water to run through existing wet sections of a wash, you will often find that a wonderful pattern occurs, created by the pigment being broken up by the flow of water. When this dries, amazing patterns can form which can become an integral part of an exciting composition.

As water was allowed to run through the crimson, gold and violet shades, it broke up the drying pigment, pushing it in different directions. Veins within the colour on paper formed, adding interest to the results.

Exercise: Water flow

Experiment on scraps of paper with the pigments you have selected. Choose a variety of subjects and work with them daily to see what you can achieve.

Tip

If you are creating a first wash that you intend to build on, it is vital that you develop a feeling of life, light and excitement in the very early stages of the creative process. If your washes are boring, your end results will be too, so take time to experiment.

Combining techniques

A combination of techniques in a first wash can make a simple subject turn into the most exciting of paintings. Look closely at the wash of primulas at the bottom of page 82 and you will see how salt effects have created texture while directional brushstrokes moving away from the central section add extra interest.

Every section of a painting can be worked either as a separate entity or in harmony with the rest of the composition. Having texture in one corner while there is a quiet wash in another will create a fabulous contrast. Look at every completed painting and study how it works. Why is it interesting? What makes it work and how could you make it more exciting if you painted it again? Make yourself into a better artist by always asking yourself these questions and striving to find the answers.

Summer Sensation

These colourful hydrangeas were created by a combination of techniques.

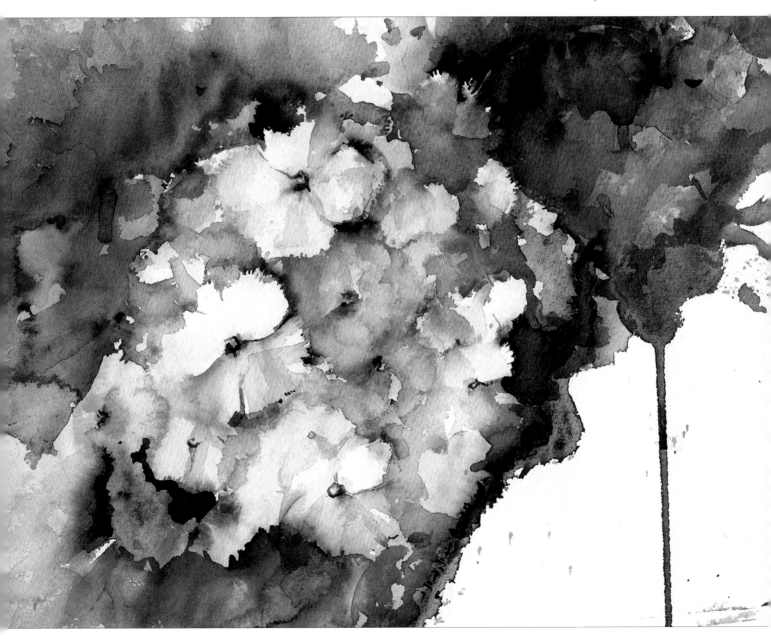

Working from a starting point

"Feeling a subject magically come to life in front of your eyes for the very first time is one of the most incredible lifetime experiences."

There are many ways to approach a painting, though first and foremost you have to fall in love with your subject. Sometimes I will look at my chosen subject and feel I could lay a whole wash over my paper and then, when it is dry, bring the subject to life using the techniques described in the earlier pages of this book. But there are other times when I want to go straight in and paint the subject directly. This is what I call 'working from a starting point'. I start by finding one area that is my favourite part, paint that, then gradually work away from this point, adding further colour as I do so.

Exercise: Working from a starting point

I have chosen a beautiful anemone to demonstrate this technique, but you can follow this exercise using any subject you like. The stages are simply finding a starting point and moving away from it – it's that easy!

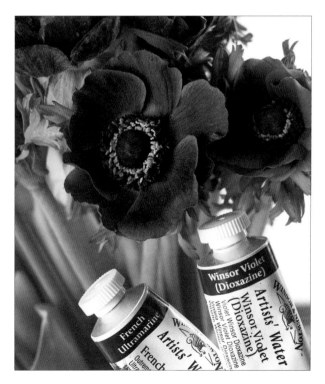

1 Choose your subject. My chosen subject is a beautiful anemone that is very rich in colour. Next select your shades by placing tubes of colour next to your subject. This saves you opening them and wasting paint!

Tip

Always aim to have soft and bold sections in all your paintings as the contrast between the two will add excitement and drama to your work.

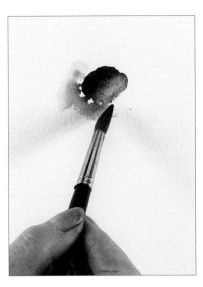

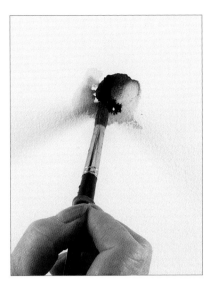

2 Looking closely at your subject, start at the centre of the flower and place a small amount of colour on your paper in a circular shape. I have used a mix of French Ultramarine Blue and Alizarin Crimson.

3 To create interest, dampen the area just to the left of the centre and add a touch of warmth to the outer edge. For this I have used a rich orange.

4 Make small, directional brushstrokes away from the central starting point to encourage the colour to move towards where the outer petals will be added in the next stage. These directional brushstrokes will lead the viewer's eye into the surrounding petals.

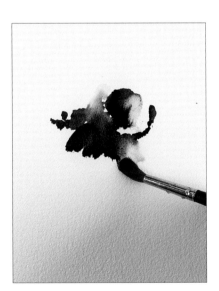

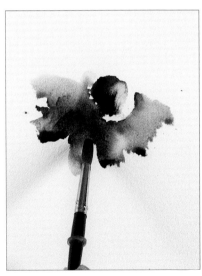

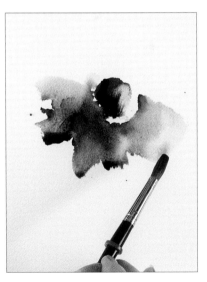

5 The fun part of this exercise comes when you can start adding petals to surround the centre. Take your time with each one, adding strong colour initially, knowing that you will flood it with water in the next stage. For this stage I have used Cadmium Violet.

6 In the next stage, add further colour and drop clean water from your brush into the new petals to create watermarks. These will add to the final result when dry.

7 Soften some edges with water completely by fading them away and diluting the existing colour at the outer edges. Add intensity and contrast to this softness with the addition of pigment to strengthen colour near the centre of the flower.

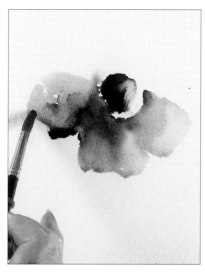 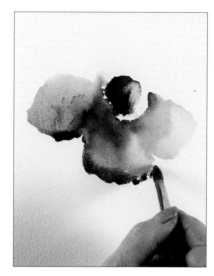 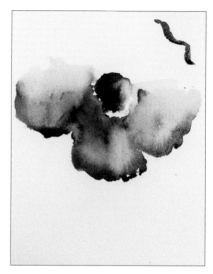

8 Add petals one by one around the centre of the flower. Deliberately leave some sections paler than others and use water to soften two of the three outer petal edges. You should begin to feel your flower come to life in front of your eyes, which is a truly fantastic experience.

9 To make the central petal appear closer to you, add more violet pigment here while the petal is still wet. The colour merges with the existing damp section, but with the paper placed at an angle you allow the colour to puddle at the base of the petal. This will create a run-back which, when dry, will form a very interesting pattern, giving the illusion of a curled-up petal.

10 The anemone is beginning to take shape. Now work on the side that is furthest away from you. This is less important than the front of the flower, as you want the viewer to look at the area that you have enjoyed painting the most. For the background area, place an outline edge and work away from it to hint at petals. The colour here is worked solely as a suggestive background minus any detail.

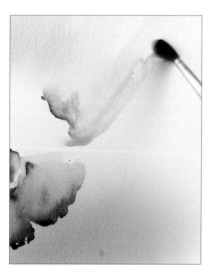 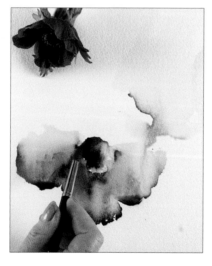

12 This is where the painting becomes very personal. Continue by strengthening the centre of the flower on one side, because this part of an anemone is often quite dark. Also, in my experience, the stronger this section is the more delicate the petals will appear to be around it – a beautiful 'strong against light' contrast. Always look for sections you can enhance with dramatic contrasts in any painting to lead to exciting results.

11 Once the outline of the furthest petal is in place, quickly add water alongside it. With your brush moving away from the subject, guide the colour to the corner of the paper in a directional brushstroke. This technique – of moving colour away from the subject – is called 'bleeding away'.

Tip

As an exercise, I would like you to stop the minute you see your chosen subject and can recognise what it is. When we paint in a loose style, knowing when to stop is often the hardest part of the creative process – not just for many new artists, but for established artists also. Always stop long before you think a painting is finished!

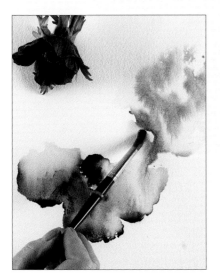

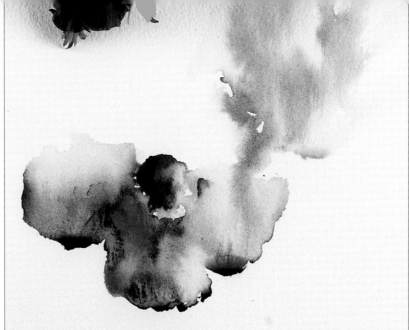

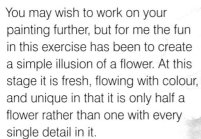

13 Finally, add a little more colour to the background of the anemone. A soft background of just one colour, varied in tone purely by the amount of water added to make it flow naturally, gives a more interesting effect as a backdrop to your subject.

14 Observe what has happened to the pigment and water when the painting is dry. Not racing each stage is vital to learning about creating paintings with atmosphere and life.

You may wish to work on your painting further, but for me the fun in this exercise has been to create a simple illusion of a flower. At this stage it is fresh, flowing with colour, and unique in that it is only half a flower rather than one with every single detail in it.

Leaving your painting alone to be enjoyed at this stage will teach you so much. It demonstrates how to stay loose when you work, how to dismiss too much detail and how to understand what has happened with the flow of colour and directional brushstrokes. You can also enjoy what has happened with the additional water applications when they dry. There really is so much to take in when working with watercolour, so try painting half subjects as often as possible to learn from and to improve your skill as an artist.

Sunbursts

"Add atmosphere and magic to your results by not being afraid of water!"

It is amazing that over the years, as artists, we are taught how to work in watercolour so that we carefully avoid leaving any watermarks. And yet in my view these are the very heart of its beauty, and at the centre of my journey and evolution as an artist. I have learned to work with it, not try to control it. How pigment reacts with water to create wonderfully magical effects is astonishing. To restrict what this fantastic medium can do seems, to me, to be unwittingly crazy. At our fingertips we have the most versatile of mediums and yet, traditionally, many watercolour artists refuse to allow it to shine in its own natural glory. It is like telling the most talented singer in the world that they can never sing again.What a great loss that would be!

Just look at the very beginning of this poppy painting. The gorgeous feeling of variety in the early formation of the petals is achieved purely by dropping water on previously applied and still-wet pigment, allowing water and pigment to interact while they dry. This flower painting is full of life and energy. There are no sections that are dull, flat or boring. This technique gives a stunning sensation of light hitting the flower, which is exactly what I am trying to share with you in this book. I adore the notion that not all watercolour techniques have already been discovered. There are a million ways in which we can use this medium, and by experimenting we can uncover even more of them.

Tip
Allow your watercolours to sing beautifully!

Petal Essence
The essence of a poppy, captured in glorious sunbursts.

How can this technique work with other subjects? An illusion of light shining on a figure can be seen even more clearly in this simple study of a young ballet dancer. There is no detail in this quick sketch, just colour and water, and yet this young girl is beginning to appear. Only by knowing how much water to use through experimentation can you achieve such amazing effects. Observe the light on the upper arm of this figure. The elbow-to-wrist section is almost life-like, and the sunburst on the girl's tutu gives the illusion of softness.

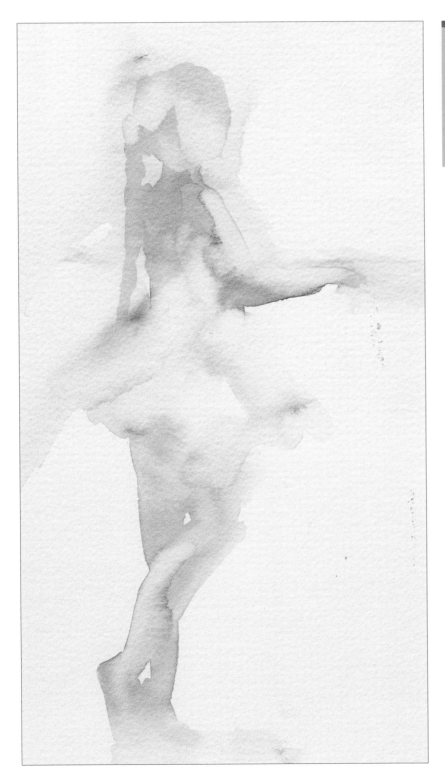

As If In a Dream

Young ballet dancer in a gentle first wash brought to life by clever use of sunbursts.

The main decision to make when using the sunburst technique is where to apply water. The answer is very easy – where you wish to add the effect of light hitting a subject! Simply drop a small amount of water from your brush on to that section and allow it to dry naturally. For larger paintings, use larger brushes with more water. For smaller paintings, drop small amounts of water from a small, fine brush. Practise this technique and all of your work will start to leap into life in ways you never expected.

If you look at this study of a cockerel in its early stages of development you can see easily that I have not only dropped in water but I have also combined techniques by using my water flow technique as well. In fact, in this example you can very easily observe how beautiful the study is because of the clever use of water application. Rather than always concentrating on pigment placement, begin to move your focus towards how and when to apply water. Add fresh, clean water and learn from your spectacular results.

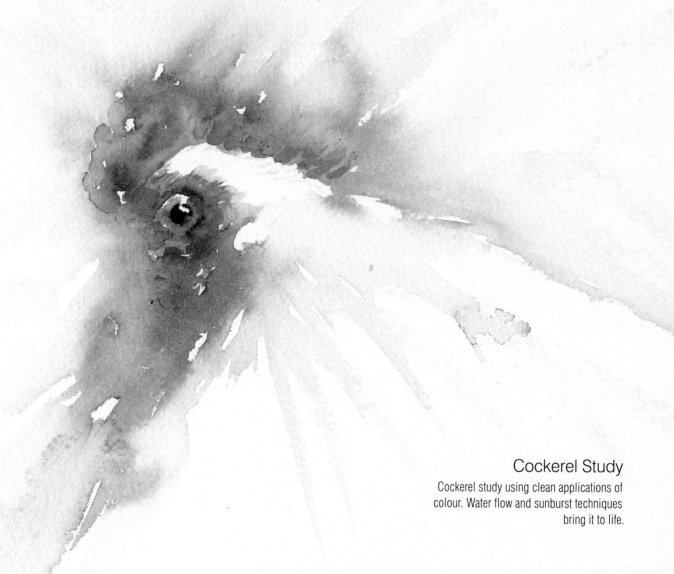

Cockerel Study

Cockerel study using clean applications of colour. Water flow and sunburst techniques bring it to life.

Exciting isn't it? I bet you can't wait to read the next section, so let's move forward and see what else we can do with this fascinating medium. Don't forget that every single time you pick up a brush after reading this book you will be aiming for paintings that sing with life, are full of emotion and capture atmosphere in ways you hadn't even considered before.

Positive negativity

"The only thing standing in the way of you being a great artist is your faith in your own ability."

The term 'positive negativity' may seem to make no sense when you first read it, but it has made a huge impact on my way of working. I avoid negativity in life because I believe it is a waste of energy. I surround myself with positive friends and focus on the positive side of life. This attitude, I believe, flows into my work. My paintings are light and often convey a sense of happiness, reflecting my cheerful personality. My mood can often be seen in my results.

Confidence in what you are planning to achieve can bring far more success than setting out on a project with the preconceived idea that you will fail. The best advice I can give you is to ask you to throw all negative thinking out of the window. The only way the term 'negative' can be helpful is when we use it positively as a technique! The exercise in this section is to help you build your confidence and self-esteem as an artist. Relax and have fun with it and simply see what happens.

Remember that, for now, you are painting 'for the bin' rather than working on a piece you wish to frame. If it turns out to be a mess that is brilliant, as you can learn more from your mistakes than from your successes. If it turns out to be a success, try again and this time aim for the bin. The more paintings that go into your bin the more you are learning!

You really can paint far better than you imagine you can. Be positive and allow yourself to succeed. See what your inner artist can create following the simple exercise on the next page.

Summer Delight

The exercise on pages 98–99 guides you step-by-step through the creation of these delphiniums using the technique of positive negativity.

Exercise: Positive and negative

Spring flower

We are going to create a wonderful painting by starting positively in the centre of the subject and then moving to its outer edges and working on the negative space there. You can use this technique on absolutely any subject and it is very simple to follow once you get the hang of it. Remember the colour exercises? Here they will be invaluable as we work on the centre of this flower.

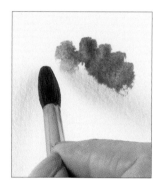

1 Start by making brush marks for the centre of the daffodil. Here I have used Schmincke Translucent Orange.

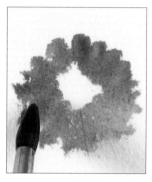

2 Complete the circle of the flower centre by making definite brush marks on the paper.

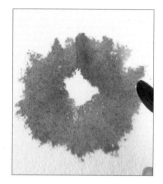

3 Extend these brush marks in places to increase the size of the flower centre.

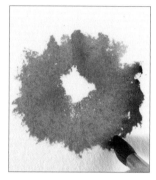

4 Add a fine edge of red to enhance the fluted rim of the centre section.

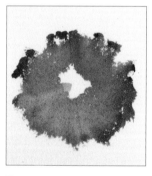

5 Bear in mind that this edge is beautifully shaped in the real flower, so add some defined brush marks to create an even more exaggerated ruffled edge.

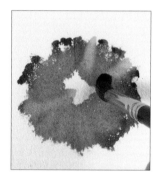

6 With a clean, damp brush, make a line from the outer to the inner edge at the centre. Lift your brush and leave the watermark. Continue forming radial lines by the application of clean, damp brush marks.

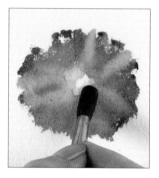

7 Make a semicircular brushstroke around the lower inner edge of the flower. This will give you a beautiful light effect at the centre of the flower.

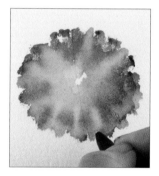

8 From this point, make brush marks with water leading away from the freshly worked centre to the lower outer ruffled edge.

Allow to dry and you have now completed the positive section of this painting. It should be glowing with colour, still wet, with sections of red and orange still fusing together naturally without being disturbed.

Now we are going to work on the rest of the flower by not painting this area at all. We are going to work in negative space around the flower to create soft hints of petals that are suggested by almost not being there.

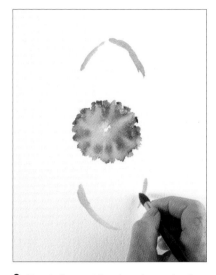

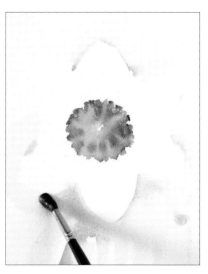

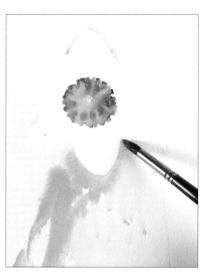

9 Begin by making brush marks for the outer petals at opposite sides of the central flower. I have used Sleeping Beauty Turquoise Genuine for my outer lines.

10 Now begin to place the outlines of the remaining petals, but bleed colour away from them as soon as the lines are placed to avoid definite brush marks; these will form if the first lines dry too quickly without colour being added or moved away from them.

11 Begin to add stronger background colour and move it to the lower left-hand corner away from the outer petals.

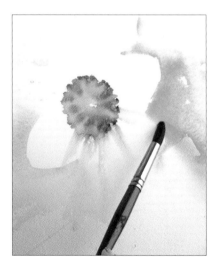

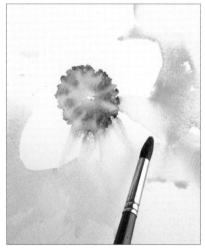

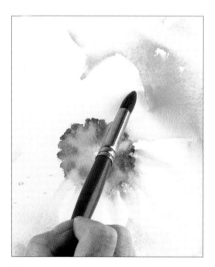

12 Now add colour to the outer edge of a top petal and bleed it towards the top corner of your paper. Move your brush in outward directional strokes. Painting around a subject while not painting the subject itself is referred to as 'negative painting'.

13 Dampen the edges of the flower centre and move your brush to the outer petals, which will allow the red and orange to dilute softly and flow towards the outer edge of the flower.

14 Soften the inner edges of the main top petal by placing a brush dampened with water on the dry, inner edge, then gently touch the blue outer colour so that it flows softly into the new damp area. This is what I refer to as an 'invitation' for colour to flow where I want it to. This colour will dilute as it fuses with water and dries.

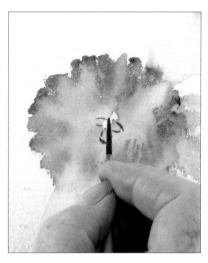

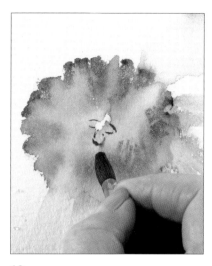

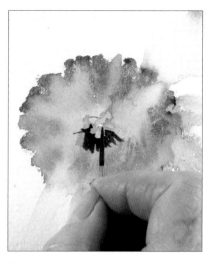

15 Now begin to add the stigma at the centre of the flower – just a few lines to hint at this section without too much detail will be enough.

16 The line here can be strengthened below the stigma and this colour encouraged to flow downwards to create interest here and depth.

17 When dry, define the centre of the flower using a rigger. A fine line of detail will add further depth to the centre of the flower. Bold colour makes the lighter area seem even more impressive.

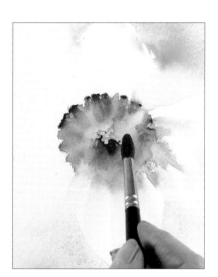

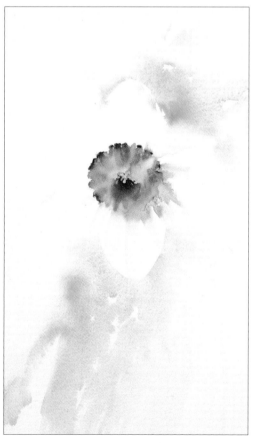

19 The finished painting with sections left to the imagination. Soft and hard edges, a positive centre, and suggestive negative work in the outer petals complete this floral painting. A wonderful exercise for getting used to working in a loose style. Now try it again but with different colour combinations!

18 Stop when you can see the flower is complete. Sometimes, when we enjoy a painting, we are tempted to keep working on it. It is important to know when the last brushstroke has been made.

Exercise: Negative advantages

White hollyhocks

It is amazing how many artists will spend ages painting a fabulous subject without any thought as to how they will paint the background later on. With this technique of painting the background first, this problem is solved! Working with negative space can be extremely useful to the creative artist.

When I visited Monet's garden at Giverney in France, I noticed a beautiful white hollyhock. It was lying on its side rather than standing vertically as they usually do. As an artist, this immediately hit me as an opportunity for a unique composition. I always look for the slightly more unusual in subjects and exciting ways to paint them. I strive to be unique. I hope you will too after reading this book.

For this painting, your paper will be in a horizontal (landscape) format rather than the vertical (portrait) format of the previous exercise. Study the photograph of hollyhock flowers closely and then only paint the background. Imagine the sun is shining and the sky is blue. It is a gorgeous, simmering summer's day, and this is what you want to get across to viewers of your finished painting.

Try to create a unique painting of your own. Decide on a composition that isn't exactly the same as the photograph; be an individual artist who creates rather than one who copies. Copying is a wonderful way to learn and improve your technique, but that is all it should be used for. What I am aiming for is to bring out the very special artist within you who is capable of making a painting far better than I can show you. With your own imagination your work can be far better than mine. Remember: whatever your art level, by learning and practising you can get to where you want to be.

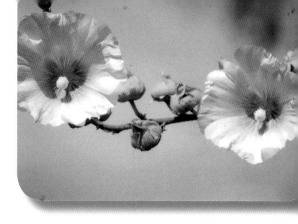

Tip
Choose your paper format to suit your subject before you even pick up your brush.

White hollyhocks beginning to appear with a wonderful sense of mood and atmosphere, created by the soft use of background colour and negative painting. Try experimenting with negative painting and do not begin to add detail or colour to the subject you have chosen until you are completely happy with the background effects.

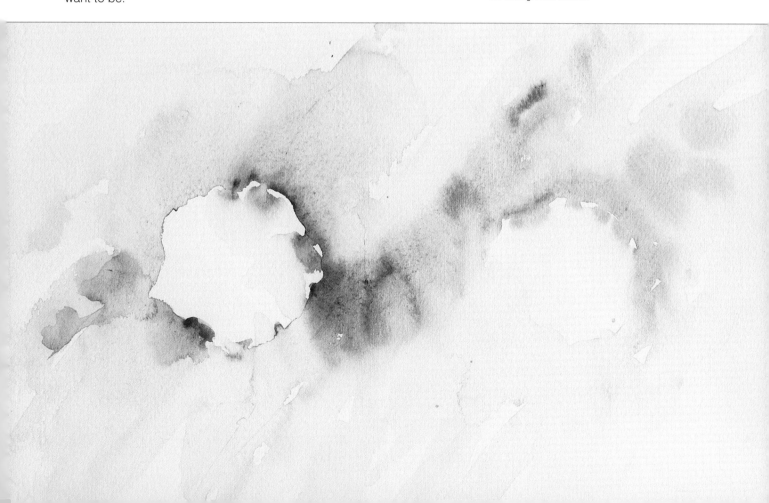

My hollyhock interpretation

I have taken the hollyhock image (page 95) and decided to paint one, not two, flowers. I have also decided to paint the background as foliage, not sky. I have added more flower buds than I can really see and I have made the flower lie at an angle rather than directly straight across the middle of the page. My painting looks very different from the photograph on the previous page because I have chosen to create rather than copy directly. It is so much more fun to allow yourself the freedom to make changes – often they work far better than what you see in reality. Aim for an interpretation only. Never be frightened of being different, brave and unique!

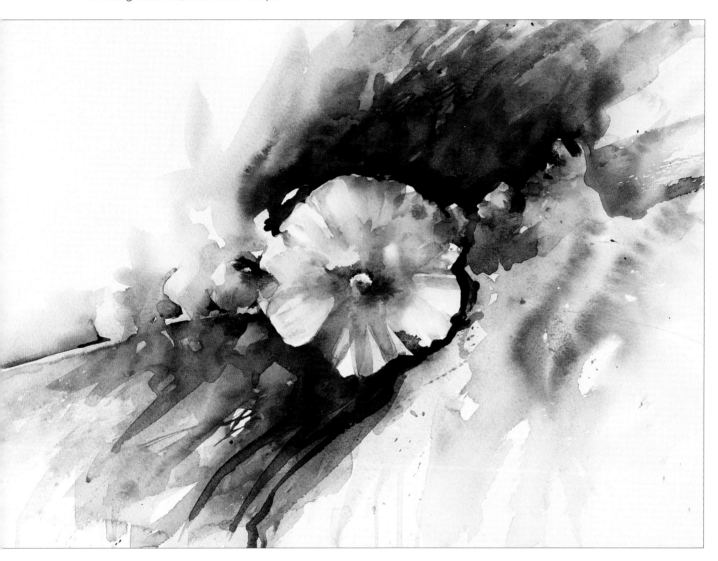

Fallen Angel

My unique interpretation of the white hollyhock. What will you change from the original photograph to make your painting even more interesting?

There are so many wonderful ways to work with negative spaces. Work around the outline of any subject, and only when you are ready add detail to bring your subject to life. But even then add only enough to tell the story. Too much definition and you will find you start losing the atmosphere and beauty you have strived to capture. Take your time, love what you are doing and learn from every single step and brush mark of the creative process.

Taking it further

Look at many white subjects and imagine how you could bring them to life by working with a negative outline. Try working with a soft wash of several colours first and then with a negative outline layer on top, as in 'Angel Whispers' below. You will be surprised at how many ways in which you can approach all manner of paintings with this simple way of working. Practice makes perfect, but don't aim for perfection – aim instead for magical and unique results.

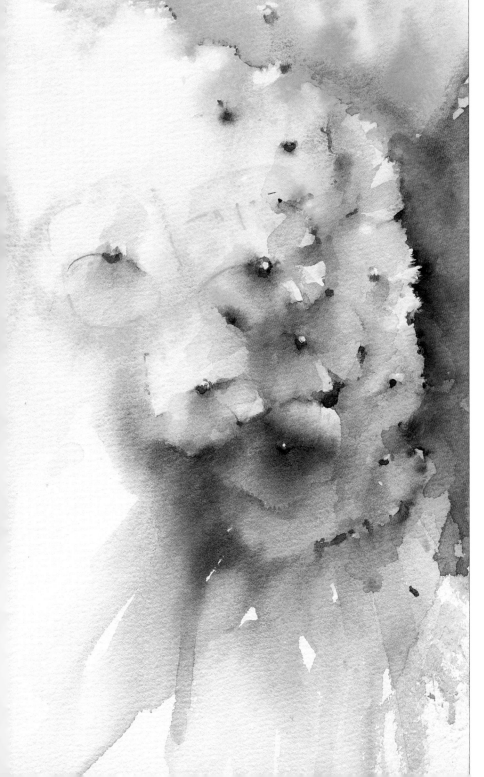

Angel Whispers

Here I have painted white flowers and gradually added detail to a few small sections – just enough to gain interest and not take over the painting. I applied a colourful, soft wash over the paper before I began working on the negative space. This meant my background colour was included in my subject, which draws harmony into my flowers beautifully.

"Don't settle for what you know you can do; strive to discover what you don't believe you can do and surprise yourself with the talent you never fully realised you possessed."

Exercise: More positive negativity

Summer delight

Once you have mastered painting a simple negative shape, try moving forwards on to a larger piece of paper and work on a more complicated subject. Your subject can be anything at all, not just flowers! The finished version of this painting appears on page 91.

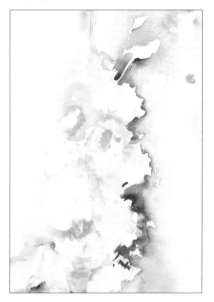

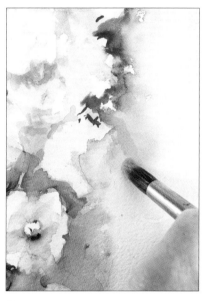

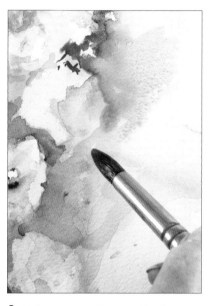

1 Paint the outline of one side of your subject and then bleed the colour softly into the negative space away from the subject. Remember: at this stage you are not painting the subject; you are simply painting the background.

2 You can strengthen sections of the outline by adding new colour at any time.

3 Soften new colour applications so that they merge with the existing shades beautifully. This will aid and enhance the feeling of atmosphere in the finished painting.

4 Begin a new outline for a second spire of flowers, positioned against the unfinished side of the first.

5 Leave some outline sections to the viewer's imagination. Avoid adding all the outline or detail as this will lead to an over-fussy composition.

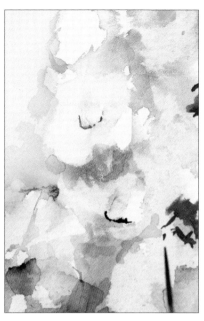

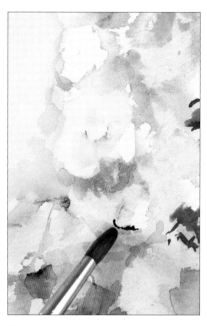

6 Once you are happy with how the background looks you can begin to add detail to the centre of some of the individual flowers.

7 A great tip is to use different colours for each centre; have some with warm additions and others with cooler colour choices. Add fine definition with a rigger brush.

8 Soften the fine definition lines with a brush that is lightly damp with clean, fresh water.

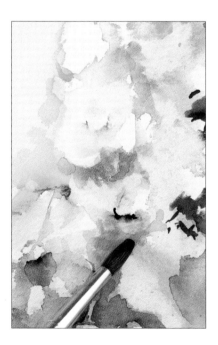

9 Once softened, leave the pigment to merge into the damp section without interfering with it using your brush.

10 An interesting composition of soft delphiniums, which can be worked on further or left as finished – all created by painting only one side of the subject first. Fantastically easy, isn't it!

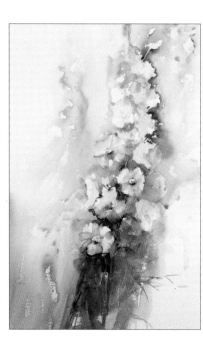

Hotting It Up

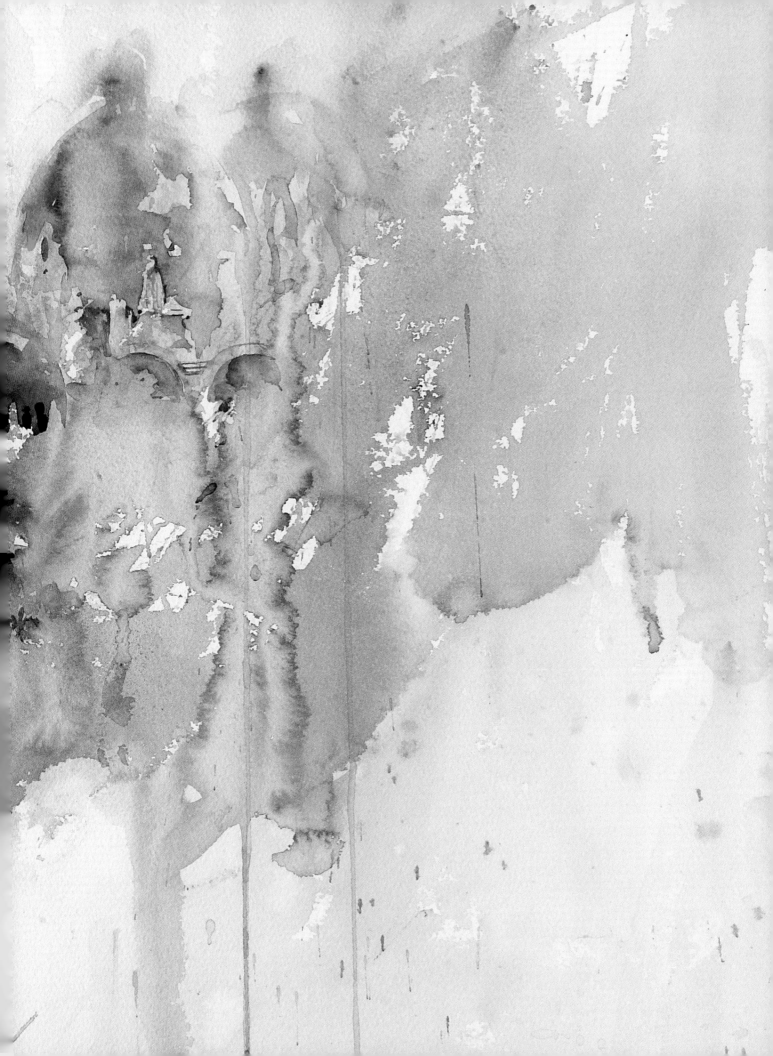

Introduction

"Like musicians, you need to learn the basics before you can begin to play complex pieces well. Practice is important if you really want to succeed at any new skill."

Musicians, when they play, create beautiful music. An orchestra comprising skilled players and a variety of musical instruments forms a sound that can be enjoyed from the moment it is first heard and become memorable. Composers of great music over the years have written the most incredible pieces that have enthralled listeners from all over the world and across many generations.

When we paint we are like musicians, creating wonderful music not with instruments but with colour and brushstrokes. We are the conductor, bringing every skill we possess to our painting. If you regard each technique you know and understand as if it were a different musical instrument, and then consider which other techniques would make them even more effective, you could create the most amazing of paintings. But, just like musicians, you need to learn the basics before you can begin to create complex compositions well. Practice is so important if you really want to succeed at any new skill. Study the section on Watercolour Secrets and experiment regularly until you feel you have reached the stage at which you wish to try something more adventurous. That is when you are ready to move on to this next section – when we 'hot things up'!

Think about an exciting musical composition. There will often be an opening which leads into the central section and eventually towards the most amazing of finales. This section of my book is the finale. We will

Greig
Portrait of the Norwegian composer, painted during a watercolour workshop in Norway.

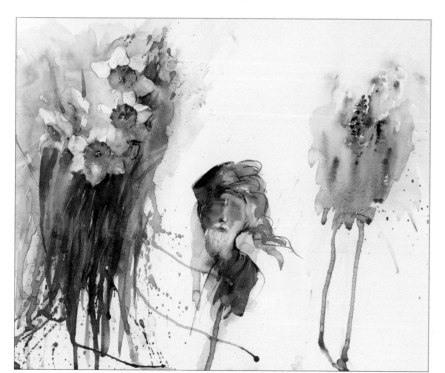

Leaping from one subject to the next, having fun with colour, experimenting with technique, learning from each brushstroke as a painting evolves can be addictive and rewarding.

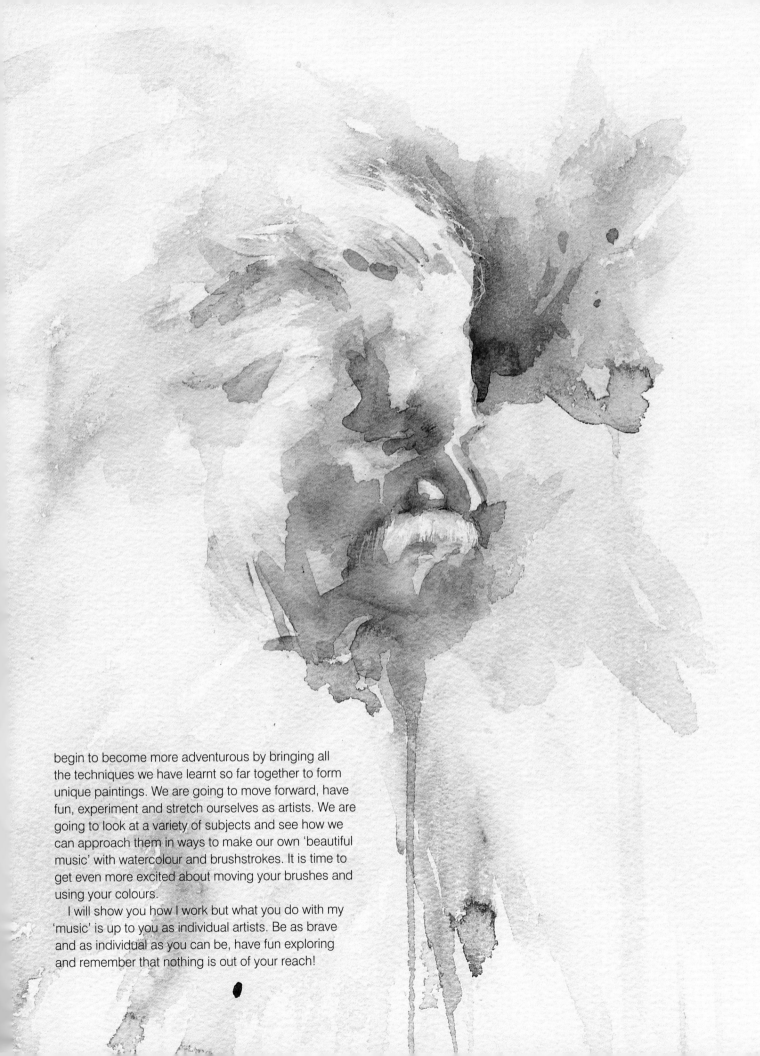

begin to become more adventurous by bringing all
the techniques we have learnt so far together to form
unique paintings. We are going to move forward, have
fun, experiment and stretch ourselves as artists. We are
going to look at a variety of subjects and see how we
can approach them in ways to make our own 'beautiful
music' with watercolour and brushstrokes. It is time to
get even more excited about moving your brushes and
using your colours.

I will show you how I work but what you do with my
'music' is up to you as individual artists. Be as brave
and as individual as you can be, have fun exploring
and remember that nothing is out of your reach!

Energy washes

"Instead of trying to control watercolour, enjoy its many beautiful facets and qualities, celebrating them and creating the most incredible of paintings."

We have looked at techniques in previous chapters, but now it is time to make each one far more exciting. We can choose colours to set the mood or suit the subject of a painting, and we can lay a first wash and find the subject within it or develop a painting from a starting point. But if we are clever and look at which direction our colour flows across the paper we can also add a sense of movement to a painting with results that can be absolutely fantastic. This gives a feeling of energy and life in watercolour washes.

Creating atmosphere

If you are passionate about watercolour, simply applying colour to paper isn't enough. It can be, but my aim is to open your eyes to working with this fabulous medium in ways that allow you to create magic.

To demonstrate my energy washes and directional flow technique I am taking a simple subject of a branch laden with berries in autumn. First, I consider the colours I could use to give the impression of a misty morning. I want to create the feeling of a cool day but with the warmth of autumn gold foliage, so I have chosen Cadmium Violet and Quinachridone Gold. With just a few subtle brush marks I hinted at twigs in the distance. As my paper was drying at an angle I also dropped water in places to form watermarks. With practice, you will soon learn how to work with these terrific patterns for a vast number of watercolour effects. When dry, this wash forms an interesting foundation on which to complete the scene by adding berries of Alizarin Crimson and foliage too.

"This is taking an idea you have already mastered and giving it that extra edge, making the difference between plain or stunning use of watercolour as a medium."

Autumn Delight

In my first autumn scene, applying colour and water while the paper is at an angle encourages a fantastic flow of colour across the paper, which can lead to dramatically atmospheric results.

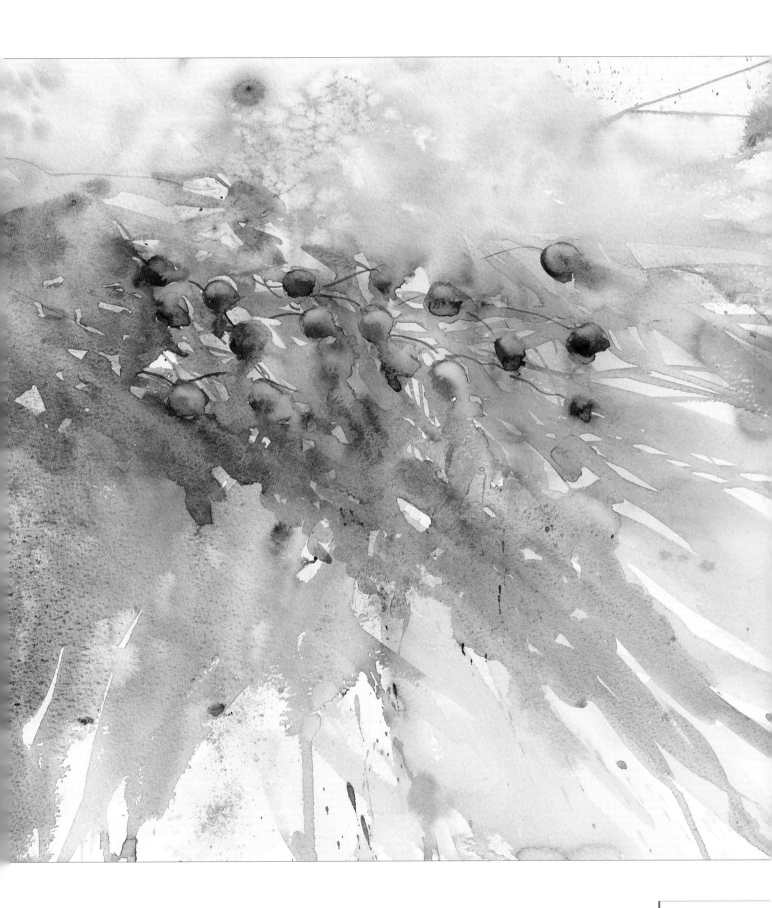

Watercolour with freedom

Many years ago, artists strived to work with watercolour so that every wash was perfect, without the slightest sign of a watermark. I am sure they would have been horrified by my results. But if you consider that this is what pigment does naturally, why fight against it? Instead of trying to control it, why not celebrate and enjoy its many beautiful facets and qualities and use them to create the most incredible paintings? It takes courage to work in this way, but it is also great fun and offers endless possibilities for combining my techniques.

Choosing direction

Whatever you are working on, you decide which direction you want the pigments and water combinations to move in. You will be amazed at how this simple trick can give you gorgeous results. But don't stop there. There are plenty of other ways in which we can hot things up and make the first wash even more dramatic.

Treasures of Autumn

Working around a white line as a branch in the initial stages of this wash and then developing stronger colour around the branch leads to an interesting autumnal scene. Directional brushstrokes and flow of colour add to the impact within the composition.

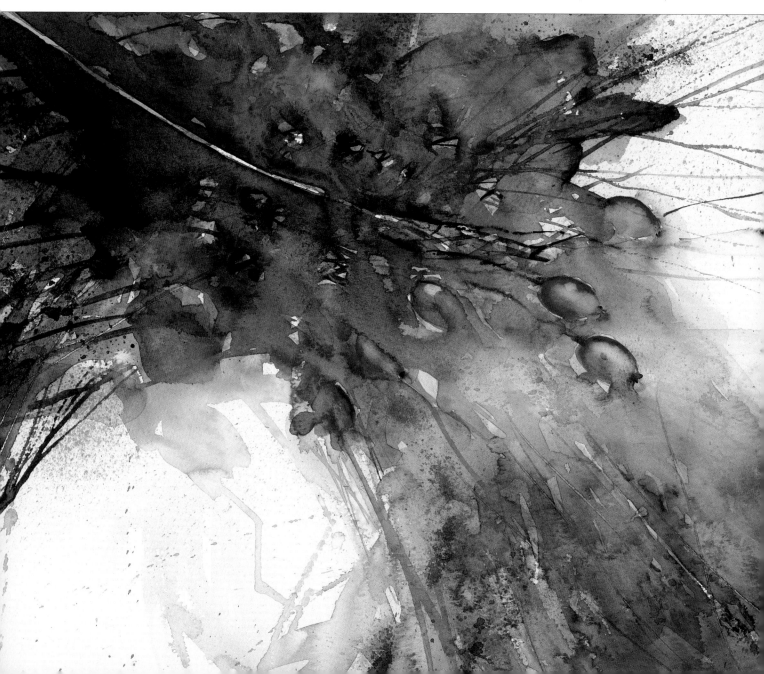

Going for the 'wow' factor

The first autumn scene (pages 104–105) is full of light and atmosphere. We are going for gold, literally, and aiming to make every painting we create full of startling energy.

Look at the difference in my second autumn scene opposite. Here I have taken everything I know and combined sunbursts with colour flow and bold, directional brushstrokes. The stronger use of pigment in places is combined with bold blocks of colour to cover large corner sections of the paper. I have also added interesting rigger-brush lines in warm tones to hint at twigs near and far. The addition of berries completes the rich autumnal scene, following the technique shown below.

1 Start to add a single rosehip.

2 Add colour to the berry.

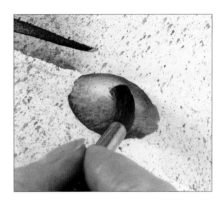

3 Soften the white-paper highlight section.

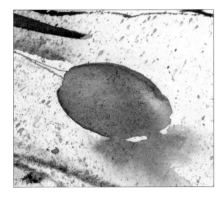

4 Bleed away colour from the berry to the background to connect it with this outer section.

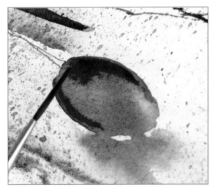

5 Add a stronger outline for effect and to enrich the colour of the ripe berry.

Time to experiment

Taking the time to imagine how we can improve on one wonderful result can lead us into even more incredible effects in our next washes. Never be content with one wash, however brilliant. Move on to another and make that one even better. Try painting two or three washes every single day to improve your techniques and knowledge of how colour interacts with water.

You can use these gloriously exciting washes on any subject to bring it to life in ways that you may never have imagined before. Let your passion and emotions flow into your brushstrokes and choose subjects you know you are going to love painting. Paint them in completely different ways and as many times as you can, ringing the changes in every single wash.

Exciting success

Cockerels are a favourite subject of mine and always have been. Each time I paint a new one I feel the same excitement I felt when I completed my first successful cockerel painting, because I never paint them in exactly the same way. 'Boring' and 'repetitive' aren't words I want to have in my vocabulary!

Red-hot washes

If you work with warm colours alone, you are more likely to gain a fabulously warm result. In my painting of a cockerel below I have simply placed an Alizarin Crimson and Cadmium Orange directional wash from one corner of my paper to another and allowed it to dry at an angle. I have again dropped water in places to form patterns as the wash dries. When the wash was dry, I happily worked the detail of the cockerel's head in the most appropriate location using any watermarks that were there to bring my subject to life. I can work further with this piece or leave it and enjoy it as it is, but the pleasure in creating it was very relaxing and I can't wait to paint another one now, with an even more interesting wash!

I improved this painting by adding dark for the eye detail and enlarging and strengthening the shape of the eye with a rigger brush. I added fine lines for detail within the wattle of the cockerel, and a touch of white gouache brought the beak to life to complete the painting.

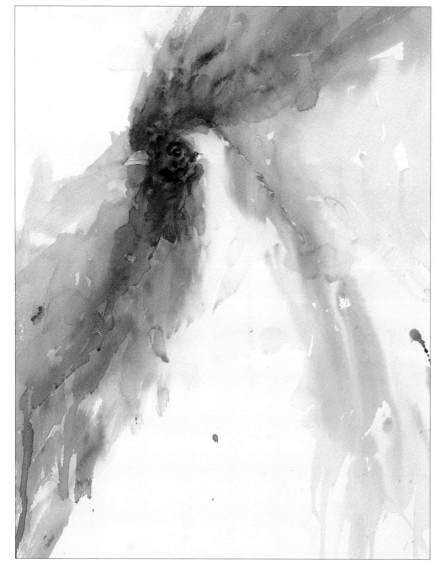

Morning Flame

Cockerel worked into a simple but exciting directional flow and energy wash for dramatic results.

Energy washes reversed

If you think the energy washes you have learnt about so far are exciting, how about this? Try placing a simple layer of a varied wash on your paper first and allow it to dry. Instead of creating texture in your first wash, add an 'energy wash' on top in a second wash for wonderful effects. If you paint your subject using fabulous energy techniques on top of the first simple wash you can gain intriguing effects. It is a stunning way to work.

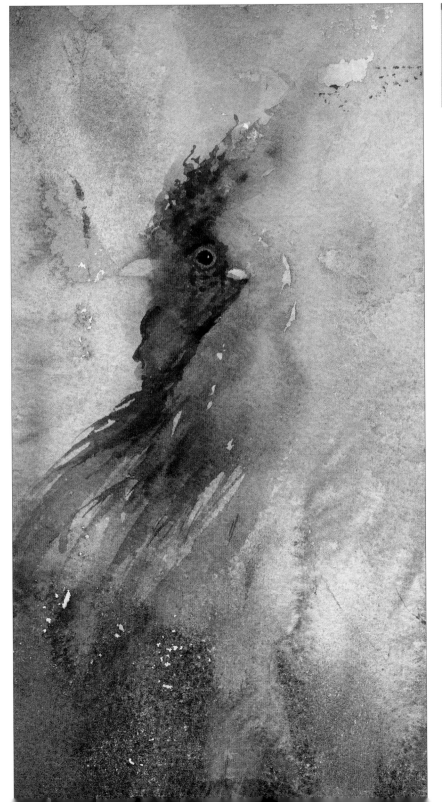

Tip

Keep your first wash very pale and work your subject in stronger colours on top.

Second Glance

A simple first wash of a variety of warm colours turns into a magnificent cockerel by selecting where to place the subject's head among the warm background forms. For any artists who fear painting backgrounds, this is a brilliant solution because you have painted the background first.

Creative energy washes

Imagine painting stunningly stormy skies with dark and moody colours with a directional flow breaking up the pigments. Then paint a few sailing boats among the colours of the wash. You can create drama, atmosphere and excitement all in one composition.

This is a fabulous way to work – simple, effective and leading to finished results that are totally unique!

Facing the Storm

This is am example of how I created an energy wash to begin and then 'found' my subject in it – here, the ships emerging from the mist.

Fabulous effects
The wrap technique

"Mastering technical knowledge is an invaluable skill for artists of all levels."

Imagine you have created a fabulous first wash but want it to be far more interesting. In my painting of a mariner on the facing page, you can see how the clever application and removal of plastic wrap (Clingfilm) has created wonderful patterns that give the viewer an illusion of the sea and yet the area becomes an integral part of the clothing the mariner is wearing. Here, I initially set the atmosphere by colour and texture alone. I then placed plastic wrap on my first wash in a selected section and left it to dry. Later it took very little effort to add a few details for facial features within the central area of my beautiful wash to complete my painting.

If you compare the portrait of the mariner on the facing page with the seascape below, imagine how much more interesting the foreground of the sea may have looked with the use of the wrap technique. The mood has been set by using colour and watercolour flow techniques in the seascape, but the mariner appears to have a greater sense of depth.

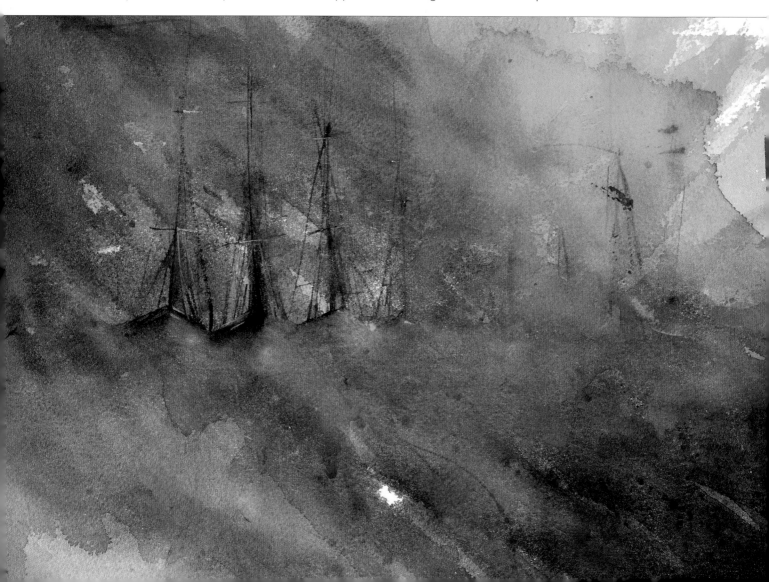

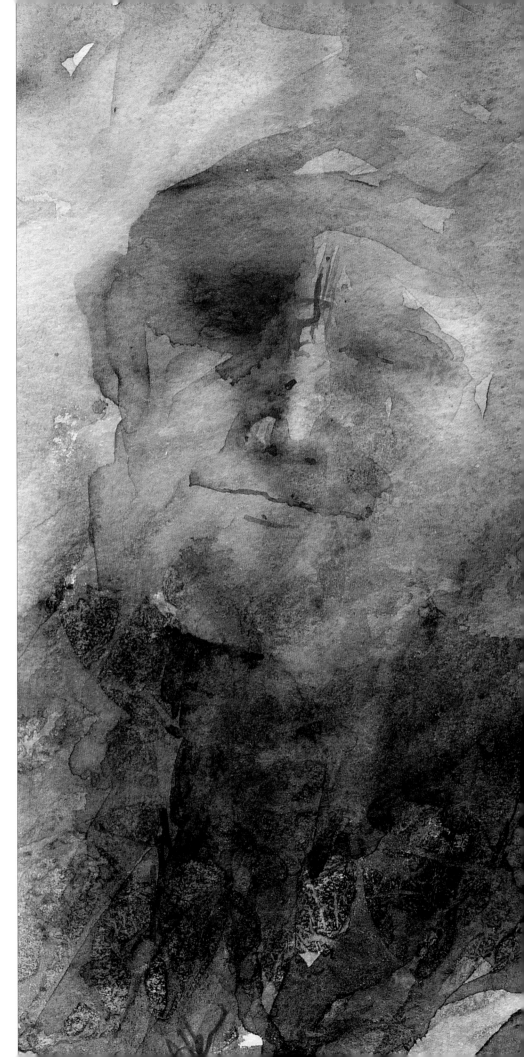

Favourable Mariner

Clever use of a first wash and well thought-out placement of plastic wrap brings this portrait of a fabulous naval character to life.

Stormy Seas

Seascape with simple use of colour and water flow to set the scene.

Clever use of colour alone can set imaginations alive. Both the mariner and the seascape are created with colour to take the viewer on an atmospheric journey. Understanding fascinating washes and how to enhance them with fabulous texture effects can make a subject literally jump off the paper by forming energetic visual illusions. Mastering technical knowledge is an invaluable skill for artists of all levels.

Subtle textural effects

Clever use of plastic wrap, or Clingfilm, can add texture and depth to a painting. If you study my primrose wash (below), a section has been left where individual flowers can be lifted out of the yellow area, while the cool purple corner in the foreground will act as a foundation for leaves in further work. This cool section had plastic wrap laid on it while the wash of colour was still damp. Removing the plastic when the paper was completely dry revealed wonderful textural marks that will enhance the corner and add to the beauty of the finished painting.

Primrose wash, using plastic wrap to create texture in a wash of contrasting colour.

Subtle versus obvious effects

Please don't make the mistake of believing plastic wrap can be used in only one way. There are many ways in which it can be used to create texture and I am certain not all have been discovered yet. This means that, by pure experimentation, you could come up with a completely unique way of adding texture to your painting, as I have done with my mariner (page 113) and the primroses opposite. Both paintings were created by playing with colour and thinking about what I was trying to say with each piece – gaining a taste of the sea or the impression of sunshine on soft flowers.

Springtime Melody
Primrose painting created with plastic-wrap corner and yellow sections lifted with tissue to form petals.

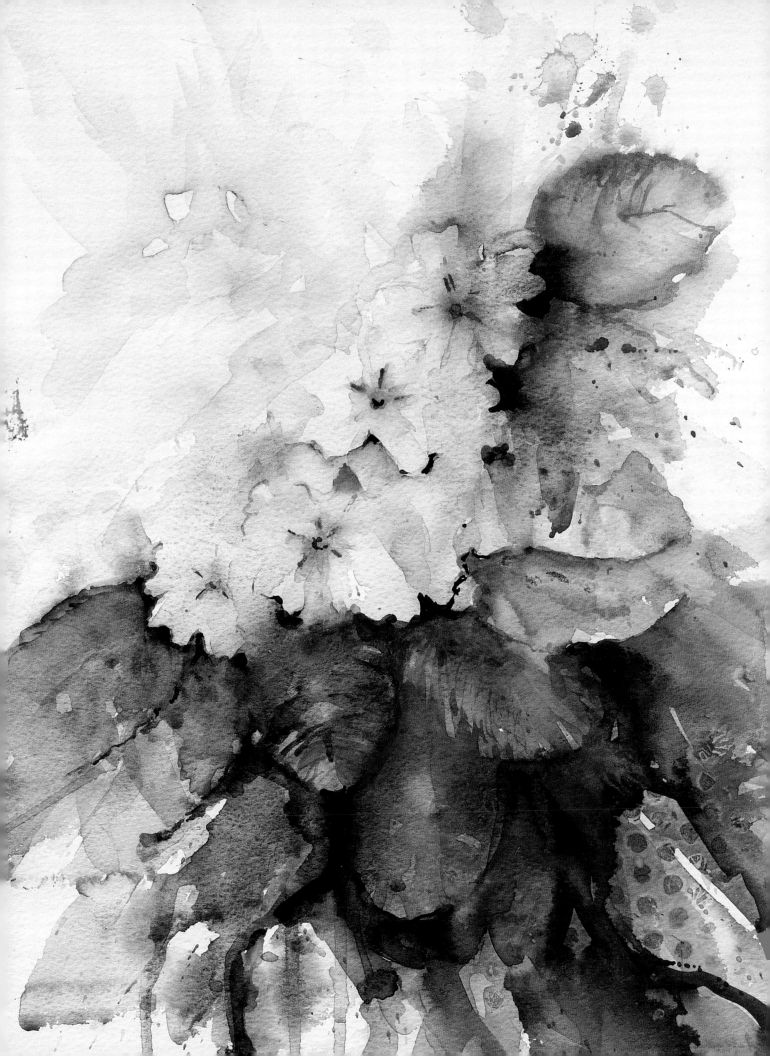

See what you can create with just one or two pigments before moving on to more advanced floral compositions. Leaving sections behind the main flower with only hints of colour gives a wonderful feeling of distance as well as allowing the viewers to use their own imagination.

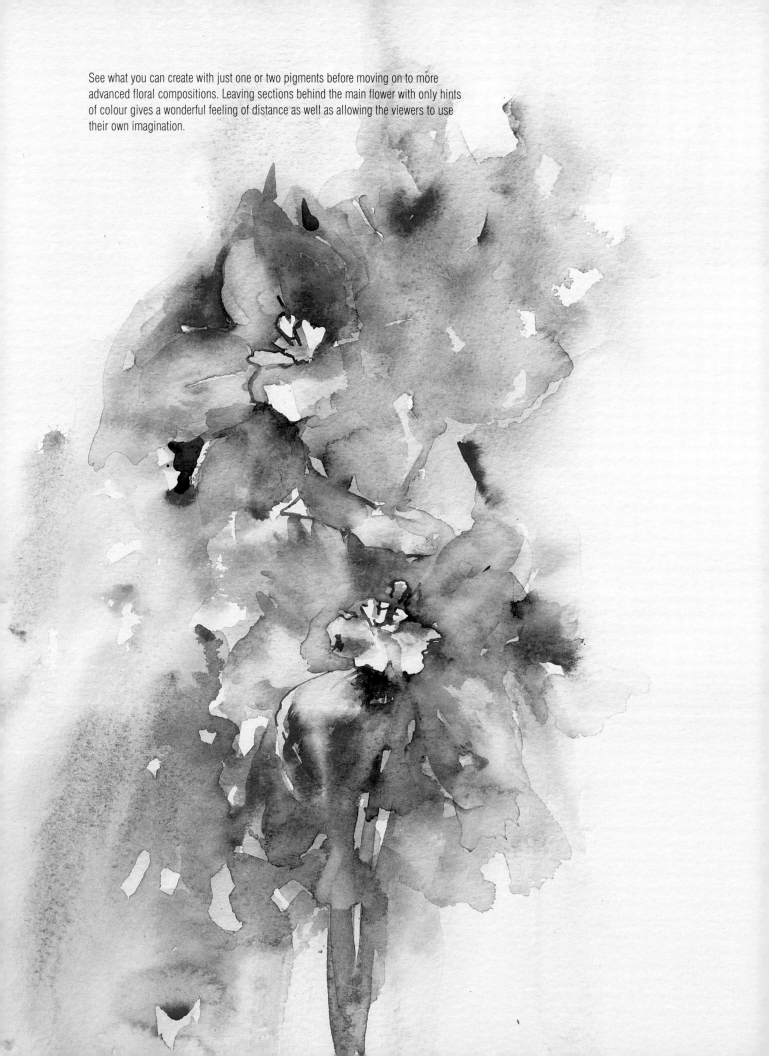

More fabulous effects

Simply stunning hollyhocks

When I look at any new subject, the first thought that always comes to my mind is, how can I bring it to life in watercolour? I consider the best techniques I could use to capture the essence of what I see. The wrap technique can be used to create stunning backgrounds or exciting foregrounds (see pages 42–47). However, with well-planned placement, this technique can also be used to create complex petal formations for many floral subjects that initially appear far too difficult to achieve.

If you look at the photograph of hollyhocks above right and imagine painting every single crinkled petal edge, you could well decide to choose something far simpler to paint instead. But wait – if you use my wrap technique you will find you can paint not only these, but many other flowers as well, with fascinating results.

Practise on a few scraps of paper until you get the right effects working with just one flower at a time first. Start by laying a circle of Alizarin Crimson on damp paper. Immediately place a stronger version of the same shade on top and in the centre. The second bold pigment application will merge with the diluted first colour already placed on the wet paper. Now, for fun, brush away colour from the outer edges roughly with your thumb, which will give you a terrific ruffled effect. Lay plastic wrap on top of the wet pigment and crease it with your fingers so that you can see shapes forming in sections underneath. Don't be too tidy! Leave this to dry. Only when you are sure the paper is dry should you remove the plastic wrap. You will see that patterns have formed that represent the flower formation. Easy isn't it?

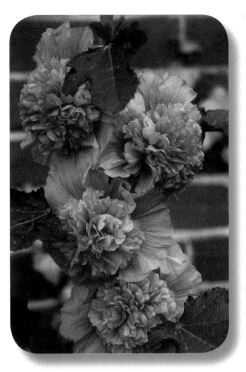

Once you have mastered how to create patterns from laying plastic wrap on wet pigment, experiment with larger pieces of paper and form a whole stem of hollyhock flowers. Overlapping flowers will add interest and give a sense of depth to your finished painting. At this stage enjoy the flowers alone before working further and adding green foliage.

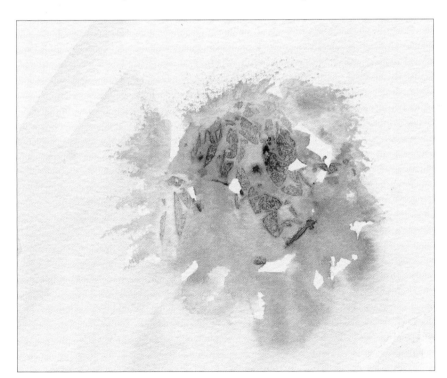

A simple, single hollyhock flower created with the wrap technique. The uneven outer edges of the flower are formed by brushing the wet pigment with your thumb or fingers to pull the pigment into the dry area of paper.

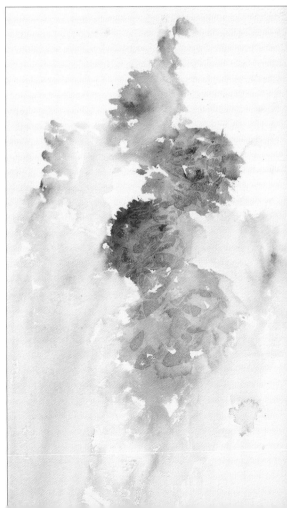

Exercise: The wrap technique

Hollyhocks

We have already touched on using plastic wrap (Clingfilm) to create texture. Now that you have learnt a few more techniques and gained in confidence, have a go at this simple exercise to create hollyhocks.

1 Make your starting point with the colour of your choice. For this exercise I am using Opera Rose.

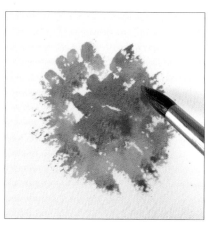

2 Make random brush marks around the centre of the individual hollyhock blossom by holding you brush at an angle around the starting point.

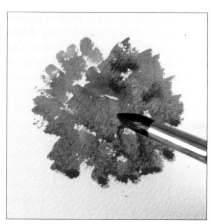

3 Strengthen the colour in places for variation in tone.

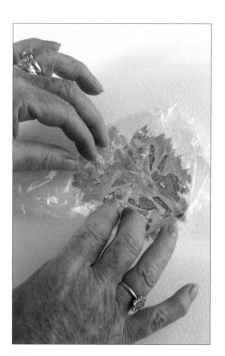

4 Take a piece of plastic wrap and place it on the wet pigment. Scrumple the plastic wrap on the pigment until you can see patterns forming through it and then leave this section to dry.

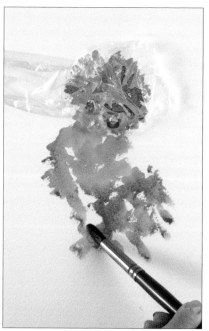

5 Work downwards, creating new individual hollyhock flowers on the same stem.

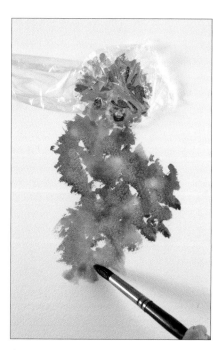

6 Add touches of Cadmium Orange to give a glow to the blossoms and to contrast with the Opera Rose.

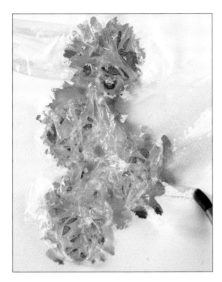

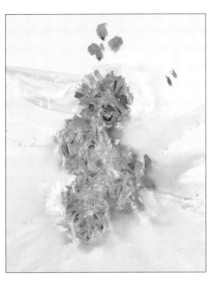

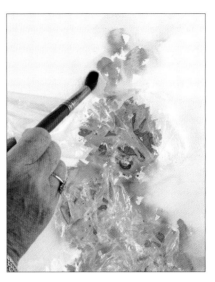

7 Continue to place plastic wrap on each hollyhock flower while the pigment is still wet. Swiftly bleed away some colour at the side of the flowers and merge this into the areas at the right and left of the main floral stem. This will help blend the background with the subject when the painting is complete.

8 Add some buds at the top of the stem, as this is how these flowers grow.

9 Drop touches of Cadmium Orange into the buds and soften with a clean, damp brush.

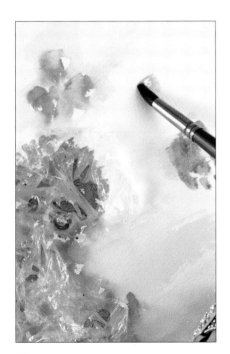

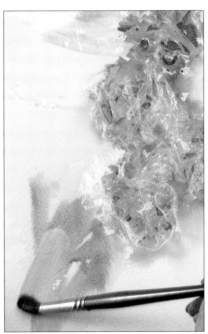

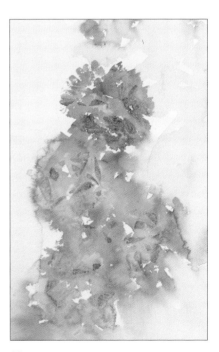

10 Begin to work at the top corner of your paper, bringing hints of a second hollyhock stem into the composition.

11 Work on the opposite lower corner, adding stronger colour to hint at the foreground section.

12 Wait until your painting is dry and then remove the plastic wrap. You should discover some wonderful pattern formations underneath that you can add further detail to if desired.

Suggestive seduction

I aim to seduce viewers of my paintings into believing what they imagine they can see. There is very little definition in some of my completed work purely because by using colour, brushwork and technique alone I have told the story with very little effort. Falling in love with my subject initially is the key, then, from there, simplifying how I create my illusions becomes a joyous process.

Knowing how to add texture is a fun way to work in watercolour. There are times when I far prefer to work minus the addition of salt or plastic wrap, but I am including them in this book so that you too can fall back on them and enjoy them when you feel they will create the magical effects you desire for your chosen subject.

Creating exciting texture

In this chapter we will take a look at using salt and plastic wrap (Clingfilm) to create texture in watercolour. From holding workshops all over the world, I have met many artists who produce limited effects when using these techniques purely because they don't take time to think about them beforehand. Carefully planned application and use of texture can lead to really dramatic results. For this reason, when I started to write this book, I knew that I wanted to include a section devoted entirely to this subject.

Whispering Wisteria

In this painting, there is a glorious sense of magnificent panicles of wisteria blossom, but absolutely nothing other than colour and the techniques I've used tell the story of these wonderful flowers. The fabulous texture effects have been created by dropping salt on wet colour and then allowing it to dry naturally.

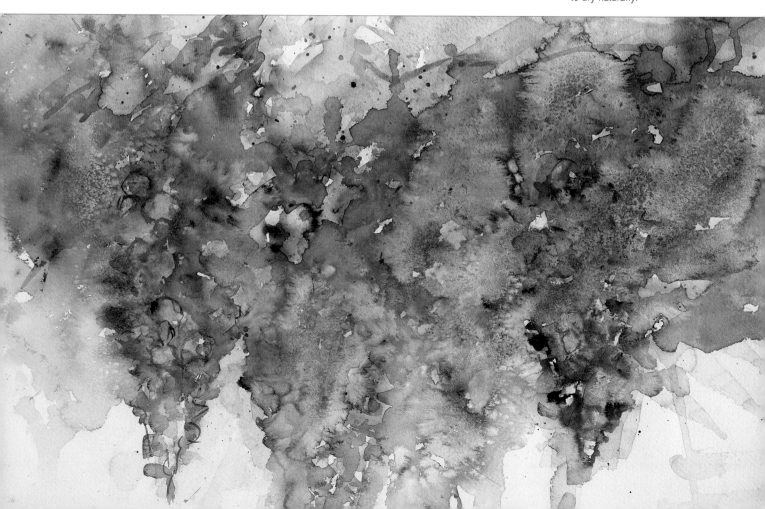

Atmospheric texture

Salt literally pushes pigment away. It appears like a large, hard rock to the small little particles of colour that simply can't make it move. Carried by water, the colour flows around each granule to find somewhere else on the paper surface to settle. The result is the gorgeous patterns that appear when you remove the salt, leading you to fantastic textural watercolour effects.

Removing the salt

Only when your paper is completely dry can you gently remove the salt. If you have applied the salt as single granules it will fall off the paper quite easily. If you have allowed clumps to form, you will now have the horrible task on your hands of removing the hardened granules. Careful application gives you fabulous results, so take your time otherwise all your hard work could be lost with ruined paper.

Getting excited about textural washes

Not a day goes by when I don't see something new that I can imagine bringing to life. In late summer and early autumn I once saw the most incredible of colour selections all on one nature walk. Blackberries were beginning to ripen and yet the colours of summer were still evident. To capture the mood I laid a colourful wash on a large sheet of paper and selected shades from my palette that I had seen on my walk. Next, I dropped water where I wanted a sensation of light to fall. I deliberately allowed it to move pigment out of the way in a beautiful flow to suggest a shaft of light falling across the hedgerow I had been admiring. I then lifted gentle dots of pigment by dropping tiny amounts of water from the smallest of my rigger brushes to hint at the individual formation of each blackberry. I finally applied salt gradually in a line to follow the water run. I also applied plastic wrap (Clingfilm) to the lower section of the painting.

Then I walked away.

When I returned to my work later, when the colour was dry, a very exciting first wash was waiting for me. Isn't it fabulous? There is no detail yet and I cannot wait to work further on the piece. Or I can enjoy it as it is and learn from the fantastic effects that have been achieved by a combination of my favourite techniques.

Until recently I have simply sprinkled salt on paper and expected it to give me what I wanted. Now, with a mix of my water run and directional flow techniques, I realise I can make washes bring subjects to life in a way I have never even begun to imagine was possible. I can literally breath life into my subjects, and it is very exciting. I have control by losing control and then regaining it. This opens up all sorts of possibilities for my future work. I can visualise many brilliant ways of making everything just sing with energy purely by working in this way.

By using all the techniques and watercolour secrets I am giving away in this book, I hope you will become excited about new approaches for creating fabulous paintings too.

You can exaggerate salt pattern formations by flicking a few drops of clean water from your brush on top of the salt once it has been added. Don't be afraid to experiment – that is how I discovered this trick, which is now one of my favourite ways to create texture for sand in beach scenes and all manner of subjects!

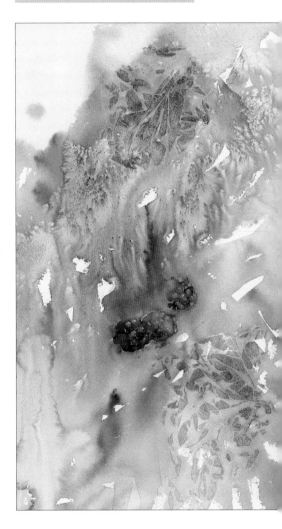

Hints of Autumn

My autumn wash, seductively suggesting hints of blackberries and autumn leaves – a unique result. Here, salt application combined with my exciting water flow and directional flow techniques create an atmospheric illusion of depth and life within an explosion of colour.

Exercise: Making subjects appear from a textural wash

Have fun creating wonderfully enriched, colourful washes full of texture and then study the sections where you could define and bring your subject choices to life. Here, in an atmospheric autumnal wash, I have used the 'positive negativity' approach to forming blackberry fruits from the initial suggestive wash.

1 Clean water dropped from a rigger brush on to an atmospheric autumnal wash creates tiny sections of light that can later be used to form blackberries.

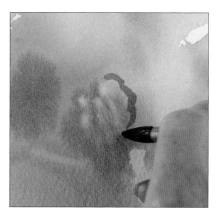

2 Paint a negative edge to create the outline of the berry shape.

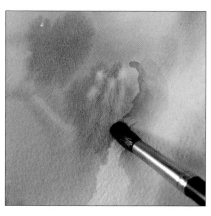

3 Soften the negative outline.

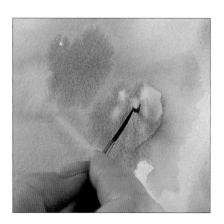

4 Begin to define the detail inside the berry with a fine rigger brush.

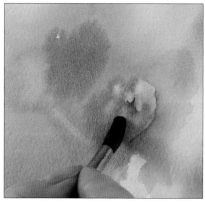

5 Soften the outline created with the rigger.

Tip

Add fine detail with your rigger brush and then soften the hard edge in places to create a more diffused effect.

Combining techniques can lead to amazing watercolour paintings. Never be too intimidated to use your imagination and personality to develop your own, unique style. You may just come up with something fantastic that no artist has ever considered before. Find the best art within you and allow it to shine as you move forward on your incredible art journey.

If you look at my blackberry wash on page 121, please ask yourself a question: 'Could I repeat this effect with exactly the same result if I were to carry it out again?' The answer is very likely to be in the negative, which is brilliant, because this means you are working as an individual artist rather than creating perfect copies of a piece of work.

With the techniques described so far I am able to gain a high feeling of drama and a wonderful sense of movement in my paintings. I could never return to the mundane, ordinary way of working in which I would sketch diligently beforehand and then almost fill in each part of my subject with colour as if I were painting by numbers. I am becoming addicted to exploring this medium that I feel so passionate about, and wonder what else I will discover.

> *"I would love every reader of this book to race for their brushes after seeing every possible subject and technique with new eyes — as if they were seeing it for the very first time."*

Exercise: Defining texture in a subject

Grape hyacinths

One way of working with salt is simply to place a wash of colour that you see in your subject, apply salt while the wash is still wet and allow it to dry.

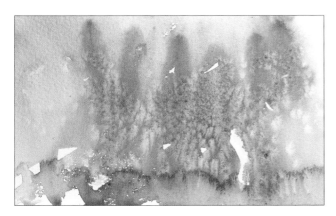

1 Grape hyacinth flowers created by applying salt to a blue and yellow first wash.

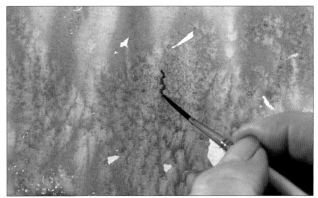

2 When the painting is dry and the salt has been removed, begin to emphasis the subject with defined brush marks and detail as needed.

3 Adding dark against lighter pattern areas creates more drama. Work with the natural salt patterns to show them off to their best advantage.

Tip

Care taken with your application of salt will give you better textural patterns when dry. You want the salt granules to fall individually, not in clumps!

Great connections

"Understanding how to make great connections really does improve your art, in more ways than one!"

When we start painting, we often begin by learning how to paint one subject at a time, sometimes as a study in the centre of a piece of white paper, and it is a great way to learn. But now we are 'hotting things up'! There is so much fun to be had by painting a subject many times within one composition. But each time we paint the same thing it is vital for it to remain unique, each time aiming for something a little more unusual. We don't want to be like a flock of sheep all following one idea and having paintings that all look identical. Which is a great way to introduce this chapter on making the right connections.

Watching Ewe
Stand out from the crowd and be unique!

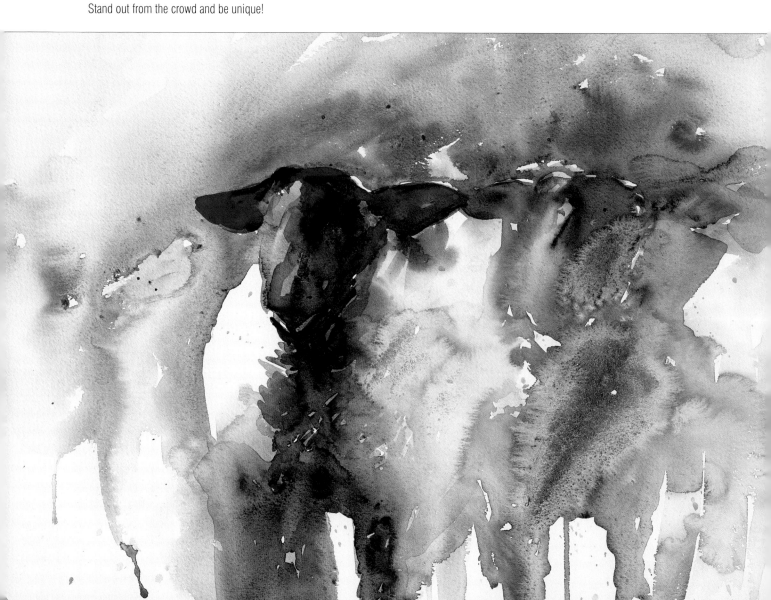

Exercise: Joining subjects together

Ewe are not alone

Imagine a field full of sheep, all with white, woolly coats and black faces. This is a fun exercise to look at how we can join subjects together in a more complex composition. We know from previous chapters that we need to work from a starting point, so the face of one will be the starting point here.

You can link any subjects together with this technique. Understanding how to make great connections really does improve your art – in more ways than one!

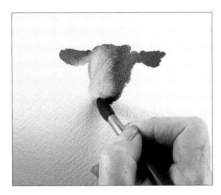

1 Making a starting point with Indigo. I have allowed water to run from one side of the sheep's face to give an illusion of light here.

2 When you are happy with this simple face shape, you can move on to the next addition of colour. A drop of Cadmium Orange adds warmth to the dark face and gives an illusion of sunlight on the subject.

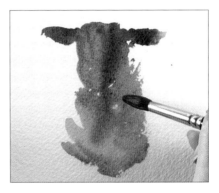

3 Working away from your starting point, move downwards to the sheep's chest, allowing both colours to flow into this newly wet area. Adding violet to the side of the sheep creates a suggestion of shadow here.

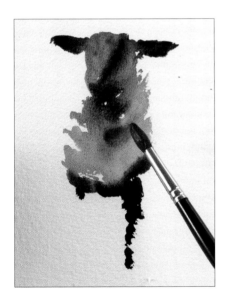

4 Use Indigo to add the lower part of the body and the front legs, and to define the muzzle of the animal. The addition of vibrant Cadmium Orange will give the sheep a glow.

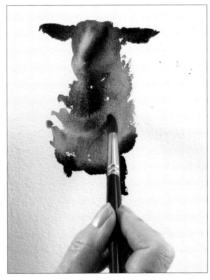

5 Allowing the colours to fuse while still wet will give a soft result. Curved brushstrokes with a clean, damp brush will give the woolly effect of the sheep's coat.

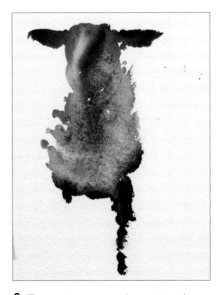

6 The water moves pigment and gives great light effects in curved lines as required here. Use salt on the wet section to create texture.

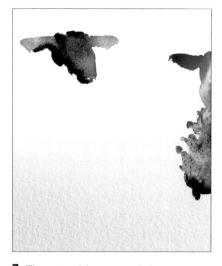

7 Time to add a second sheep, and this time the face will be looking at the first subject for a sense of fun. Adding dark to the face will give character.

8 Add warmth to the subject with a touch of Cadmium Orange under the chin to match the first sheep, and move towards the chest section. Now add the Indigo to bring depth into your new subject.

9 Add the legs. While the pigment is still wet you can redefine any areas you feel need adjusting. Now for the curved brushstrokes using a clean, damp brush to create the rippled effect in the woolly coat.

 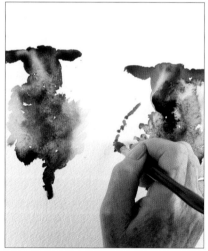 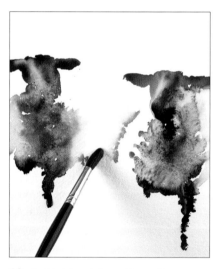

10 To make this second subject look softer in appearance than the main, first sheep, drop water in place to exaggerate the salt effects that will be here. Add salt very carefully.

11 Make a brush mark to hint at the outer edge of the first sheep.

12 Softly bleed the still-wet line away from the first sheep into the body of the second, then take a brush line from under the second sheep's body towards the first sheep to connect the two animals.

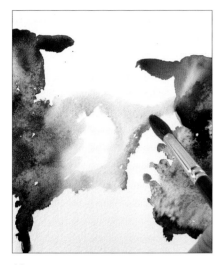

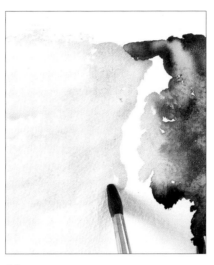

13 Soften some of the same colour to hint at the top area of the second sheep's body. Introduce a second shade for warmth along the side of the body of the first sheep. Turn your paper at an angle to allow colour flow as you do so.

14 Now work on the outer edge of the second sheep, leading it into the background. Bleed colour away with a clean, damp brush.

15 With your paper at an angle, add a colour of your choice in the wet section to the left of the second sheep.

16 Add a bold, new colour on top of the first wash for drama.

17 Turn the paper back to the correct orientation and begin to paint the back of the second sheep to connect it with the first. Work with the negative space by bleeding colour into the background and do not paint your subject directly.

18 Turn your paper upside down and guide the colour to flow into the furthest top corner away from your subjects.

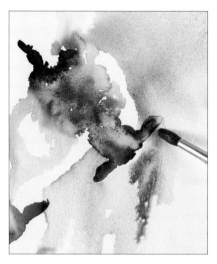 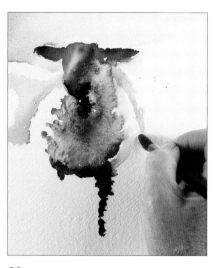 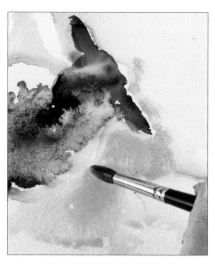

19 Add a stronger colour here to create more impact and remember that watercolours dry far paler than when they are first applied and wet.

20 Turn the paper the correct way up and begin to define the outer shape of the first sheep on the right-hand side.

21 Add strong blue to the new section beside the sheep (I used Sleeping Beauty Turquoise Genuine). Increase the softness in this new section with the addition of water.

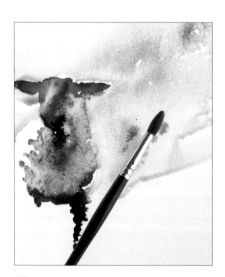 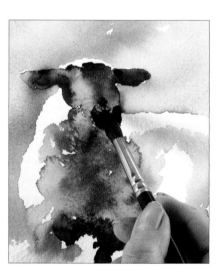

22 Drop warm orange and violet into the new section. By using all the colours you have used within this composition throughout the whole painting, you will gain a sense of cohesion.

23 The new colours look very strong until they dry and fuse. Add salt finely to the new wet section.

24 When the second sheep is dry you can begin to define its face.

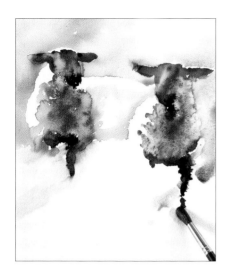

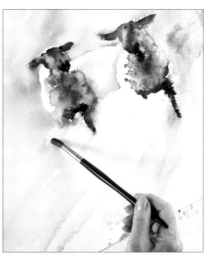

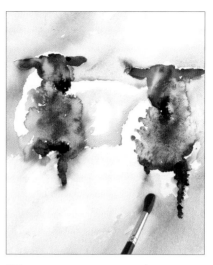

25 Add colour to the legs so that you can fuse this new addition into the foreground section.

26 Allow this new colour addition to flow into the foreground left-hand corner by holding your paper at an angle.

27 You are aiming for a painting full of mystery and atmosphere, so not all the details are added. Sections are deliberately left to the imagination and there is a lovely flow of harmonious colour throughout the varied and textured wash.

28 You can continue adding sheep, but by only hinting at others you will make your main subjects become more of a focal point. A few finishing touches and your painting is complete. Working in this way really is very personal, so only you can decide when to put your brush down. I like this painting as it is, and could easily stop at this stage.

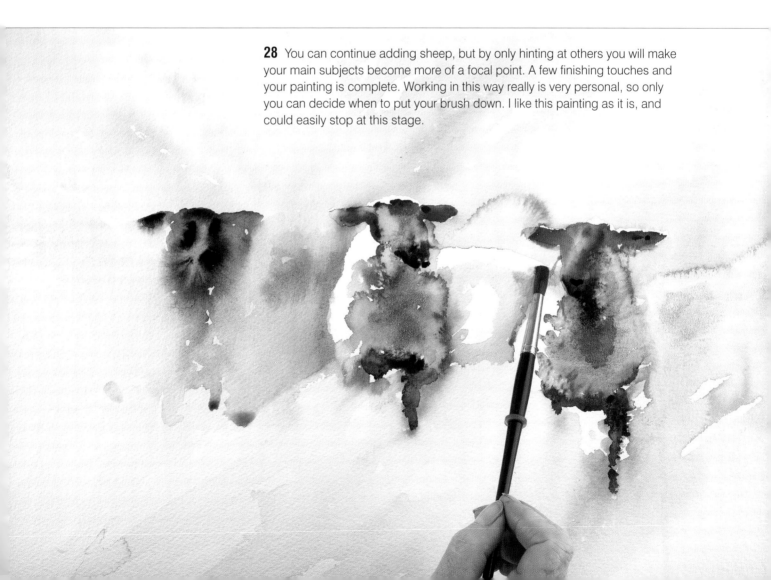

Exercise: Reconnecting in a new session

Bearded Collies

Bearded Collies are a favourite subject of mine, as I own them. I stopped after one session of working and now wish to continue with this composition by adding more dogs.

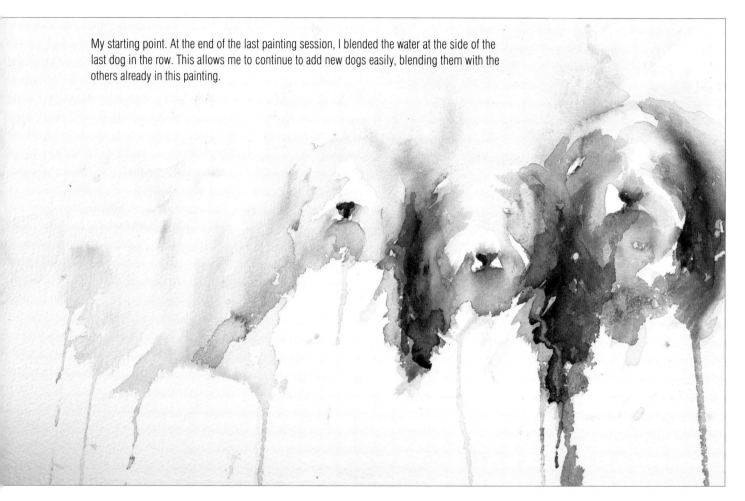

My starting point. At the end of the last painting session, I blended the water at the side of the last dog in the row. This allows me to continue to add new dogs easily, blending them with the others already in this painting.

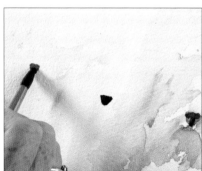

1 I added two more noses to work from as starting points.

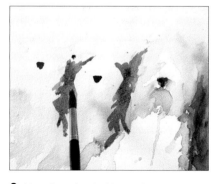

2 Next I worked with positive negativity, applying colour between the dogs to make a connection. Notice the vital touch of warmth added to the very cool blue.

Tip

If you don't want to finish a painting in one session, make sure you don't leave any obvious lines. These can dry into hard marks and it will be impossible to remove them when you start painting again.

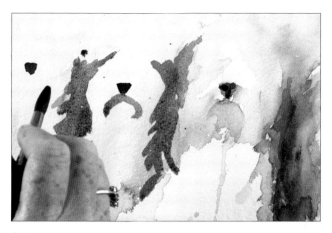

3 Here, the first sign of a mouth is put in place.

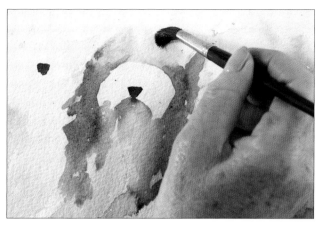

4 A drop of water to soften the mouth and it is beginning to look more like a Bearded Collie. Now I added water with a curved brushstroke to create a soft head shape.

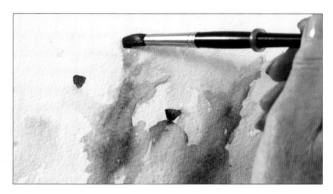

5 Connecting to the next dog's head.

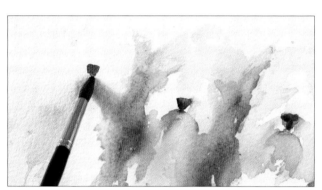

6 Working on the next new dog!

7 Would you stop here or continue to develop the painting further? You are the artist so you must decide.

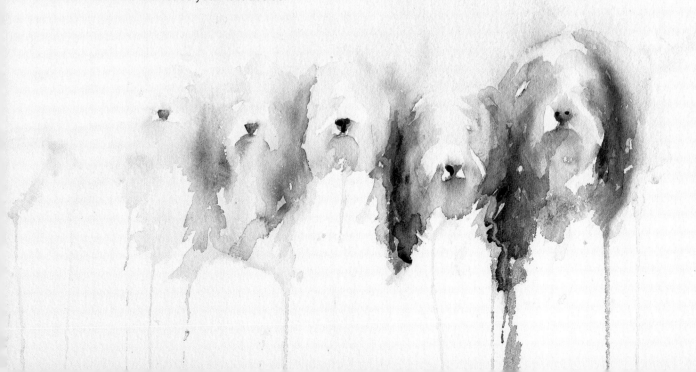

Light and life

"Nudes can be glorious to paint in watercolour because the very quality of translucent pigments works so well for skin tones in a way that heavier mediums cannot match."

I adore painting portraits. Discovering the exact shades to use for different skin tones fascinates me. Over the years I have painted people of all ages and nationalities. Getting a feel for a subject and presenting it in a way that is alive and draws viewers to your work is a wonderful experience.

Choice of colour is vitally important along with how you apply it. If you are too heavy with the amount of pigment you use or the brushstrokes you apply, you could kill the sense of life in your finished paintings. Use light brushstrokes and translucent shades, and allow water to carry your pigment in various directions using water flow techniques to create shape (see step 4 on page 37). Working with a large brush can give a sense of freedom in your brushwork and prevent overly fussy detail which would hinder the fluidity of the result.

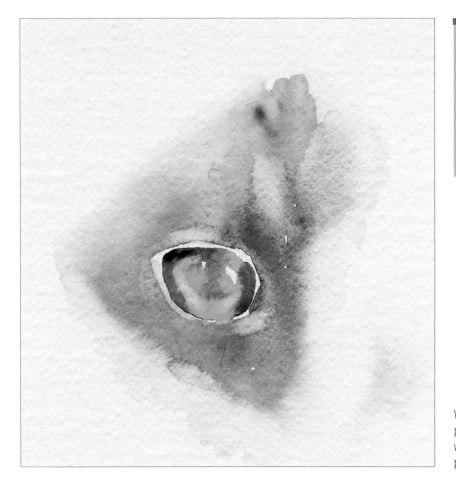

Tip
My Chinese mentor once gave me a very interesting tip. If an object moves, your touch with the brush should be very light. If your subject is solid and non-moving, your brushstrokes and colour placement can be stronger.

Working from a starting point, a simple pet portrait could magically come to life with the wrap technique for the addition of fur as this painting evolves.

Exercise: Capturing a figure in an interesting watercolour wash

La Femme

In this exercise we are going to use whispers of colour to hint at the skin tones and suggest a figure is there. Start with the paper in the vertical position, though your finished piece will be in landscape format.

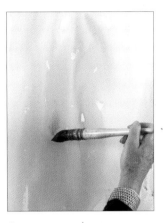

1 Begin by applying a soft, light wash of transparent colour in skin tones, allowing the pigment to flow from the top to the bottom of your paper.

2 You should easily see the paper through your translucent wash. At this stage, begin to identify the outline of the woman lying on her side by painting the curve of her lower back and hip.

3 Blend this colour into the body of the figure and allow the pigments to merge naturally.

4 Move across the paper and allow the soft, translucent wash to continue to flow downwards.

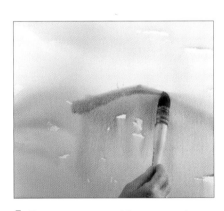
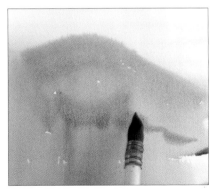
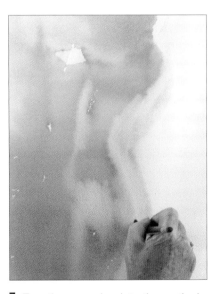

5 Turn your paper sideways and being to define the hip with stronger pigment on the outline of the body. Repeat until the colour seems to flow well in this area.

6 Begin to define the side of the upper leg. Allow the colours to softly fuse together as this is only the foundation for detail to be added at a later stage.

7 Turn the paper back to the vertical position and, with a clean, damp brush, create a line for the backbone. Repeat on the hip outline. Carefully use a sweeping, curved brushstroke to 'mould' the body into shape within the pigment. A gentle touch is vital to achieve a good result.

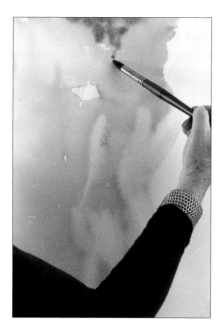

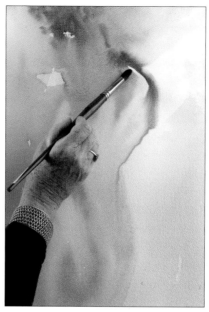

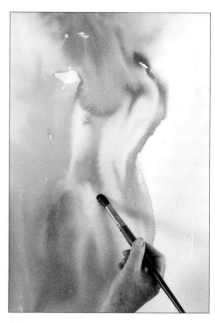

8 Start to add darks for the hair section at the head of the figure.

9 Find the shoulder section and define this area. Drop the same colour as you used for the hair in the outer edge of the shoulder and allow it to fuse naturally. Strengthen the colour, if necessary.

10 Continue this outline towards the waist section. Begin to work on the lower body, adding shadows where needed to create the sense of the figure appearing.

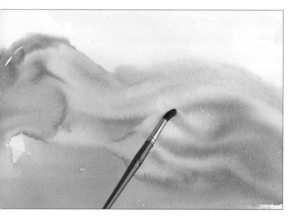

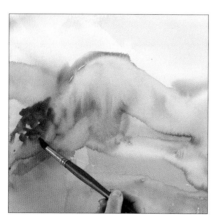

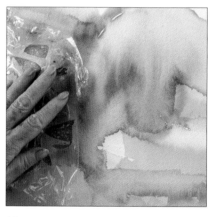

11 Turn your paper to the horizontal position to view the reclining model and decide where to add colour next. Working with the figure, lighten or darken any sections you feel need more definition.

12 Moving back to the hair section, add more colour to contrast with the skin tones. I am using warm shades for the hair as I feel they work harmoniously with the glow that is appearing beautifully in flesh section.

13 Place crumpled plastic wrap (Clingfilm) to create texture in the hair while the pigment is still wet. Push the wrap firmly into place and allow it to dry without interfering at all with the natural flow of pigments and their interaction during this stage.

Tip

Turning your paper at a variety of angles while you work will allow colours to flow naturally into the new, wet sections. This in turn will bring more life and energy into your finished painting.

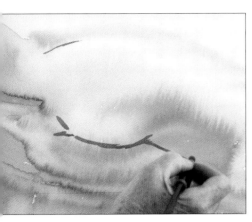

14 Work on the outline of the figure with stronger natural skin-tone pigment. Work between the buttocks, making a subtle curve rather than a heavily defined one. Add the indents at the top of the thigh. Move your brush downwards to continue the line of the upper leg.

15 Soften this new line with a clean brush before adding darks to fuse naturally outwards towards the lower leg. Work along the leg line in the same manner, softening each area and encouraging colour to flow gently downwards into the lower leg.

16 You can break the line to hint at the suggestion of it being perfect rather than leave a solid, defined line in single brushstrokes.

17 Decide which sections need further work, but at this stage allow your painting to tell you what it needs. Take your time and don't race to complete it.

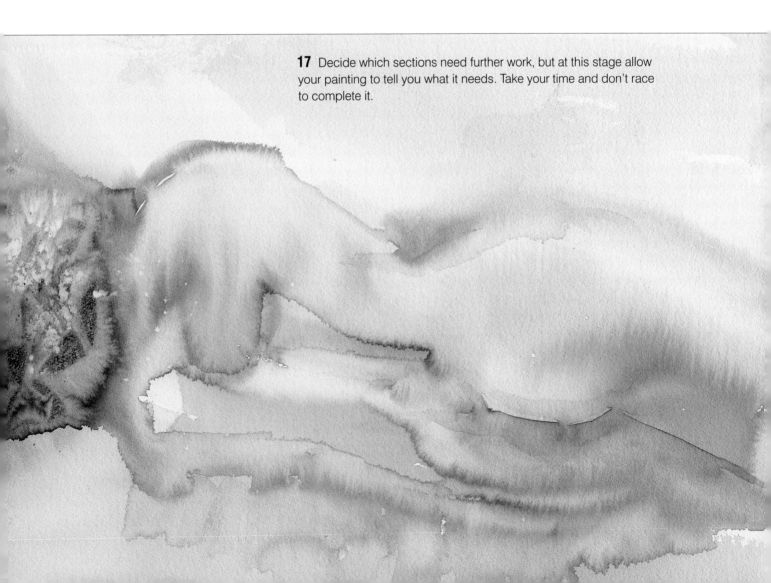

Venetian technique

"Every time we pick up our brushes we learn from the process, and this leads us into much better tomorrows, full of hope."

It's a wrap!

In the previous chapters we have covered many subjects and many techniques, but as I adore Venice it seems only right to include a favourite scene as an exercise here – the Bridge of Sighs. This scene carries many meanings, one of which is that prisoners who walked across the bridge could be on their way to face the executioner. These prisoners would 'sigh' as they crossed the bridge, possibly taking in their last view of the world and of their loved ones. But the story I like most tells of how, if lovers kiss while in a gondola passing under the bridge, they will enjoy eternal love. I would like to think that, by painting this bridge and making a wish at the same time, you will enjoy many years of passionate watercolour painting!

Every time we pick up our brushes we are making marks. These marks are part of our creative journey as artists. Once you have started a painting you can never return to that blank, new piece of paper. The professional artist cannot go back to being a beginner and the beginner cannot return to the day they had never once tried working in watercolour. Many times when you paint you will feel disheartened and you may sigh with regret that you haven't achieved what you originally set out to paint. But every time we pick up our brushes we learn from the process, and this leads us into much better tomorrows, full of hope.

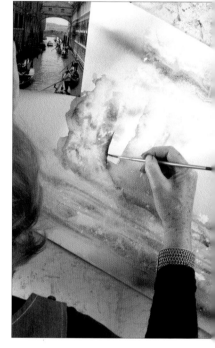

Exercise: The Venetian technique

The Bridge of Sighs

When I started this painting I discovered a new technique that I hadn't even considered before, and I hope you are going to enjoy experimenting with it. I call it the 'Venetian technique' and it is a great way to achieve an aged or antique effect in your watercolours. It involves sprinkling salt on to a still-wet wash in a controlled way, then immediately laying plastic wrap (Clingfilm) over the top and manipulating it to create lines and patterns underneath. The plastic wrap prevents the salt pattern from forming too loosely, so the colour is forced to dry where the wrap traps water, salt and pigment. It is a brilliant technique that can be used for many old buildings and subjects that beg for aged character.

I have used a large piece of paper placed in a portrait position for an upright composition. This gives me far more room to experiment and enjoy each new section and technique within the painting. I will be using the 'four-corner trick' to bring added interest into my work and will start by planning my corner sections first (see page 168). For reference, I am using the photograph (see above right), as well as my memory and imagination.

My first goal is to create two sides of my composition – the walls leading the viewer's eye to the bridge that connects the two. One is in shadow so I will use cool shades for this side and allow the warmth of the opposite wall to add a new dimension to my results.

If I study the reference photograph closely, the figures are hardly recognisable but I do know they are there as this is a spot where I have stood in Venice many times. I am painting largely from memory to bring this atmospheric scene to life. I only want to paint an interpretation; the essence of what I have seen and felt rather than an exact replica of every single detail in this very complicated landscape. I will pick out what is important to me and hope that the next artist painting this scene will do the same. It is this that leads us into creating beautifully unique results.

The cool side

 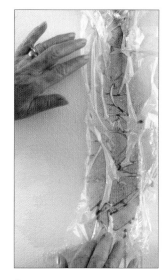

1 Start by adding blue to the right-hand side of your paper and allowing it to flow in a downwards direction. Add violet as this is going to be the cool side of the scene.

2 Do not race to interfere with the pigments' natural flow. Allow the colours to merge well before moving on with the next brushstroke. Add darks to strengthen the colour in the centre of the flow.

3 Now add warmth in the foreground corner. Carefully apply salt here before moving on to the next stage. You are going to trap the salt under plastic wrap (Clingfilm) to create a unique result.

4 Next, strategically place plastic wrap over the still-wet wash so that you can see the pattern forming underneath. It is important not to just lay the wrap on the paper without thinking beforehand exactly what pattern you are aiming to create. Using your fingers, manipulate the wrap to form the lines and shapes you wish to appear in this architectural section.

Tip

You can use this idea of a cool and contrasting warm first wash for many paintings as it makes a wonderful backdrop to a whole variety of subjects.

The contrasting warm side

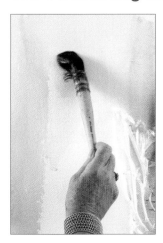 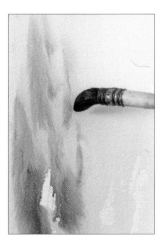 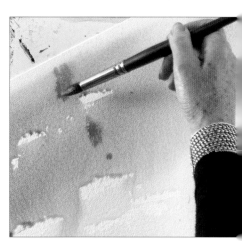

5 Begin to work on the warm side of the scene by adding Quinachridone Gold.

6 Drop in some Perylene Maroon to add warm depth. Allow these colours to fuse naturally.

7 Applying violet here will contrast well with the previous colours.

8 Turn your paper sideways and begin to add colour so that it will flow inwards to the central area of the scene.

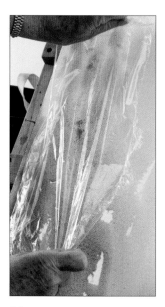
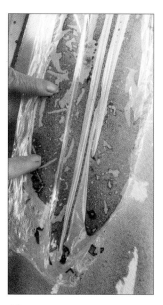

9 Be bold with your colour application in this corner. Turn the paper the correct way up and encourage the now strong colours to merge.

10 Put in hints of windows, which will be built on later. Add salt finely while the pigment is still wet (I will be using this technique throughout my painting when necessary). After the salt application, move swiftly on to the next stage.

11 Very carefully place the plastic wrap on the still-wet surface over the salt so that you trap the tiny granules in places. These will add to the intricate pattern of aging that is about to develop while the pigment dries.

12 Before the wrap is in the final position, adjust the patterns it makes with your fingers to form lines that you can add detail to later. Sometimes a 'happy accident' occurs – can you see the outline of a fish forming? This could quite easily have been turned into a glorious salmon painting instead!

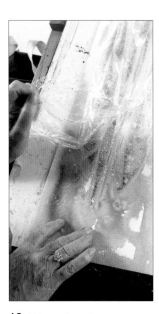

13 When the pigment is totally dry, remove the plastic wrap very carefully, lifting it away from the paper gradually.

14 The salt will have formed an additional texture while trapped by the plastic wrap.

Making a connection

The beautiful arch that I work on next is the connection between the two walls and has many interesting features. It is the section of the painting I have fallen in love with as I adore the textural effects here. It will sit above the Bridge of Sighs in the distance and frame the misty focal point so that the two sections tell very different stories in the finished composition.

The Bridge of Sighs has some sad assocations in its history. My focus in life is always on the happier and more positive side so, to me, making the arch work as a frame for the bridge brings the focus on to something that is far more beautiful and appealing.

Tip

Remember that watercolour is paler when dry, so your initial application of pigment will often look far stronger that you intend it to be.

15 Make the connection with a sweeping, curved brushstroke to form the top of the arch. Begin with cool shades and then immediately drop warm ones in, which is a favourite technique of mine called 'opposite energies' (see page 147). The warm colour floods into the cool, giving fabulous effects when it dries.

16 Develop the architecture by softening the colour as you work. Strengthen the outline by adding gold for warmth and use your brushwork to form downward colour effects.

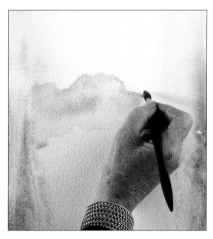

17 Add the wonderful shape on the central edge at the top of the arch. This will form a first-wash foundation for further intricate detailing later on. Extend the top of the bridge with the first cool foundation wash for this section.

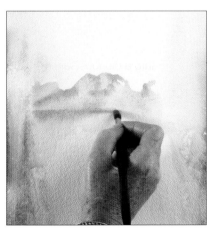

18 Add warmth and allow the new colour addition to fuse and flow naturally into the first cool wash. Add a new line as part of the arch, which will add impact and drama to this section.

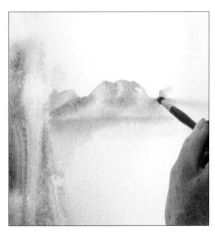

19 Place diffused darker pigment as a base for detail. The pigments will fuse during the flowing process. This happens beautifully if you leave the pigment to work naturally without interfering with it. Trust pigments to work well on their own for far cleaner and more exciting results.

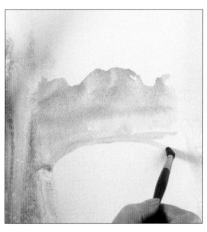

20 Downward brushstrokes with water only will create interesting light effects in this section. Add a line of cool blue to give the illusion of some light shadow under the arch.

Tip

Often artists use far darker colours than necessary for shadow work, which kills the gorgeous illusions of light, particularly in the water reflections so desperately yearned for in scenes of this kind.

21 Strengthen the arch by adding gold where needed, then start to add the windows. I love it when the time comes to begin adding a few features. I am keeping them soft still as I want to enjoy working on them in the final stages.

22 Add a strong shadow line. Notice how I am holding my brush. By working near the sable end I can gain a stronger straight line.

23 Holding my brush at the end of the handle helps me to use very light brushwork for softening colour.

Tip

How and where you hold your brush makes all the difference to the flow of the pigment once it hits the paper. If you put too much pressure on the paper you will diffuse the natural flow and spontaneous reaction when colour hits paper. That particular moment is very important, so be gentle!

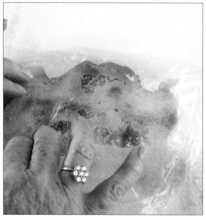

24 Now for the wrapping! First flick clean water on to your still-wet pigment, then sprinkle salt on to the section in which you want the most texture.

25 Place your plastic wrap on top of the salt application but deliberately make some marks with your fingers on the wrap to create shapes while the pigment is drying.

26 When the plastic wrap is removed you should discover a fabulous antiqued result of mottled colour.

Tip

The Venetian technique is a superb technique for creating texture and it gives amazingly beautiful aged effects, depending on the colours you use with it. Try practising on scraps of paper first to see which are your favourites.

27 Begin to add the Bridge of Sighs in the distance with soft colour. Add intermittent darks for interest. Knowing that, in the past, people crossing this bridge never knew if they would see their families or loved ones again should affect how you feel about painting this section.

28 Add the line details and lower arch on the distant bridge, then place strong pigment and soften it at random along the line.

29 Paint a direct shadow line on the left-hand building next to the arch and bridge. Add cool colour to the bridge in the distance, holding the brush near the end of the handle for distant subject colour applications.

30 Turn the paper to work at an angle for greater accuracy, and strengthen the edge of the arch near the cool side of your painting.

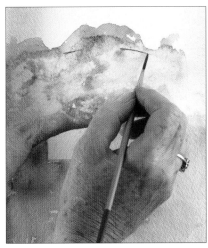

31 Enjoy the intricate brushwork with your fine rigger brush to add gorgeous detail here.

32 At this stage, take a break to enjoy the painting so far. Learning from looking at a half-finished piece of work is vital.

I often see artists racing to complete a painting in one sitting with little consideration for what is actually happening in the creative process. This is such a shame as it really is like jumping into a car and racing directly towards your destination without looking at any of the fabulous scenery along the way. I cannot stress highly enough how important it is to take breaks every now and then to recharge your own creative batteries and allow your eyes to see your work in a fresh, new light. Learn to walk away from a beautiful piece so that you can enjoy it, learn from it and listen to what it tells you it needs in its next stages of development.

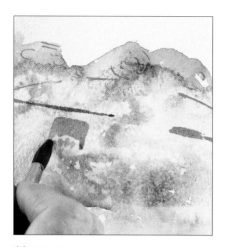

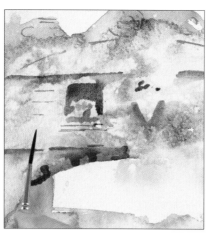

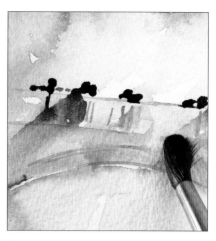

33 Working on the next layer of colour, add detail in a strong opposite shade; cool on top of warm. Add a defined window.

34 Extra lines of architecture can be added now. Use your rigger to add the crest at the centre of the arch and fine lines under the windows. This is the time to study your subject closely and add definition to your painting that you feel will add to its character.

35 Work in hints of figures crossing the bridge in the distance and architectural details with a rigger brush. As the figures are a moving subject, 'blur' them with a sweeping brushstroke using only water applied with a no. 10 brush.

Tips

Always work in opposite shades on layers for added impact, and use the same shades for diffused drama.

Always have an interesting mix of horizontal and vertical lines in your compositions to gain as much interest as possible (step 43).

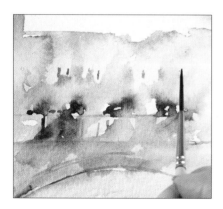

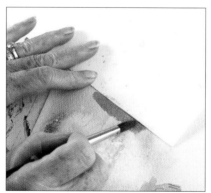

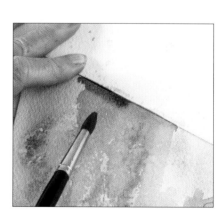

36 Bravely diffuse the figures into the background so that they merge here and are not too defined. Diagonal brushstrokes using a clean, damp brush will give a feeling of movement and a hazy, undefined atmosphere in this section of the painting. Use a rigger to add hints of windows on the distant buildings.

37 Lay a clean sheet of card on the paper so that you can paint an accurate roof line on the top of the warm side of the composition.

38 With the card still in place, work the warm pigment away and downwards to create a new layer of colour on the warm side of the painting. You can return and add stronger colour to flow at the top edge while the card is still in place.

39 When the pigment is completely dry, remove the card to reveal a beautifully glowing fusion of colour, creating a gorgeous feeling of warmth and light. The 'patternisation' created by the Venetian technique is now evident throughout the painting, giving it a wonderful ancient feel.

40 Add a second line of interest above the first using another piece of clean card. Diffusing colour between the two lines and encouraging watermarks creates even more texture and interest, and gives an aged look.

41 Add long, atmospheric brush marks on the warm wall for hints of old windows that could tell stories if they could speak. Add windows only where you feel they will enhance your painting so they will not detract from your textural Venetian effects.

Tip

The painting at this stage is looking good and should be a pleasure to work on. If what you are working on makes you feel unhappy, put it down and move on to something new. Never let a bad result get you down as there is so much more to paint that could make you feel excited and happy.

42 Now it is time to add interest to the cool wall on the opposite side of your painting. Add an interesting balcony with strong blue pigment. Loosely merge the strong, new brush marks into the initial wash.

43 Sideways brushstrokes not only blend the new colour into the wall, they also create an interesting contrast with the existing downward brushstrokes. You should now have created a very soft, hazy effect by working over your initial strong colour application with a clean, damp brush, and it is time to move onwards in the painting.

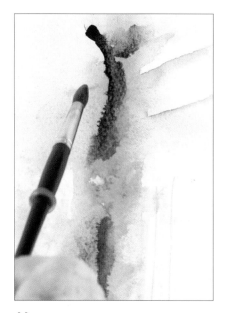

44 Whispers of colour hint at architectural lines on the walls. Work on your second layer of the balcony, adding colour and detail to the cool wall.

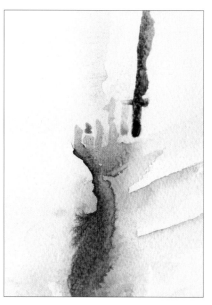

45 Using Quinachridone Gold now will give a glint of light to this dramatic part of the composition. Work upwards and away from the balcony.

46 Beautiful lines on top of the whispery wash will enhance this section. Use strong Quinachridone Gold and Indigo to create this gorgeous, contrasting glow.

Tip

Use soft and strong colour applications as bold contrasts. Whispery colours against very bold ones look fantastic when applied wisely.

47 Add a cool purple as a base colour for the foreground of this cool wall corner. Next, drop Quinachridone Gold into the purple and allow the two shades to fuse. Tilting your paper to the angle in which you wish the colour to flow will give a sense of directional light in this area.

48 The painting at this stage, with the directional flow showing on the cool side.

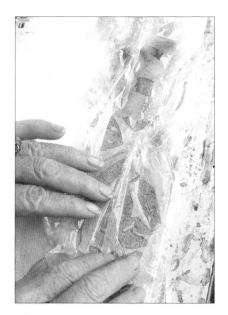

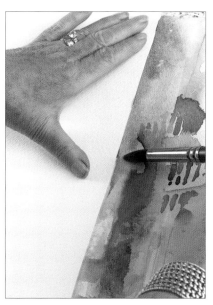

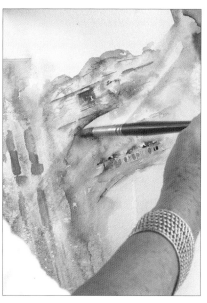

49 Sprinkle salt on to the new wet section and merge the colour into the white space so as not to leave a defined line between the two. Lay on the plastic wrap and gently make patterns with your fingers where you wish the shapes to fall when dry.

50 Add definition to the blue wall by laying card on the paper to allow you to paint a straight edge.

51 A sweeping movement with a clean, damp brush connects the wall to the opposite side.

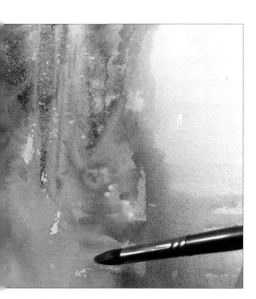

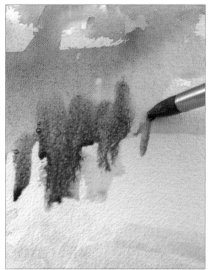

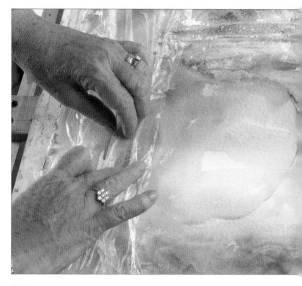

52 Working in the warm foreground corner, drop in darks for watery reflections. Use sideways brushstrokes to create contrast to the verticals of the walls.

53 Turn the paper sideways and add strong greens for weather-worn walls that have been affected by the canals of Venice over time. Have fun applying colour and allowing it to drip and run as a base for the Venetian technique.

54 Lay plastic wrap across the base of the painting for the canal's watery ripples. Apply the wrap carefully for large patterns in one section and smaller patterns in another.

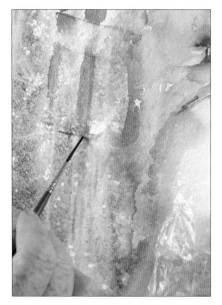

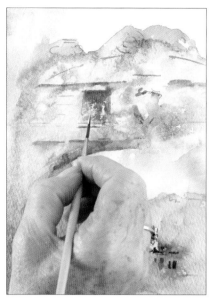

55 Add definition to the windows on the warm wall to finish this section.

56 Always look at your paintings when you feel they are complete and then add the very last touches. This is a time when you can overwork, but if you can already see your bridge you know you need to stop soon. Here, I am working detail into one of the windows of the arch.

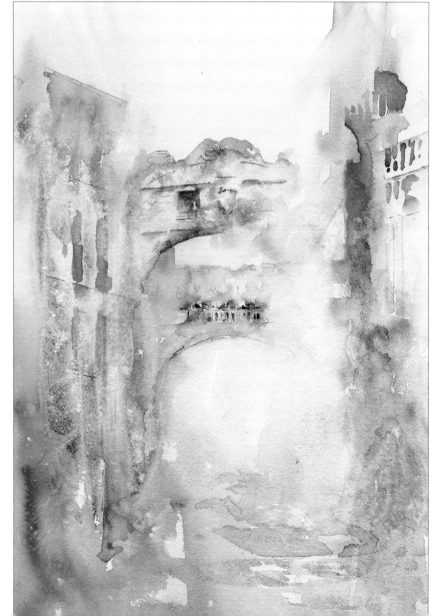

Of course, you can work further on this piece. You could add gondolas in the foreground, or more fabulous architectural features. This exercise is purely to guide you into using your own imagination when painting amazing scenes that are full of interest, drama, texture, light and life, and to show you how to use the Venetian technique for aging, opposite energies and opposite energy layering.

As you grow as an artist you may develop your own personal techniques. I do believe there are many terrific discoveries yet to be uncovered while using watercolour, and you could just be the one to find them.

Opposite energies technique

In step 15 on page 139, I dropped warm tones into cool ones. This is a favourite technique of mine, called 'opposite energies'. The warm colour floods into the cool, giving fabulous effects when it dries. Try this exercise on scraps of paper. While your pigment is still wet, try dropping cool colours into warm and vice versa to gain gloriously unique wet-into-wet results.

There are times when you will come across an area within a painting that seems too warm or too cool. Placing a layer of the opposite colour on top of the section that needs warming up or cooling down will correct an area that could otherwise completely detract from your subject or ruin your results. By learning how to deliberately introduce opposite cool and warm colours you can determine the energy within a painting from the minute you pick up your brushes. Alternatively, when you have completed your watercolour you can place a layer of warm or cool colour in a small section to create opposite energies.

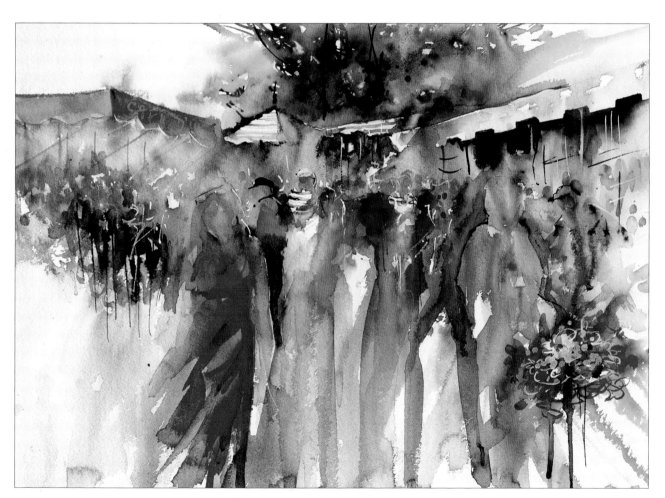

Tip

This technique can be used as a wet-in-wet method or while working with a new, fresh watercolour layer on top of an already-dry first wash.

Le Marché des Fleurs

A combination of bold and quiet colours creates interest in a composition. Study your completed watercolours and learn from them to improve your own style. Imagine where stronger brushwork could add to or detract from a scene. Consider which techniques will bring life and drama to your results. Leave sections to the viewers' imaginations so that the contrast against detail is greater. Find a way of introducing a flow throughout your compositions to add harmony and a feeling of movement, leading to a fabulous sense of dynamic energy in your finished pieces.

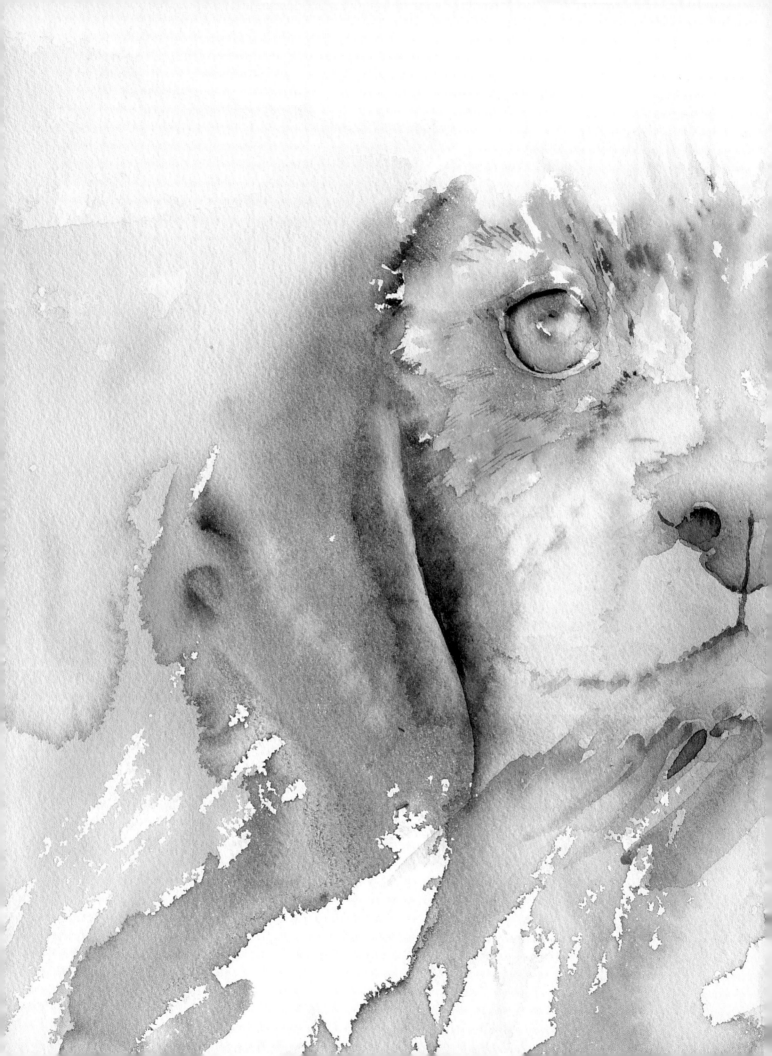

Inspirational Touches

Evolving as an artist

"I believe everyone should have a dream and I also believe dreams can come true."

Learning a new skill is a road many people take at various times of their lives. We learn to walk before we can run. No one would expect to jump into a car and drive it without any form of instruction first. Over time, experience helps a new driver to face many journeys to a variety of destinations which have been undertaken for a huge number of reasons.

Getting to where they wish to be in life is really important for many people. For others, having an adventure and encountering the unexpected can often be far more exciting. When working with watercolour, it is often the unknown, unplanned-for outcomes that appeal to the artist who loves a feeling of spontaneity and freedom.

For some, the need to see where they are heading with their art is not so great, while for others a goal is really vital. Many artists have dreams that they feel they desperately need to reach. In the final section of this book you will find more information and tips aimed at helping you develop your own style, grow as an artist and paint beautiful compositions that truly are original.

I believe everyone should have a dream and I also believe dreams can come true. If you want them to hard enough.

Starting to See the Subject

There comes a point in every artist's journey when they really feel they can see how much they are improving and how far they wish to go with their style. Always be observant and learn from your own art as much as that of other artists. You may find you are your own best teacher.

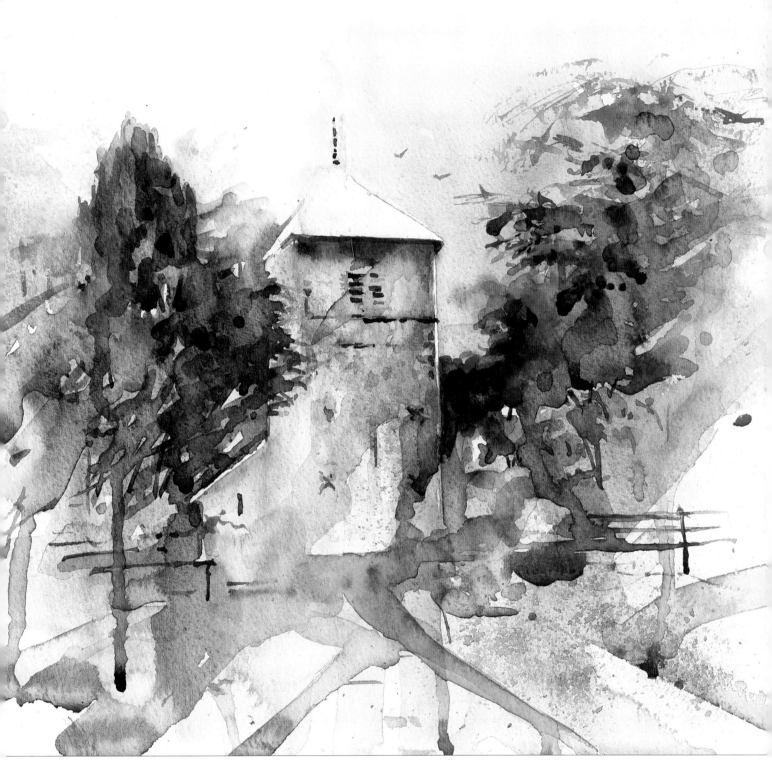

Follow Your Dreams

Want to be a great artist? Then what are you waiting for? Pick up those brushes and get started on a journey of discovery that could last a lifetime.

The final touches

"Knowing when to stop is going to be your biggest lesson as an artist."

There comes a point in every painting when we have to put our brushes down and admit our painting is complete. Sadly, this is the time when many artists discover they have overworked their piece, which is a shame when the beginning is often so exciting and promises a great result. We have looked at stopping long before a painting is complete and assessing whether or not it is finished, but we haven't yet discussed how to add those final marks to make a painting feel more alive, finished and with that extra touch of detail.

When to add the final touches

When you can see your subject begin to emerge it really is a time to enjoy and also to be cautious. At this stage in a painting's development, I suggest always adding one brush mark at a time. Then patiently wait to see if your painting really does need any more touches. Ask yourself when you are nearing the end of a painting whether you are now working just because you are enjoying holding the brushes – are you really denying that your work is done? Many new artists are so excited when a painting goes well that they get carried away when it really is time for them to stop. By continuing to paint they often ruin what could have been something magical. So take time to step away from each piece you create and decide if you really need to add any more. Do not race to complete a painting. Learn from each stage in the creative process because knowing when to stop is probably going to be your biggest lesson as an artist.

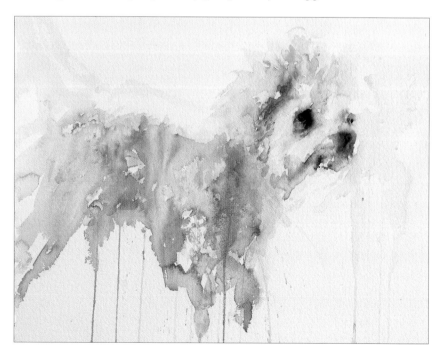

Mama Mia

A little Bichon Frise dog, painted during a demonstration while I was taking workshops in Norway. I stopped at this point to enjoy the way the little dog had developed during the creative process, and I am still enjoying this stage so I haven't worked any further on the painting.

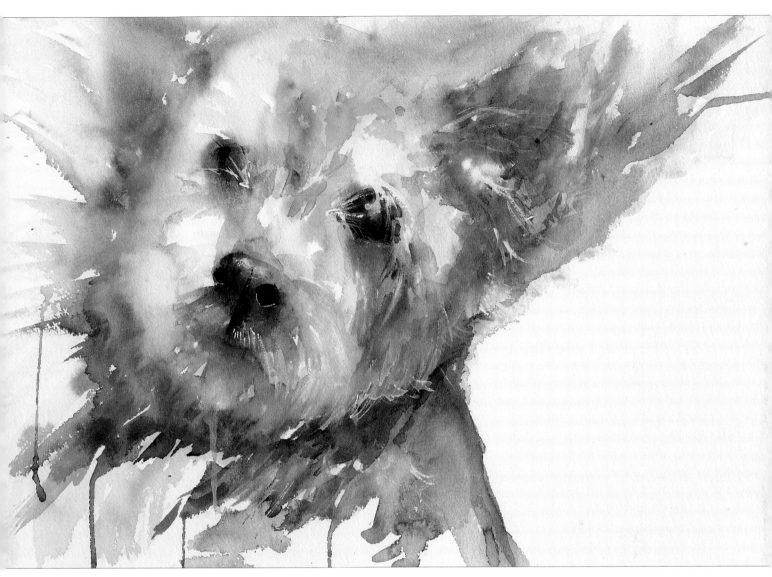

Walkies

Final touches were added in the form of the nose and fine lines to represent the hair. These were all that was needed to complete this painting of a gorgeous little Westie. A larger version of this painting appears on pages 6–7.

Knowing when to stop

If you look at the painting of a West Highland White (Westie) above, you should be able to see the difference you can make by adding a small amount of detail to complete a painting. The painting above is full of atmosphere. The nose was very important to me, and the feeling of soft, fuzzy, white fur. I have tilted the head at an angle to give the impression of an inquisitive little character ready to go out for a walk or receive a treat. The finishing touches here were simply a few lines for the direction of the fur, and bold touches of colour to strengthen the nose and eyes. These really were all the painting needed. I stopped long before I overworked the piece.

Adding detail

The secret to any good painting is adding the right amount of detail to tell the story without taking away from the beauty of the first stages of development. In the painting 'Purrfectly Spoilt', the ears, nose, eyes and whiskers of the cat tell the story. That was all the definition I needed to create this simple piece and the effect I achieved from leaving out the complete outline is really interesting.

Purrfectly Spoilt

Simple detail for the eyes, nose, ears and whiskers bring this cat to life. Limited use of detail can be very effective so be careful not to add too much!

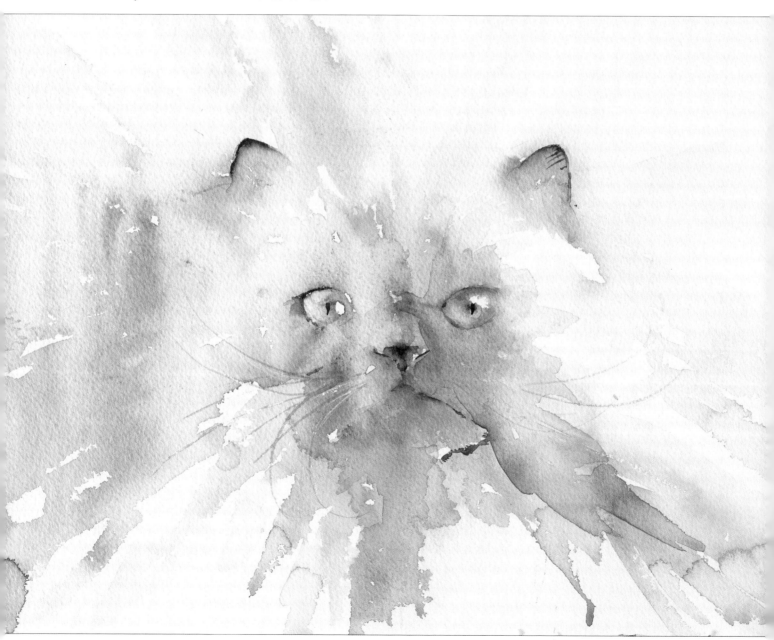

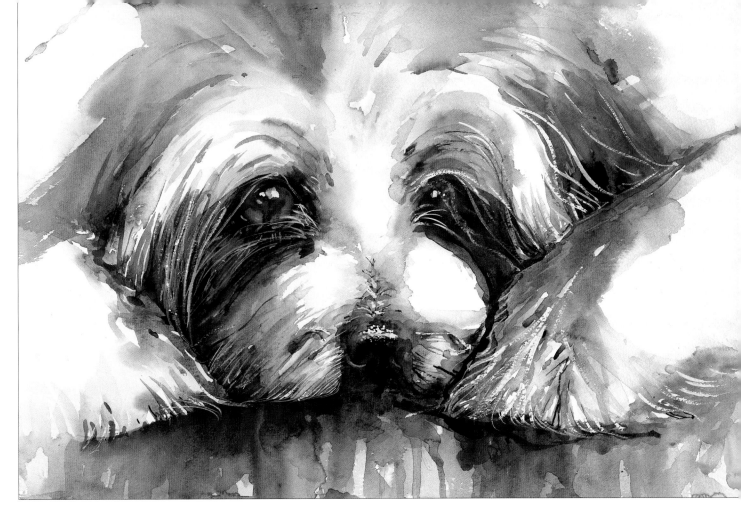

Please Don't Go

Sometimes, walking away from a painting is the best thing you can do, however difficult it may be!

Tips on adding detail to a painting

- Add only half the amount of detail that you think you need.
- Add your final touches one at a time. Step back from your painting in between each one and let the picture tell you if it really needs any further brushstrokes.
- Take a break. Look at your work with fresh eyes the next day rather than race to finish a painting.
- Avoid overworking and do not make your compositions overly fussy!

Walking away

Knowing when to walk away is very hard for the new artist and often even more-experienced artists have a dilemma in the last few stages of a painting's development. Often the problem is that we are enjoying a successful painting so much we just don't want to admit our work is really finished. We want that gorgeous high of a fabulously brilliant panting to go on and on forever, but this is the exact time to put your brushes down and start a new piece, pulling that adrenaline rush of a great result into your next successful watercolour painting.

Atmospheric illusions

"Opening up our creative ability, exploring all the options of how we can turn something simple into something much more exciting, is the most brilliant of all lifetime highs."

Subtle differences

Taking time to study the techniques in the previous chapters can give us an insight into how to create illusions in watercolour, and add a sense of movement. Understanding the importance of soft and hard edges and how, in combination, they can add a sense of undefined excitement to a painting is a valuable asset for any artist who wishes to add atmosphere to their work. We are not aiming for ordinary results, we are aiming for the extraordinary; paintings full of life and energy that, without the techniques described in the previous sections, would be impossible to achieve.

While you build up your knowledge of each watercolour secret, tip and technique held within these pages, begin to imagine how you can improve on each one so that your own work becomes even more incredible. With each finished piece, aim to take the viewer's breath away.

Look closely at the painting of baby owls below. Study the soft and hard edges; the sections that are less defined add mystery. Watermarks add fascinating interest, as do unusual colour combinations and fusions. Subtle brush marks define detail where needed. There is a sense of illusion as to what is and is not there. The variety of techniques used in this composition makes this painting far more exciting than if every single detail were in place.

Only by experimenting with techniques can we discover ways to create beautiful paintings that seem full of life, atmosphere and mystery. Sometimes the half-finished painting can say so much more to the viewer than one that has every single detail in it.

Baby Owls

What we leave out in a painting can add drama and create intrigue, but there is a limit as to how far we can go with omitting sections of a subject. Look at the painting below. The half-finished owl on the right is full of mystery, but can you make out what the subject is? Gradually the left-hand owl came to life on paper, but only when more definition had been added.

The study of an owl's eye (right) was a small, simple demonstration which I thoroughly enjoyed creating during a workshop. It has sat unfinished since that day because I still learn so much from this tiny piece of work. It is full of watermarks, evident brushstrokes and obvious use of water as well as pigment. Had I not mentioned it was the eye of an owl, I doubt many readers would have worked out what it is. And yet it appeals to me.

There is a limit to what is and what isn't an unfinished painting. Learning when to stop is the hardest part for many artists as they tend to overwork. Underworking, however, can also lead to problems.

Creating atmosphere by underworking

It is wrong to assume that leaving details out is the only way to add a sense of mystery and create a form of illusion. However, it is a wonderful way to invite viewers to use their own imagination and 'fill in the blanks'. In my workshops, I often have limited time to complete a painting. Many of my pieces are left at the half-finished stage for my students to enjoy and learn from. Only later, when I return to my studio, do I realise that many of these half-finished pieces actually are finished; I love them as they are. This has led me to discover my personal style, which has often resulted in subjects being half-painted, leaving much to the viewers to fill in – and they enjoy doing so.

Over the years, I have noticed that some pieces look far better with more detail and others definitely looked better without. Observe the strength of colour in 'Babes Too' and compare it with the softness of the two previous paintings of owls. Here, nearly all the information is included, not much is left to the imagination, and the baby owls can be seen very clearly. Compare this with the first painting of owls, with so much missing from the finished composition.

Study of an owl's eye, showing colour fusions and brushstrokes.

"The smallest of differences in how we work can make the biggest impressions on our style and the amount of atmosphere we pull into our paintings."

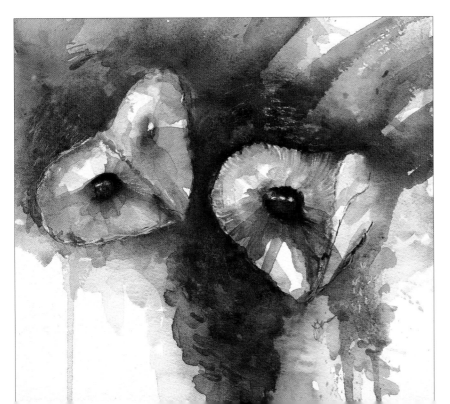

Babes Too

An example of the heavier use of watercolour, making the faces of the subjects appear.

Breathing life into your results

Now imagine painting action scenes that include moving subjects such as athletes, animals running or people walking, all with selected sections missing and left to the viewer's imagination. It is easy to see how our work can become absolutely fascinating and full of atmosphere. We can use these techniques and styles of painting for both simple and complex compositions.

As you grow as an artist you develop a thirst to achieve more. An inner energy awakens and you begin to comprehend that everything you see, from a simple vegetable in the kitchen to the most complicated of landscapes, can become the most magnificent of paintings.

Undefined definition?

We need to examine the difference between working in a loose style and working in a more detailed way. Artists who prefer realism may aim for perfection by masterfully adding every single detail to a composition. The artist who works minus a preliminary sketch often has to fall back on tricks and 'watercolour secrets' to achieve a successful result. This way of working can often lead to unique paintings, steeped in atmospheric washes and masterful techniques that really bring their subjects to life.

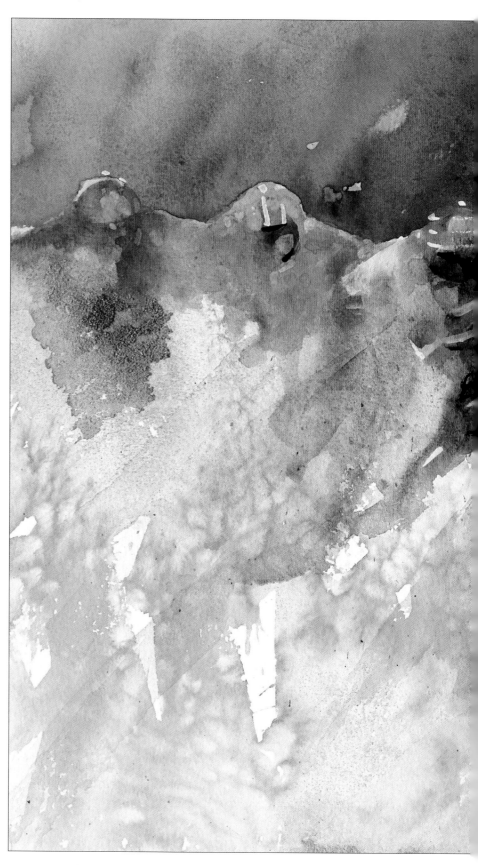

Racing to Win
This painting of a horse-racing scene is built up of layers of colour, and many sections are left to the viewer's imagination.

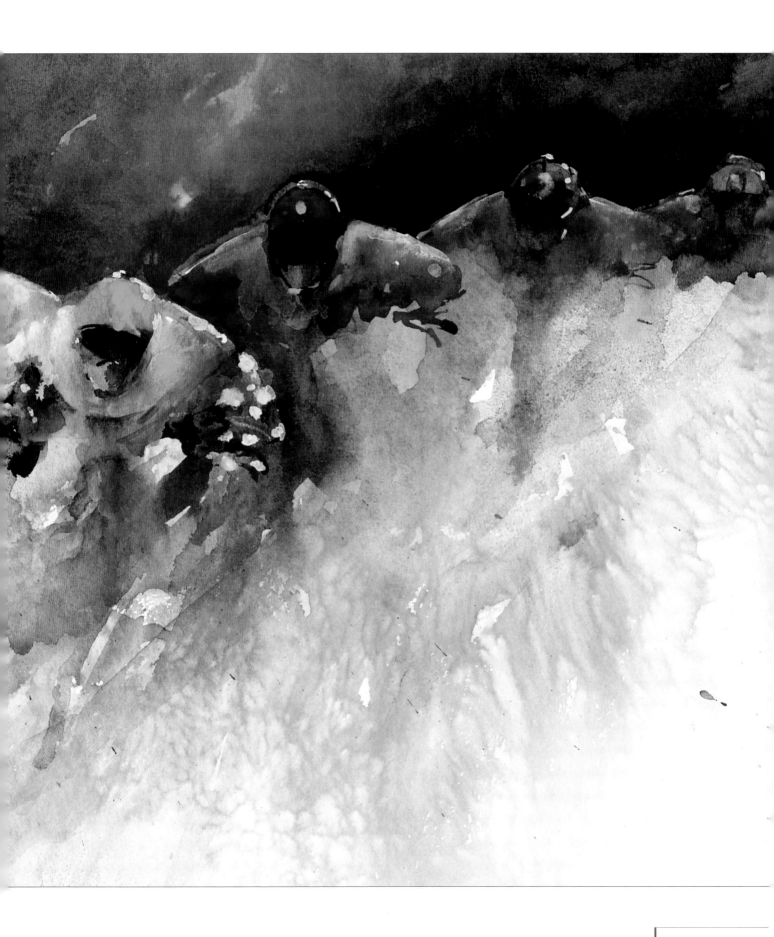

Capturing the essence

"We are forming an illusion of what can be seen by the unseen."

Have you ever listened to someone telling you a story and you have found your mind drifting because the narrative was taking too long or you were becoming bored? It really can be an embarrassing situation when all you want to do is walk away and find something or someone far more interesting. Isn't that exactly what we do when we visit an art exhibition? It isn't quite so awkward as you can easily walk past the art that doesn't appeal to you and enjoy the paintings that do. When we visit a gallery, we will all be attracted to very different pieces. I wouldn't expect an artist who enjoys paintings full of detail, for example, to be interested in my work but, strangely enough, that is happening. I have many art friends who paint beautiful, exquisitely detailed masterpieces, but they are as fascinated by what I leave out of my work as by what I put in, if not more so!

When I paint I am telling a story but with as few words as possible. I am aiming to capture the essence of my subjects alone. I want to gain a feeling of excitement and life in my results by not putting every detail in, and for everyone looking at my finished paintings to enjoy filling in the missing sections for themselves. I want to avoid being like the most boring of story tellers; I want viewers of my work to come back for more, not walk away uninterested.

So how do I do this? First, I fall in love with my subject and try to paint it in a simplified way, using colour to set the atmosphere and directional brushstrokes where appropriate to give a sense of movement. The small study of a Spanish lady's face (above right) has very little detail in it but you can recognise what it is.

There is so much missing in my painting of a flamenco dancer opposite, yet the story is all there. The dress is moving, as are her arms. But wait, are there any defined arms in my painting? On close examination, is the skirt of the dress defined? In fact, I have merely placed colour with the slightest hint of detail here and there. This, to me, is what capturing the essence of a subject is all about; just reaching out and painting the spirit of what you feel and see. There is an air of mystery about a scene that leaves something to the imagination, almost as if we are forming an illusion of what can be seen by the unseen.

Tips on capturing the essence in a painting

- Stop long before you think you have finished your painting.
- Avoid painting all the detail by choosing what is and isn't important.
- Deliberately set out to paint half of your subject!
- Allow colour to set the mood so that only the minimum of defined sections are needed in order to complete your first wash.

One of the most exciting outcomes of painting in this way is that you can never create exactly the same result again, which is, to me, what makes this style so exciting!

Spanish Lady
Hints of a subject from colour placement alone.

Spirit of the Dance
There is hardly any detail in this composition and yet a sense of excitement and movement is evident, purely from colour placement and directional brushstrokes in a dramatic composition. Often viewers are more fascinated by those details that are left out of a painting than those that are actually included.

Capturing more of the essence

"Not all paintings have to be framed, nor should they be on the road to success."

If you wish to paint figures, try painting a few small studies like these each day. You will soon improve as an artist while learning how colour and shapes can interact to make a larger, more complete painting, full of unique sections and effects.

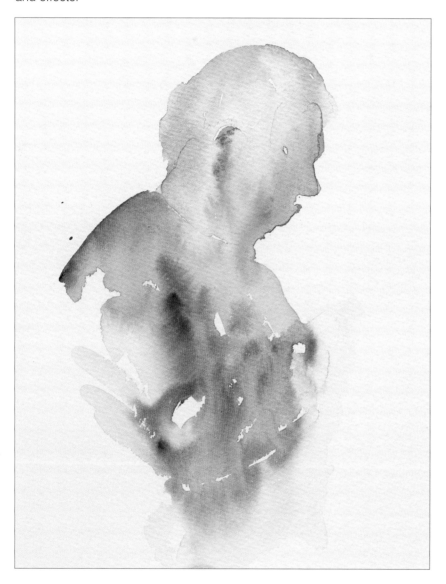

Tip
Many new artists make the mistake of painting an overly large head, so err on making the head section smaller than you think at first until you get the proportions absolutely right.

Mending Nets

This quick study is of a fisherman in Portugal mending his nets. I stopped as soon as I could see my subject begin to appear and allowed colour fusions to create interest. Look at the ear. It really is a simple watermark and very effective. Water flow techniques have really helped in this very quick exercise.

Exercise: Painting figures

Choose any figure, and observe colour and how the light hits your selected subject. Then, on a scrap of paper, play with your personal shade selections for the flesh tones, garments and backgrounds. I have chosen Alizarin Crimson and Yellow Ochre in a very dilute first wash for the face of this gentleman.

Get a brilliant beginning and build on it, but do not race any stage of this painting as you will learn so much from getting every colour application and brushstroke correct. If you love a section you can choose to strengthen it if it is too quiet in colour but, if you hate a section, simply drop a little clean water on it to confuse the lines and detail of your 'mistakes'. These mistakes will be a part of your journey to being an even better artist, so make as many as you can and love them for what they can teach us. Personally, I make 'mistakes' deliberately as I hate boring paintings! All my watermarks are exciting successes not disasters, as I set out to make them on purpose.

1 Make your first brushstroke where you wish the subject to be placed on your paper (see 'working from a starting point', page 84). Decide if your painting is going to be a portrait or a landscape composition. Make sure you start well into the centre of your paper to allow room for your subject to grow without getting too close to the paper edges.

2 Quickly soften the edge of your starting point on one side only and gently bleed the colour downwards into what will be the facial section (see page 36). Observe your subject closely so that you understand how large the face will be in proportion to the hat or body as your painting progresses.

3 Building up the subject by adding details such as the hat can really create interest, so move away from your starting point. Remember to leave white spaces on your paper to represent light.

4 Working with a clean, damp brush on the previously placed flesh tones with a simple brushstroke can lead to beautiful fusions. These could form an interesting ear shape later on, for example, without you having to paint one.

5 If you see an area you like, then improve it with an application of stronger colour tones. I have used the same flesh tones but with more pigment to add a suggestion of shadow under the hat.

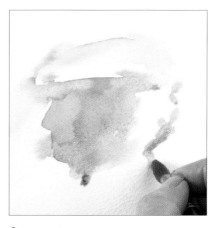

6 Now use the positive negativity technique (see page 91) to form the back of the head. Blend this section with the background to gain a feeling of movement.

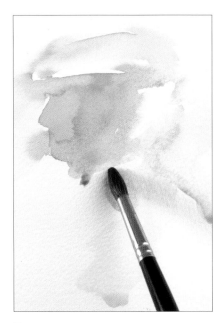

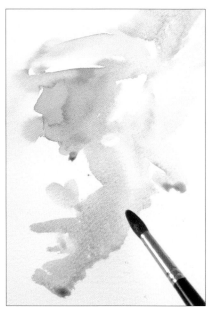

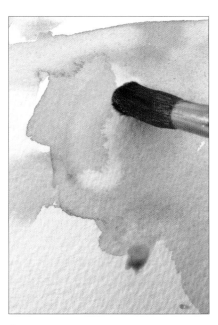

7 To add life and the illusion of possible movement, soft edges are invaluable. Work downwards softly towards the shoulder and neck but still keep all sections very soft until you are sure of where you wish to add definition.

8 If your first wash looks great, from here it is a simple journey to the complete finished painting. At this stage, if you are not happy with your result simply stop and try again.

9 A close-up of further definition added with a simple brushstroke to the face. One downwards movement of the brush with a lift will leave pigment to puddle and dry on the cheek – a great tip for adding unusual facial features!

Hotting it up!

Now we are ready to go for bold colour and have even more fun. Soft first washes are magical to build on, and as your subject appears in them you will reach a point when you are desperate to add strong colour and bolder directional brushstrokes. In this exercise, that time has come!

10 I love this part of creating a painting! The face is looking brilliant so now I can work downwards to the body by adding clothing. Beautiful Daniel Smith Sleeping Beauty Turquoise Genuine is the base for the man's sweater. It will merge with my flesh tones well and I won't be interfering with what is happening as the colours dry here. I can then add strong colours on top of my first directional brushstrokes to indicate the curve of the body.

Tip
An empty bin means you are not practising enough to be a great artist!

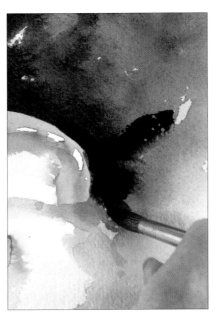

11 When the first wash of body colour is dry you can add really strong brushwork and lines to create depth and interest to the man's body. Try not to overwork this detail. If something looks wonderful, stop and enjoy it; too many lines and too much fussy brushwork tends to ruin what could be a fabulous painting.

12 Positive negativity really comes into its own when used with very strong pigment application. Just look at how stunning the strong placement of Indigo against the negative outline of the hat looks! Isn't it wonderful? When the first application of Indigo has dried, go in with a second, almost neat application of colour and bleed it away. The impact is positively stunning!

13 Here, you probably believe that the first placement of the head will be the actual head size in the finished painting. In fact, I have used a second negative outline to include my first wash as part of the head. This forms an almost three-dimensional effect (see the tip below).

Tip

Making a second negative edge on a previous outline, incorporating the first wash, can lead to a fantastic three-dimensional result.

14 The painting is complete. You can see the man easily in an atmospheric background. The goal was to capture the essence of the man and gain a feeling of light, and this goal has been achieved. You could add more if you wished to, but the aim of this exercise was simply to paint a hint of your subject and produce a unique result.

This approach to painting figures is highly motivating, so try it with older people, children, dancers or sportsmen and women. See just how much movement, life and light you can gain in each new study. You will improve each time you pick up your brush.

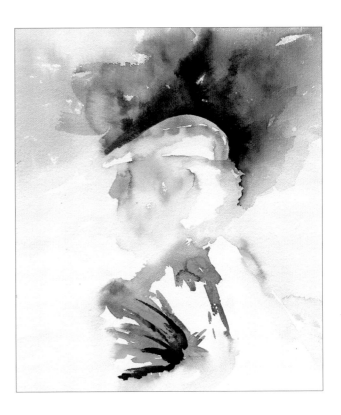

Composition

"Creating atmosphere with exciting colour and directional brushstrokes in the right places can produce a very beautiful composition."

Before you begin any painting, it is wise to consider how best your subject is going to work in the completed composition. You have important choices to make to ensure that your subject looks wonderful and isn't the result of a 'happy accident' with no initial planning. My Shanghainese mentor always told me to close my eyes before I even picked up a brush and imagine the finished painting first, then to try to paint what I saw in my mind. It is a wonderful tip that I have used every day.

The first consideration is that there are two basic formats; you can place your paper horizontally, as in a landscape format, or vertically, which is called a portrait format.

Landscape composition

In my painting of an autumn hedgerow (below) I have selected to have a branch of berries across the paper, which is in the landscape format. To me, this looks very natural as the branch was growing this way when I first saw it. I have allowed nature to give me a hand in choosing how to paint what I saw.

Autumn Hedgerow

An autumn hedgerow with a laden branch of blackberries painted across the paper in a landscape format. Use of plastic wrap (Clingfilm) on the first wash gave a subtle texture effect; twigs in warm and cool colours give an illusion of distant branches, with more defined ones sitting among them in the foreground to add interest. Sections are left to the imagination. For me, this painting epitomises a day of blackberry picking to make gorgeously sumptuous blackberry jam!

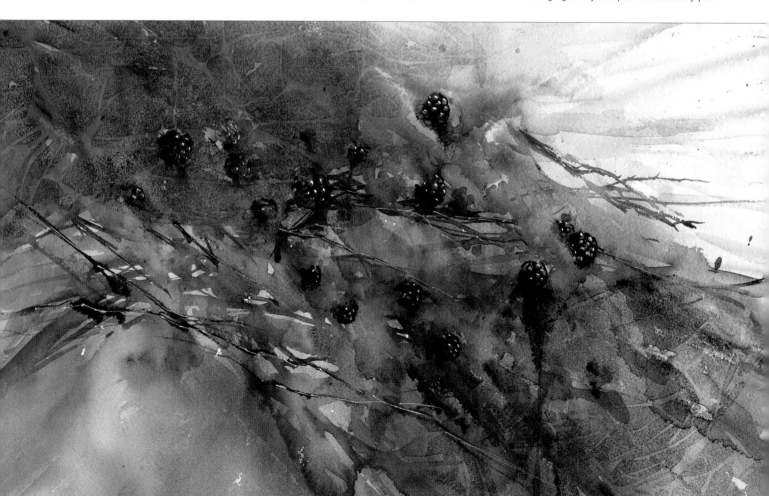

Portrait composition

When you look at your subject, don't always opt for the obvious way to paint it. In 'Autumn Hedgerow' I really did paint what I saw. The painted branch lay across the width of my paper and was perfectly easy to work on in a landscape format. In 'Tumbling Berries', however, I chose a slightly more unusual format, the portrait format, in which the fruits tumble downwards from the branch to cover the paper in a more unique manner.

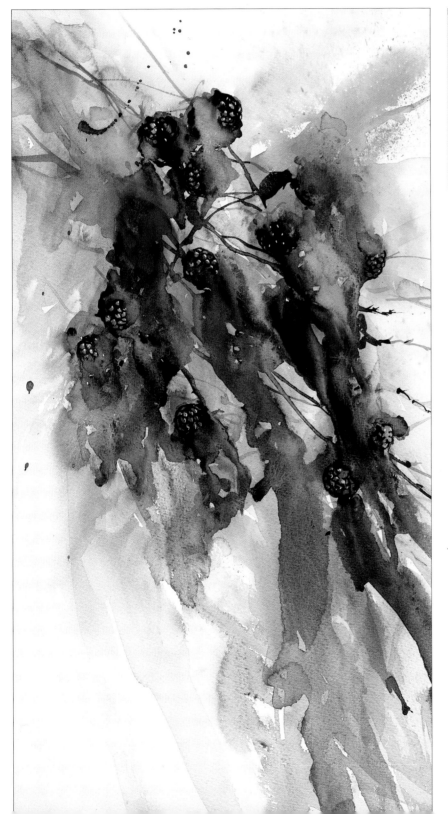

Tip

Squeeze a blackberry on to your palette or a white plate to give you a great base for matching your fruit colour. It really helps to get you in the mood by giving you a real feel for your subject and, yes, I have painted with the juice too at times, mixed with my paint colours!

Tumbling Berries

These berries falling downwards create an unusual effect. It is a slightly more abstract way of painting the subject, and it leads my imagination towards countless other paintings of exactly the same subject because now I am completely in love with the idea of this composition and searching for new ways to create. The paper has been placed in a vertical position, making this a portrait composition.

The four-corner trick

It isn't enough simply to paint subjects or cover paper with colour. You need to try to make every section of each painting fascinating. Creating atmosphere with exciting colour and directional brushstrokes in the right places can make a very beautiful composition, but don't forget to think about the corners of your work and do not underestimate how important they are. Try to make each corner of every painting different as this will add drama and impact to your work. It is a wonderful way of creating 'out of this world' compositions.

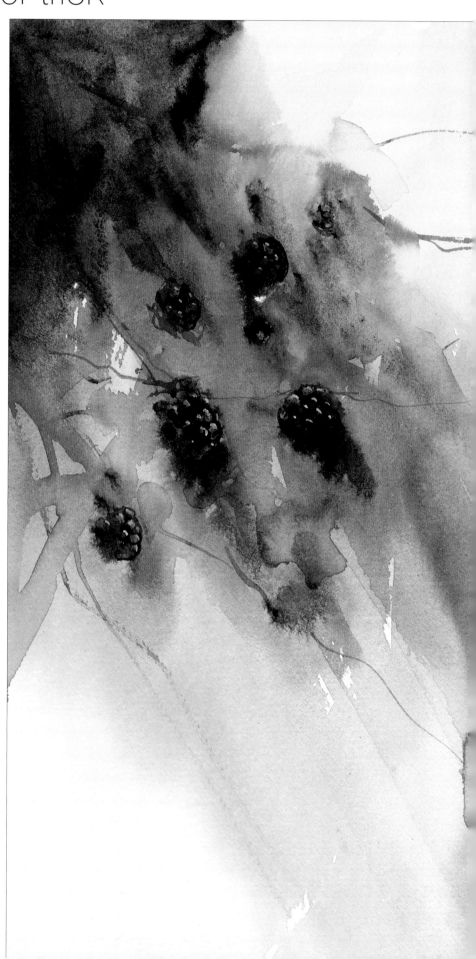

Simply Berries

No complicated background here, just luscious colour telling the story that this is a painting of blackberries. Pure and simple berries! Notice how the lower half of the painting is left as white paper but the upper section fades gradually into it. Many Chinese paintings are successful with limited cover over the paper; try imagining how you can learn from that style. Each corner in this painting is also slightly different. Observe how they work together to make an interesting composition.

Think before you paint

Before starting a new painting, decide right at the beginning how you will be working, in landscape or portrait format. Think about which section of the paper is the most important. Work out where you will be adding the most vibrant and the softest of colours before you even pick up your brushes. Think before you start to paint. Decide if the whole paper or just part of it will be covered with beautiful colour, and place your subject accordingly. The aim is to make your painting exciting and fascinating, but remember that not all paintings have to be complicated to be successful; sometimes the simplest of paintings gain the most attention. Be unique, explore unusual compositions and don't always paint what you see as you see it!

Autumn Delight

Here, the key fruits are placed centrally but water and colour flow direct the viewer to other areas too.

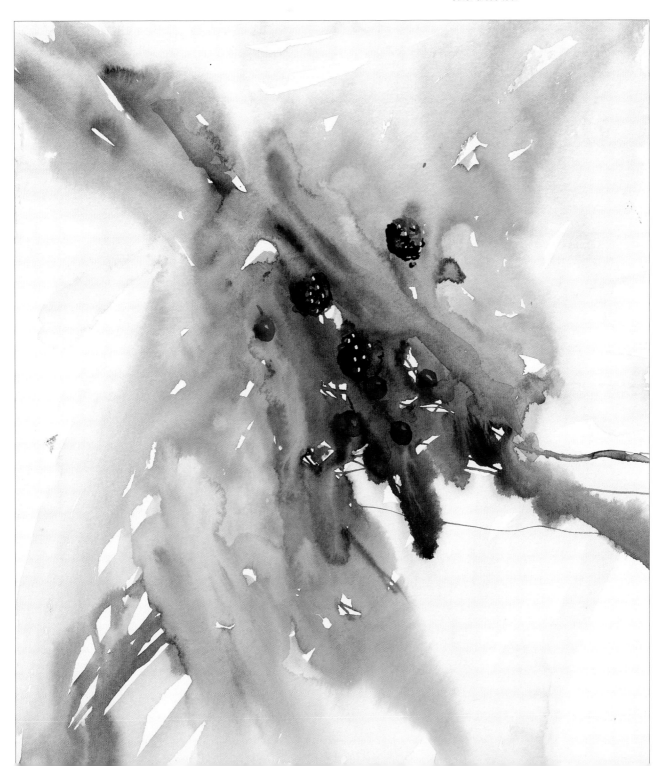

The road to success

"Whatever your level as an artist, set positive goals for yourself concerning how to learn or improve your technique."

Every artist, no matter how great they are, started out in life as a beginner. This is a fact well worth remembering. It is possible that some people have more natural talent than others but in time a new skill can always be mastered. Any difficulties can be overcome if you face them with enthusiasm and the will to succeed. A fabulous combination of a positive attitude and a passionate yearning to learn is an incredible foundation to build on and a powerful way to reach where you wish to be in your own, personal art journey. You need to believe that absolutely nothing is out of your reach. Once you do, there will be no holding you back.

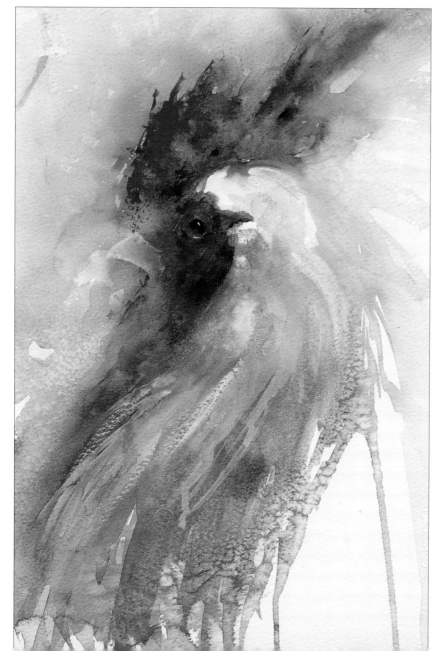

Over My Shoulder

There can be no going back from professional to beginner as an artist, so enjoy every step you take in your art journey.

I am convinced it is a passion held deep within us that makes us strive to create individually. If you are reading my book it will be because you are interested in painting something unique and unusual. So how does anyone leap from being a beginner to an established artist?

We often hear the words 'practice makes perfect' but I often meet newer artists who have no confidence in their ability. It is this negative factor that can destroy an artist's soul along with any chance of their succeeding. And this is a feeling I wish to throw out of the window so that everyone, no matter how talented they believe they are (or not), can enjoy working in watercolour as much as I do.

Tip

Whatever your level as an artist, set yourself positive goals for how to learn or improve your technique.

Small beginnings

Start small. Do not expect to finish a huge painting that is suitable to frame each time you pick up a brush. In fact, try the opposite! Take a piece of paper and deliberately set out to paint a section of a subject and love it. Stop when you can see the very first signs of what you are painting and leave it to enjoy at the half-finished stage. Try consistently painting another new, small study or section and see if you can achieve an even better result.

I have been asked many times what has motivated me and improved my style the most. The answer lies in this simple exercise of only painting small studies regularly.

I demonstrate internationally so I have had to find ways to express my style that are simple and easy to follow because I often come up against a language barrier. Also, I have observed that many new artists find it impossible to paint a full composition after watching a complete and lengthy demonstration, mainly due to the fact that by the time the demonstrating artist has completed the scene the members of the audience have either faded with boredom or forgotten what the first steps were.

To be successful your first steps need to be so fantastic that they leave you wanting more each time you put down your brush. My goal is to keep your enthusiasm levels as high as possible, so follow the simple exercises and techniques in this book and repeat them continually until you feel you are ready to move on. Enjoy being a beginner if that is your level as you can never go back to this stage. Love each part of the learning experience.

Tip

Remember that everyone has down times when nothing seems to go right, so you are not alone if this happens to you. When you get days of unsuccessful paintings, put the brush down and go outside. Learn to 'see' instead and this new vision will help you improve when you eventually feel like painting again.

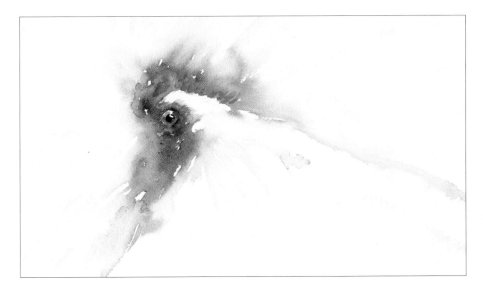

Cockerel Study

Learning from a small, perfect section of a subject is a great way to become a great artist.

Building experience

Eventually, in time, you will find that your studies and small paintings are becoming more recognisable as subjects. You may even find new techniques in them that improve your handling of both the medium and your brushes. You will find favourite colours that work well for you, and some techniques that you enjoy more than others. Your style will slowly develop, and this is a wonderful part of your art journey.

Do not be hard on yourself when things do not go as planned because these are definitely the times you learn and grow the most. When a painting is successful aim to repeat it, but when you face a disaster it raises more questions as to why things didn't work. Take the time to think about how things could be improved, and the answers will lead you to a far better place.

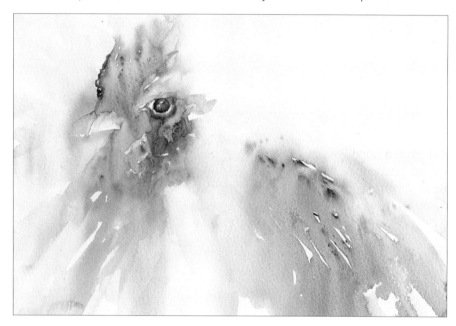

Adding more colour to a first study and learning from the experience.

The road to discovery

Over the years my own style has evolved and I have discovered new techniques that work for me. Colour runs are one of my most recognisable trademarks, but many art tutors would view these as mistakes and tell their students to remove them.

The whole point of loving art and wishing to be an artist who creates is developing a style that is unique, and discovering new ways to approach familiar subjects. You will never please everyone or appeal to the whole world with your art preferences. What you must always do, though, is be true to yourself. Paint from your heart, paint what you want to paint and how you want to paint it. Consider famous artists who made huge leaps into the unknown with their work – Picasso and Dali, for example. Look at paintings by the Impressionists, who changed the way people thought about art forever. Believe in yourself, give your own art opinions credit because they are worthy, as are you, of fitting into this wonderful world of art.

The Beauty of Dawn

A beautiful cockerel created by allowing colour to run while the painting developed. This new technique has become a favourite and recognisable feature of my style. What could be your signature?

Never let anyone get you down. Only take negative comments from those who you really admire. Bear in mind, if you are aiming for a loose style you cannot always expect anyone who adores more detailed work to love your results, so respect others' opinions. Keep going and improve with every new painting. Develop your own style and grow!

Growing as an artist

When you feel your studies are growing into full paintings and you are happy with the compositions, then it is time to make decisions on what to do with your art. Will you show, teach, write or exhibit? Or maybe you are more than happy to give each new week a wonderful burst of life purely by painting and making yourself feel happy. And what could be more satisfying than that? There is no right or wrong in this art journey but there is a factor which is well worth considering.

If you are painting for the sheer joy of creating, what happens to your results should not matter. Whether they end up in the bin or on a wall is unimportant because you have admitted you want to paint and that is exactly what you have achieved. An enjoyable painting session can simply be spent allowing colour to flow across the paper. More often than not, however, we place huge boulders of pressure on our shoulders to always aim for that elusive masterful painting that the whole world will admire. By doing so, we open the doors to massive disappointment and a sense of failure instead.

Every single time I move my brushes I am in a world I wish to be in. I am free, happy and exhilarated. When I put my brushes down I can't wait to pick them up again, purely because there are no 'boulders on my shoulders', and I don't want any to be on yours!

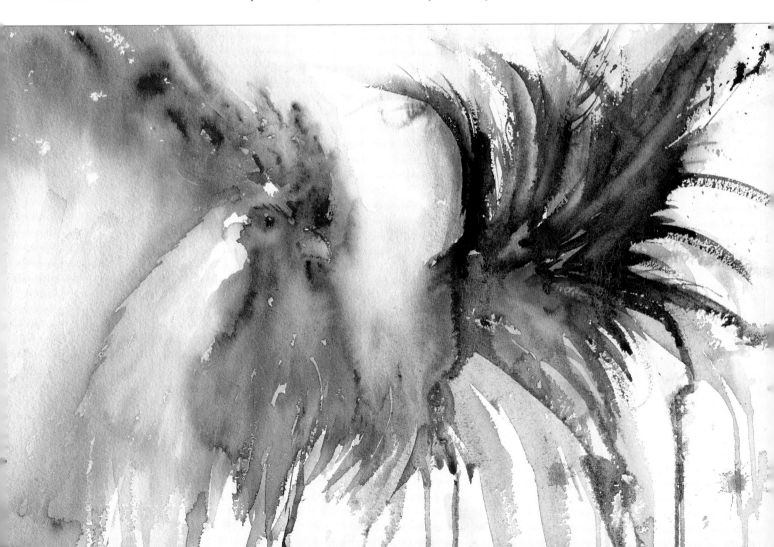

Inspirational quotes

Throughout this book I have included various quotes that I often use during my teaching to help my students on their journey to becoming a better artist. Affectionately known as 'Jeanisms', I have reproduced some of them here and added some extra ones in the hope that, when you feel you are on the point of giving up, they will inspire you to carry on.

Believe

The only thing standing in the way of you being a great artist is your faith in your own ability.

Believe you can, forget the words 'I can't'.

The only way the term 'negative' can be helpful is when we use it positively as a technique.

Don't aim for perfection but do aim for magic in your unique results.

Practice

Like musicians, you need to learn the basics before you can begin to play complex pieces well. Practice is important if you really want to succeed at any new skill.

By learning, and with practice, we can all get to where we want to be as artists.

Many beautiful small studies are far better than one huge disaster.

Everyone has a favourite section within a painting. The aim is to create a large painting full of favourite sections.

All my watermarks are exciting successes, not 'mistakes', as I set out to make them on purpose.

Reach

Don't settle for what you know you can do; strive to discover what you don't believe you can do and surprise yourself with the talent you never fully realised you possessed.

Leap out of your comfort zone and try something new regularly.

Don't get stuck in a rut.

Paint for the bin

The more paintings that go into your bin, the more you are learning, so fill it up.

An empty bin means you are not practising enough to be a great artist.

Not all paintings have to be framed.

Stop, look and listen

Study a beautiful, unfinished painting during the creative process so that you can learn from it and also listen to what it tells you it needs in its next stages of development.

Try stopping long before you think you have finished a painting. You will be amazed at how often you make the right decision to walk away.

Be you

Never be frightened of being different, be true to yourself as an artist by being brave and original.

Don't be a sheep, be unique.

Creative thoughts

Opening up our creative ability, exploring all the options of how we can turn something simple into something much more exciting, is the most brilliant of all lifetime highs.

Every time we pick up our brushes we learn from the process, and this leads us into much better tomorrows, full of hope.

Watercolour holds magic that even now has still not yet been fully explored.

My techniques explained

Bleeding away: moving pigment from one area to another by using your brush and guiding wet colour away from the subject.

Colour flow: pigment is encouraged to flow and interact with other pigments as it moves. This technique aids amazing pattern formations as the individual and combined pigments dry. Compare with 'water flow' where it is water alone that is allowed to run rather than pigment.

Directional flow: this is when your paper is placed at an angle to encourage either pigment or water alone to flow through your painting. This creates a sense of movement and unusual harmony throughout the composition.

Energy washes: an exciting combination of techniques such as texture effects, watercolour flow or directional brushwork to give paintings that extra 'wow' factor.

The four-corner trick: making sure each corner of a composition is unique to aid successful and interesting compositions.

Making a connection: adding further subjects to a new or half-completed painting at a later stage.

Opposite energies: using cool colours on top of warm or vice versa to form unusual layers of contrasting shades. This technique can, for example, warm up a cool section of a painting or add extra interest to areas that need a boost in an almost finished piece.

Patternising: using salt on wet pigment to create wonderful effects when the paper and colour are dry.

Positive negativity: working around the negative shape of a subject to bring it to life. This technique can be used on fresh white paper or on top of an already-painted soft first wash.

Sunbursts: beautiful forms created by careful application of clean water which disperses and pushes pigment out of the way during the drying process. Results are unique and exciting, leading to the most dramatic of watercolours.

The seaweed effect: a first wash brought to life by a second layer of stronger colour in bold, contrasting shades placed on top in flowing patterns. It is necessary to leave a few sections of the first wash uncovered by the second layer so that the first wash can be seen easily in these spaces. Each wash must be completely dry before the next layer is added. A maximum of three layers is advisable with this technique; often the most beautiful results are gained with only two layers at a time in each section.

Trapping the light: leaving a fine line of white paper or lighter colour between sections of a painting to give an effect of light hitting the surface or subject.

The Venetian technique: a technique for creating fabulous watercolour effects by a combination of patternising and wrap techniques. Salt is applied to wet pigment before plastic wrap (Clingfilm) is carefully applied on top, trapping the salt and limiting how it creates patterns in a controlled space. This technique can create a wide variety of brilliant effects. Using your fingers to press shapes in the plastic wrap before the pigment is allowed to dry can achieve lines or even brick shapes in architectural structures. It is perfect for aged effects.

The wrap technique: a technique in which plastic wrap (Clingfilm) is used to create energising texture within a watercolour wash.

Water flow: paper is placed at a gentle angle and water alone is allowed to flow through pigment to create unique effects throughout a painting. Compare colour flow.

Index